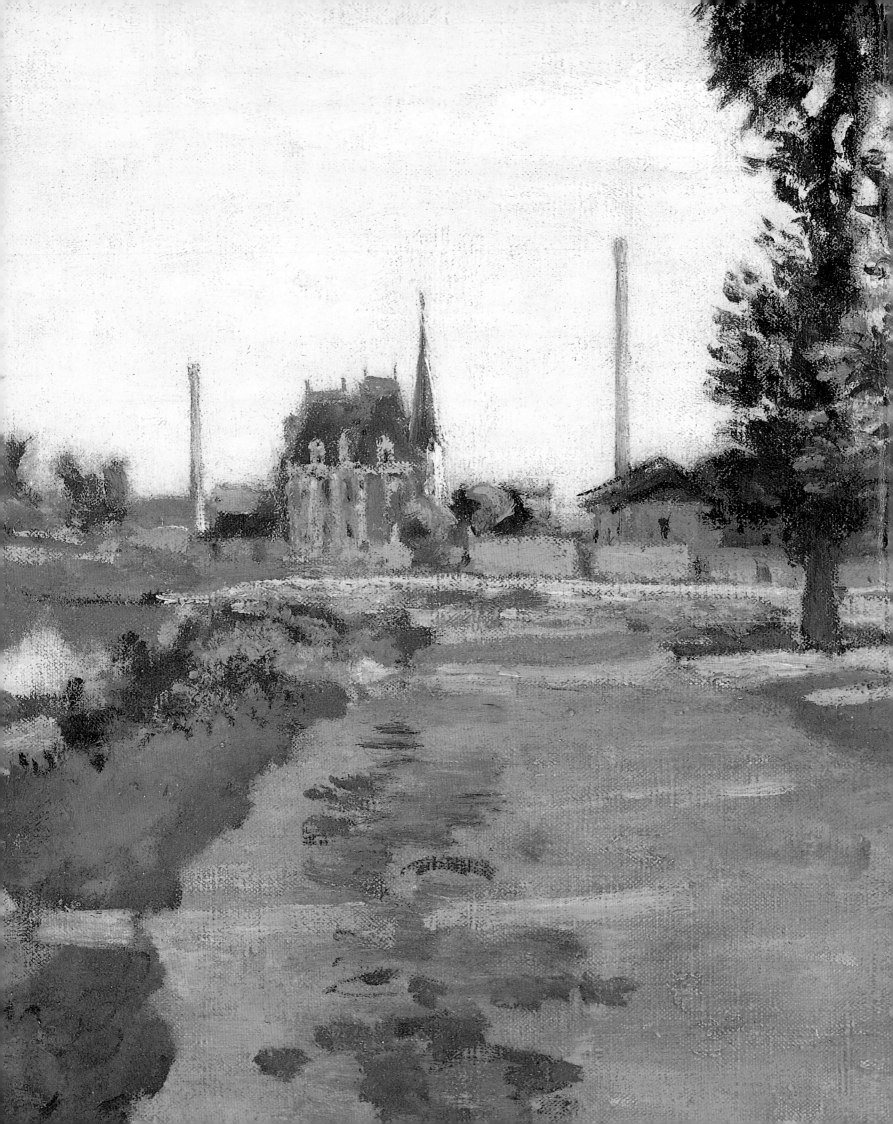

The Impressionists at Argenteuil

Paul Hayes Tucker

National Gallery of Art, Washington
Wadsworth Atheneum Museum of Art, Hartford
Distributed by Yale University Press,
New Haven and London

The exhibition is made possible by United Technologies Corporation

The exhibition was organized by the National Gallery of Art, Washington, and the Wadsworth Atheneum Museum of Art, Hartford

It is supported by an indemnity from the Federal Council on the Arts and the Humanities

Educational programming at the Wadsworth Atheneum Museum of Art is supported by Christie's

Additional support for the Hartford showing of the exhibition comes from the Beatrice Fox Auerbach Foundation

Exhibition dates

National Gallery of Art, Washington
28 May – 20 August 2000

Wadsworth Atheneum Museum of Art, Hartford
6 September – 3 December 2000

Produced by the Editors Office, National Gallery of Art, Washington
Editor, Tam Curry Bryfogle
Production Manager, Chris Vogel

Designed and typeset by Cummings & Good, Chester, Connecticut
Typeset in Granjon
Printed on Biberist Allegro 150 gsm by Mondadori Printing, Verona, Italy

Clothbound books distributed by Yale University Press, New Haven and London

Library of Congress Cataloging-in-Publication Data

Tucker, Paul Hayes, 1950–
The impressionists at Argenteuil / Paul Hayes Tucker.
p. cm.
Organized by the National Gallery of Art, Washington, May 28–Aug. 20, 2000, and the Wadsworth Atheneum Museum of Art, Hartford, Sept. 6–Dec. 3, 2000.
ISBN 0-89468-249-0 (pbk.) — ISBN 0-300-08349-1 (cloth)
1. Impressionism (Art)—France—Argenteuil—Exhibitions. 2. Artist colonies—France—Argenteuil—Exhibitions. 3. Impressionist artists—France—Argenteuil—Exhibitions. 4. Argenteuil (France)—Social life and customs—19th century. I. National Gallery of Art (U.S.). II. Wadsworth Atheneum Museum of Art. III. Title.

ND551.A74 T83 2000
759.4'367—dc21 00-028731

Note to the Reader
Dimensions are given in centimeters, followed by inches in parentheses; height precedes width.

Front cover: Claude Monet, *The Highway Bridge and Boat Basin* (detail), 1874, National Gallery of Art, Washington, Collection of Mr. and Mrs. Paul Mellon (cat. 28)

Back cover: Auguste Renoir, *Monet Painting in His Argenteuil Garden* (detail), 1873, Wadsworth Atheneum Museum of Art, Hartford, Connecticut, Bequest of Anne Parish Titzell (cat. 19)

Frontispiece: Claude Monet, *The Promenade at Argenteuil* (detail), c. 1872, National Gallery of Art, Washington, Ailsa Mellon Bruce Collection (cat. 8)

Page 6: Auguste Renoir, *The Seine at Argenteuil* (detail), c. 1875, Private Collection, Switzerland (cat. 49)

Page 8: Claude Monet, *The Gladioli* (detail), c. 1876, The Detroit Institute of Arts, City of Detroit Purchase (cat. 47)

Contents

Directors' Foreword

Although less well known today than Giverny, the small suburban town of Argenteuil, situated down the Seine from Paris, was the single most important site for the birth of impressionism. It was here that Claude Monet and his colleagues invented and codified a new artistic language of broken brushwork and divided light and color, addressing themes of unprecedented modernity. Working in the open air, often side by side, they depicted sailboats and regattas, train trestles and towpaths, gardens and factories, as well as their families and each other. With apparent spontaneity, they captured not only the fleeting effects of light and atmosphere but also the character and temper of the age, with subjects that struck the critics as startlingly progressive. Monet first settled at Argenteuil in 1871 and was joined at various times by Auguste Renoir, Edouard Manet, Alfred Sisley, Eugène Boudin, and Gustave Caillebotte. The subject matter and style of their work achieved nothing less than a revolution in the art of painting. In a uniquely topical fashion they defined the *genius loci,* the spirit of place of Argenteuil, its landscape, peoples, customs, and pastimes.

A working town, Argenteuil had been known for its tanneries, silk mills, ironworks, and gypsum mines, which produced what is still known as "plaster of Paris." The town was also synonymous with the new craze for leisure boating. Situated only fifteen minutes by train from the Gare Saint-Lazare, it beckoned as a convenient weekend excursion destination. Though extensively damaged in the Franco-Prussian War (1870-1871), Argenteuil was quickly rebuilt and soon drew back its well-to-do day tourists. In the intensively creative years of the 1870s Monet and his fellow avant-garde painters shared companionship, recreation, and the stimulus of intellectual and artistic exchange. It was in Argenteuil that the group perfected the classic impressionist style, conceived the first impressionist exhibition of 1874, and hatched strategies for the promotion of their art.

The present exhibition was initiated by Peter C. Sutton, former director of the Wadsworth Atheneum Museum of Art, who persuaded the noted impressionist scholar Paul Hayes Tucker to serve as guest curator and author of the insightful catalogue. Bringing together more than fifty paintings, many of which have rarely been lent by their private owners, this is the first exhibition ever dedicated to the subject. Organized jointly by the National Gallery of Art and the Wadsworth Atheneum Museum of Art, it opens in Washington in May 2000, then travels to Hartford in September of 2000. We are abidingly grateful to the lenders, whose sacrifice in making their works temporarily available to us ensures the success of the show.

We wish to thank United Technologies Corporation, especially George David, chairman and chief executive officer, for making the exhibition possible. United Technologies has been a friend of both the National Gallery and the Wadsworth Atheneum for many years, and we are grateful for their continuing support. The show has also received an indemnity from the Federal Council on the Arts and the Humanities.

Earl A. Powell III
Director
National Gallery of Art
Washington

Elizabeth M. Kornhauser
Acting Director
Wadsworth Atheneum
Museum of Art
Hartford

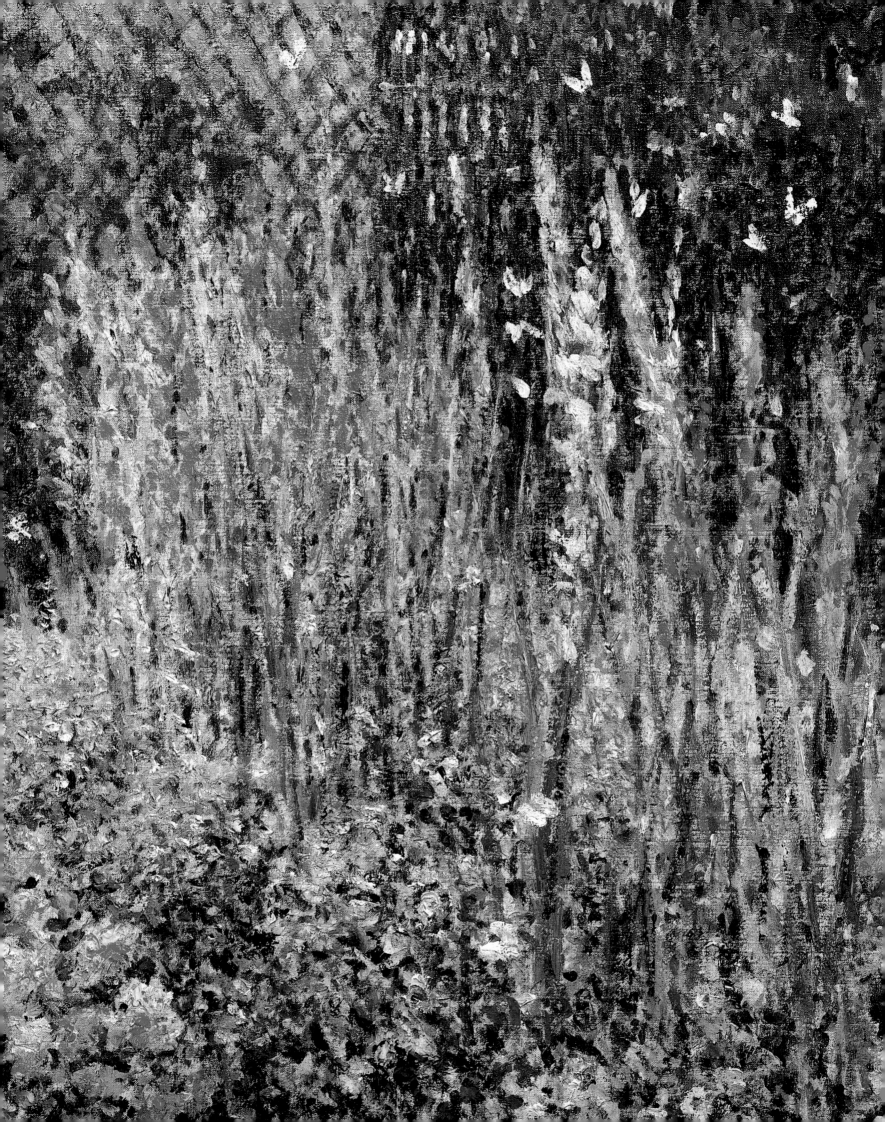

Lenders to the Exhibition

Albright-Knox Art Gallery, Buffalo
The Art Institute of Chicago
Mr. and Mrs. Trammell Crow
The Detroit Institute of Arts
The Fitzwilliam Museum, Cambridge
Fondation Corboud, courtesy of the
 Wallraf-Richartz-Museum, Cologne
Kröller-Müller Museum, Otterlo
Kunstmuseum Bern
Collection of Mr. and Mrs. Paul Mellon,
 Upperville, Virginia
The Memphis Brooks Museum of Art
The Metropolitan Museum of Art, New York
Musée d'Orsay, Paris
Museum of Fine Arts, Boston
The National Gallery, London
National Gallery of Art, Washington
National Museum and Gallery, Cardiff
Niigata Prefectural Museum of Modern Art
Norfolk Museums Service (Norwich Castle Museum)
Philadelphia Museum of Art
Portland Art Museum (Oregon)
Private Collections
Staatliche Museen zu Berlin, Nationalgalerie
Staatsgalerie Stuttgart
Sterling and Francine Clark Art Institute,
 Williamstown
John M. and Sally B. Thornton Trust
Wadsworth Atheneum Museum of Art,
 Hartford
Wallraf-Richartz-Museum, Cologne
Yale University Art Gallery, New Haven

Acknowledgments

This exhibition and the accompanying catalogue would not have been possible without the generous assistance of many individuals, beginning with Peter C. Sutton, former director of the Wadsworth Atheneum Museum of Art, who invited me to undertake the project in 1997 and has supported me in its realization at every stage. There could be no better colleague. I also owe a great debt to Earl A. Powell III, director of the National Gallery of Art, who has lent the considerable resources of his institution—including eight major paintings by Monet, Renoir, and Sisley—to ensure an exemplary presentation of the groundbreaking works of the impressionists at Argenteuil.

Among the museum directors, curators, private collectors, and professional friends who gave generously of their time and assistance in securing key loans for the exhibition, I would like to thank especially Gunter Abels, David Alston, George Ayoub, Donald Bacigalupi, Daniel Bauman, Graham W.J. Beal, Brigitte Béranger, Helen Braham, Richard Brettell, John Buchanan Jr., Dr. Rainer Budde, E. A. Carmean Jr., Shun Chikaato, Michael Conforti, Mr. and Mrs. Trammell Crow, Marianne Delafond, Anne Distel, Douglas Dreishpoon, Douglas Druick, Colin Ford, Katsunori Fukaya, Caroline Durand-Ruel Godfroy, Gloria Groom, Anne d'Harnoncourt, Dr. Christian von Holst, Steven Kerns, Aliene Laws, Janice Levin, Henri Loyrette, Neil MacGregor, Seiro Mayekawa, Mrs. Paul Mellon, Takashi Miura, Katsumi Miyasaki, Philippe de Montebello, John Murdock, Hideo Omi, Joachim Pissarro, Richard Rand, Jock Reynolds, Christopher Riopelle, Joseph Rishel, Duncan Robinson, Malcolm Rogers, Simon Sainsbury, Barbara Schäfer, Douglas G. Schultz, Peter-Klaus Schuster, George Shackelford, David Solkin, Toni Stooss, Evert J. van Straaten, Tsuneshi Suzuki, John M. and Sally B. Thornton, Gary Tinterow, Catherine M. Wilson, and Jim Wood as well as those who wish to remain anonymous.

The exhibition has also benefited from the discrete help of friends in the trade: William Acquavella, Alex Apsis, Joseph Baillio, William Beadleston, Ernst Beyeler, James Borynack, Desmond Corcoran, J. Barry Donahue, Michael Findlay, Thomas Gibson, Robert Gordon, Paul Herring, Waring Hopkins, Ay-Wang Hsai, Mariko Ito, Yasunari Kumon, John Lumley, Charles Moffett, David Nahmad, David Nash, Maria Reinshagen, Elizabeth Royer, James Roundell, Michel Strauss, Sandra Tschuden, Alec Wildenstein, Daniel Wildenstein, Guy Wildenstein, and Sarah Zorochin. A special thanks as well to Anna Swinbourne.

In Argenteuil, Gérard Troupeau and Jean-Paul Mirbelle of the Musée du Vieil Argenteuil allowed me access to important visual materials, while Isabelle Lefeuvre, the city archivist, came to my aid with documents and answers to last-minute inquiries. Lucienne Legrande-Dreher proved to be the spirit of this project, as of others before, with innumerable gestures of kindness. The distinguished mayor of Argenteuil, Roger Ouvrard, provided essential support, as did his colleague across the river, the député des Hautes-de-Seine and mayor of Gennevilliers, Jacques Brunhes, together with his chargé de mission, Michel Ratard.

Many other individuals contributed to aspects of the catalogue. Stephen Frankel offered critical advice at an early stage, pulling me back from many an entangled phrase. Robert Herbert read the completed manuscript with his typical acumen and made many valuable suggestions. So did Kate Diamond and Bruce Garr, both of whom proved ever reliable. I received unfailing support from Suzanne Delay on many fronts. Barbara Bruce Williams gave helpful legal guidance over many months. I am also grateful to James Allen, Richard Doherty, Adene Gregman, Mark Henderson, Colin Heywood, Gerard Jourdas, Rico Mochizuki, Olivier Muraire, Antoine E. Naaman, John Nicoll, and Valerie Steele. Sarah Goodwin,

chair of the English department at Skidmore College, and Professor Barry Goldensohn made available office space, where I wrote much of this book in the summer of 1999, while my colleagues in the art department at University of Massachusetts Boston tolerated my sometimes distracted presence in Boston.

Marie Dalton-Meyer manages the cultural programs and sponsorships at United Technologies Corporation, which has generously supported both the exhibition and the publication of this lavishly illustrated catalogue. Peter Good and his design team, especially Kirsten Livingston, transformed the raw material of the book into a lively and elegant final production.

I greatly appreciate the expert work of the staff at the two organizing museums. In the National Gallery of Art exhibitions office D. Dodge Thompson, Jennifer Cipriano, Jennifer Bumba-Kongo, Kathleen McCleery Wagner, Jessica Stewart, and April Canfield were indispensable allies. Senior curator of European paintings Philip Conisbee was a model confrere, lending his time and energy at critical junctures and offering insightful comments on a draft of the essay. In his office Florence E. Coman and Ana Maria Zavala provided knowledgeable assistance on many occasions. In the editors office Chris Vogel oversaw the production of the catalogue, Mary Yakush managed contract negotiations, and Tam Curry Bryfogle applied her remarkably refined eye and mind to the manuscript, while Sara Sanders-Buell went to great lengths to gather photographic material. Susan Arensberg and Mari Griffith were responsible for the excellent brochure and exhibition texts. Sandy Masur and Susan McCullough worked closely with the corporate sponsor, United Technologies Corporation. Deborah Ziska orchestrated publicity and press coverage. Marilyn Shaw and Isabelle Jain crafted legal documents. Sally Freitag and Hunter Hollins handled the myriad registrarial arrangements to assemble the works in Washington, while Mervin Richard and Ann Hoenigswald provided conservation expertise. The design talents of Mark Leithauser, Gordon Anson, Donna Kwederis, and William Bowser became evident in the splendid installation.

At the Wadworth Atheneum Museum of Art the exhibition has enjoyed the skillful guidance and support of acting director Betsy Kornhauser. Nicole Wholean coordinated countless aspects of the presentation in Hartford, while Matthew Siegel supervised registrarial details. Dina Plapler was instrumental in securing the generous support of United Technologies as well as other welcome assistance for the Wadsworth's venue.

To relieve some of the pressure of the project, I relied enormously on my family, Maggie, Jonathan, and Jennie, who responded with a continual supply of patience and understanding, for which I will be forever grateful. They merit more than I was able to give in return and certainly more than this humble thanks, as I hope they know.

My father, who has always been my touchstone for sane and clear writing, like my grandfather Carlton Hayes, was unable to read this manuscript owing to illness. It is the only one he has missed. My loving mother read it to him with her typical devotion, underscoring how much recognition they both deserve.

During the course of this project, two special people on two sides of the Atlantic slipped out of my life, taken by different forms of terminal cancer: Sally Kolker and Sam Walker. Their loss is a painful reminder of how fickle existence can be, but their legacies—of spirit, deed, and character—live on, as I trust they always will. It is therefore to Sally and Sam and their respective families that I dedicate this book.

Paul Hayes Tucker

On Place and Meaning:
Argenteuil and the Impressionists,
1871-1894

Paul Hayes Tucker

In late 1885, when the impressionists were frayed and factionalized and when all except Gustave Caillebotte had abandoned Argenteuil as a communal site for advanced painting, the satirical magazine *Gil Blas* published the first installment of a new novel by Emile Zola. Entitled "L'Oeuvre" (literally "The Work," but often translated "The Masterpiece"), the story was serialized in eighty issues of the magazine and published as his fourteenth book in April 1886. Unlike his previous fiction, "L'Oeuvre" focused on the Paris art world, a terrain Zola knew well. From the early 1860s onward he had followed developments in French art closely, producing a substantial body of criticism of contemporary painting and sculpture on which he drew for this not-so-thinly-veiled portrayal of avant-garde affairs in the capital.

Halfway through the novel, the hero-artist, Claude Lantier, is fêted by his friends at a dinner in Paris. Four years earlier he had established himself as the leader of what was dubbed the "Open-Air School" after he exhibited a controversial painting of a nude woman lying in a forest with a clothed man beside her and two nude females in the background "rolling together on the grass."[1] In the process of painting the picture, Lantier had fallen in love with the woman who posed for the foreground figure. Without warning, he decided to leave the city with her to establish a new life in the country, fleeing the fracas of the Salon and the abuse of critics—in short, forsaking his career.

The lure of Paris was too strong, however, and he eventually returned to take up the fight for recognition, much to the delight of his fellow "open-air" painters: "Prostrate with admiration, they poured out all their hopes, told him

what great store they set by him...he alone, who had all the makings of a great painter and such a firm grasp of the requirements of his art, was worthy of being hailed as the master." He was essential, they claimed, because "the Open-Air School had developed considerably...but its efforts lacked cohesion....Its new recruits turned out little more than sketches and were easily satisfied with impressions tossed off on the spur of the moment. What was needed was the man of genius whose work would be the living image of their theories." Full of eagerness, they proclaimed their agenda: "To conquer the public, open a new period, create a new art!"

This brief passage in Zola's lengthy tale is laced with familiar references. The Open-Air School is clearly modeled on the impressionists; Lantier's galvanizing painting is based on Edouard Manet's *Luncheon on the Grass,* the *succès de scandale* of the Salon des Réfusés of 1863; the leader's flight to the country is analogous to the moves of various impressionists from Paris to the suburbs in the 1870s and 1880s; and the notion that Lantier's followers were merely producing mindless sketches derives from the diatribes of conservative critics who lambasted the impressionists for this perceived shortcoming. Zola knew the impressionists' work and agenda firsthand. He had defended them as emerging artists in the 1860s in a series of scathing articles that cost him his job at the Paris newspaper *L'Événement.* He continued to write about them in the 1870s, although he had lost some of his enthusiasm for their achievements. He thus prepared his book with considerable authority.

Yet there are more subtle implications to this account, for Zola was informally gathering material for "L'Oeuvre" when

the impressionists formalized their movement in the 1870s and Argenteuil arose as a primary locus. Zola used the above-quoted passage, for example, to affirm the importance of Paris as the center of contemporary art. It is where reputations were made or broken, where theories were formulated, debated, and tested in front of a discerning public, and where great art was created, often with the city as its subject. Thus when Lantier walked the streets of Paris in the weeks after dining with his friends, he "could feel [the city] in the very marrow of his bones....Never had he experienced such an urge to work, never had he known such hope or felt that all he had to do was stretch out his hand and produce master-pieces which would put him in the rank which was his by right, the first rank."[2] The suggestion of course is that the countryside fosters artistic dallying, if not decline. In the years Lantier spent away from the capital, he had painted nothing of importance, whereas the masterpiece he began soon after his reunion dinner was destined for history because it was a view of the heart of Paris from the working quays of the Seine.

Despite Zola's insistence on a carefully applied scientific naturalism, his sleight of hand and personal bias are felt throughout the book. Most telling is the emphasis on what he considers three outstanding problems: the technical lapses of the group, its need for strong leadership, and the lack of a single painting to secure the artists' position in the annals of French art. Zola had voiced these concerns in the 1870s, asserting in a review of the second impressionist exhibition in 1876, for example, that the group needed "more painters sufficiently talented to bolster the new artistic formula with masterpieces."[3] In 1879 he chastised Manet for not having a hand that equaled his eye. In the 1880s his concerns became more emphatic, causing him to break with the painters and to write "L'Oeuvre."

Zola was right on several counts. First, none of the impressionists created a single masterpiece that set the standard and led the way; no canvas of the 1870s equaled Manet's *Luncheon on the Grass* or his similarly provocative *Olympia*. The success of the movement derived instead from a broad body of work created by different artists with distinct personalities. Second, although Manet and Monet were often identified as leaders of the group, the impressionists did not depend on one exclusive authority; in fact Manet never exhibited with the impressionists in their independent shows. The success of the movement therefore depended on group dynamics: it was only through a collective vision and communal effort that the impressionists were able to "open a new period, and create a new art," as Lantier's Open-Air School so fiercely desired.

In notes he made before beginning his book, Zola declared that he wanted to reveal the difficulties of creating great art and grappling with truth, hoping in the end to con-vince a hesitant public of the value of innovation, including his own. He was successful in this (and readers recognized the significance of his subtext). But he was sorely mistaken in terms of French painting, for history sorted out the field in a way that Zola did not foresee—indeed, in a way that would

probably have surprised Lantier and his fictional contem-poraries: for it is the impressionists who have been granted highest honors, largely on the basis of their accomplishments of the 1870s, mostly realized at Argenteuil.

There are many ironies in this turn of events. Chief among them, and most familiar, is that the impressionists earned their reputations and livelihoods from paintings that appeared unfinished to many, as Zola frequently pointed out. Nothing would have riled the conservative factions of his day more than knowing that their time-honored principles of disciplined paint application, decorous color choice, and ele-vated subject matter would be found inferior to the seemingly spontaneous scumblings of the riotous impressionists. They would have decried the lowering, or abandonment, of stan-dards as well as the slandering and shunning of the noble art of the past, which they had revered and emulated. To the most resistant, the triumph of impressionism would have been tantamount to a national disaster, as the academic artist Jean-Léon Gérôme claimed in 1894 when the government was debating the merits of accepting Caillebotte's bequest of his unparalleled collection of impressionist paintings.[4]

Although Zola appropriated Monet's first name for his protagonist and gave the rural village that Lantier adopted the trappings of Monet's Giverny, he did not model the char-acter on any one figure in the impressionist group. As the impressionists themselves realized—and all of them read the book except Manet, who had died in 1883—Lantier was a deftly constructed amalgam of Monet, Manet, and Paul Cézanne, Zola's boyhood friend from Aix-en-Provence. This provides another irony, for twentieth-century scholars were quick to disassociate Manet and Cézanne from the impres-sionists. They claimed that Manet was never officially part of the group and that Cézanne was a postimpressionist or protocubist. Arguments about these labels persist.

In a further irony, while the impressionists, minus Manet, exhibited together and formed a bona fide though contentious association, they resisted calling themselves "the impres-sionists." Unlike Lantier's Open-Air School, they did not give their group a title. They did not want to be pegged or labeled by critics, and they did not want to be seen as a "school" or a movement. Thus for their first joint exhibition, they chose the commercially based appellation "Société anonyme des artistes, peintres, sculpteurs, graveurs, etc." This under-scored their communal orientation, aesthetic neutrality, and business focus. They maintained a similar, nondescriptive title for each of their eight exhibitions held between 1874 and 1886, although for the third, staged in 1877, they put a sign above the door that read "Exposition des impression-nistes." The catalogue for the show, however, bore the title "Troisième exposition."

The greatest irony may well lie not in specific people, paintings, or names, but in the issue of place. Zola's emphasis on Paris as the center of French culture was entirely appropriate. It was the continuing hub—for historical references, sales,

criticism, and exchange of theories. In the 1870s, though, the majority of the impressionists spent most of their time not in the capital but in the outlying suburbs. And the suburb that became the most important to them and their movement was Argenteuil.

Some Facts and Figures

Located only eleven kilometers from the center of Paris, Argenteuil was a fifteen-minute train ride from the Gare Saint-Lazare. Monet moved to the town in December 1871 after nearly ten months of self-imposed exile in England and Holland during the Franco-Prussian War and the Commune insurrection of 1870-1871. He stayed for about six years, leaving in January 1878. All of his impressionist friends except Morisot and Cassatt visited at various times—Sisley, Renoir, Manet, Caillebotte, Pissarro, Degas, and Cézanne. Some came singly, others in groups, some to visit and share a meal, others to paint and strategize about their goals. Collectors came too—Georges de Bellio, Georges Charpentier, Victor Chocquet—as did critics, such as Théodore Duret and perhaps Paul Alexis.

Monet was enormously prolific in Argenteuil, painting about 180 canvases, for an average of 30 pictures a year, or one every twelve days.[5] Pissarro, Degas, and Cézanne visited without producing any work. (Pissarro, the patriarch of the group, was fruitfully ensconced in Pontoise, a town of very different character from Argenteuil; Degas, the arch-Parisian, rarely painted anywhere outside the capital; and Cézanne was either with Pissarro in Pontoise or in his native Aix in the south of France.) But Sisley, Renoir, Manet, and Caillebotte, painting in and around Argenteuil, created some of the most novel canvases of their careers. Combined with Monet's achievements, their paintings constitute one of the most remarkable bodies of work in the history of art, making Argenteuil synonymous with impressionism and a touchstone for the development of Western visual culture.

Most of the impressionists first came to the *agréable petite ville,* as guidebooks of the period called Argenteuil, because Monet was there. After he left, Caillebotte bought land in Petit Gennevilliers across the river from Argenteuil, built a house on the shores of the Seine, and declared it to be his permanent residence in 1888. Renoir continued to visit the area, mostly, it seems, to see Caillebotte. Manet may actually have known these suburbs better than anyone else in the group, for his family owned a home in Gennevilliers, slightly closer to Paris. It had been his summer retreat in the 1850s and 1860s and may have figured in his formulation of the landscape setting for his notorious *Luncheon on the Grass.* Although Manet never painted Gennevilliers itself and worked in Argenteuil only briefly in the 1870s, he may have introduced Monet to the area by putting him in touch with Mme Emilie-Jeanne Aubry, who owned property in Argenteuil, including a house that she rented to Monet in late 1871. It was the first house Monet and his family occupied in the town. In fact it was the first house he could call his own since the early 1860s, when he had left his boyhood home in Saint-Adresse on the Normandy coast to seek his destiny as a painter in Paris.[6]

It is not clear why Monet chose to settle in Argenteuil. There is no evidence that he had visited the town prior to making his decision, although he may have passed through it when commuting to Paris from Normandy and from other suburbs in which he lived and worked in the 1860s: Sèvres in 1866, Bonnières in 1868, and Saint-Michel near Bougival in 1869–1870. Given the number of other towns he painted during the decade—Saint-Adresse, Honfleur, Le Havre, Etretat, Fécamp, Chailly, Trouville—it seems strange that he did not opt to return to any of them and instead moved to Argenteuil; all were delightful places and had inspired significant paintings that expanded his repertoire of subjects, enhanced his reputation among his contemporaries, and advanced his own sense of direction as an artist. But perhaps he wanted something new and different. Never having stayed in one place for more than twelve months during the 1860s and then having left France for England and Holland, he may also have been yearning for a permanent home.

Other factors may have contributed to his decision. In November 1870, during his exile in London, he turned thirty. Life expectancy for the average thirty-year-old French male at the time was about sixty, which meant he had reached middle age. Moreover, his father died while Monet was abroad; since his mother had died in the 1850s, this second loss probably made him more aware of his own mortality. Finally, just before leaving France in 1870, he had married Camille Doncieux, who had been his model and lover since 1865; they had had a son, Jean, in 1867, who was four and nearing school age when they returned to France.

Argenteuil was blessed with many advantages. It was closer to Paris than were any of the suburbs in which Monet had lived during the 1860s, and it had excellent rail service to and from the capital, with trains running every half hour. It had good housing, a healthy economy, and stores for virtually everything one needed. It also offered a range of motifs that modern landscape painters such as Monet and his impressionist colleagues would have found attractive, most notably a spectacular stretch of the Seine. After tracing an arc through Paris, this national waterway took a northward turn at Bellevue-Billancourt, looped back on itself at Saint-Denis, and curved north again at Saint-Germain-en-Laye on its way to Le Havre and the English Channel. The Seine reached its greatest width of 195 meters and dropped to its deepest level of 21 meters as it flowed from Epinay to Bezons, or right past Argenteuil (fig. 1). It was unencumbered by islands or projecting points of land along its shores, so residents could profit from the river's fullest expanse.

This natural asset was not fully exploited until the 1850s, when the town fathers, at the urging of Paris partisans, sponsored the first sailing races held in the suburbs (fig. 2). The initiative proved so successful that such races became regular events. Over the next decade La Société des Régates Parisiennes, the most important boating club in the Paris region, established the headquarters for its sailing club, le Cercle de la Voile de Paris, on the banks of the Seine at Argenteuil, holding races and festivals there until 1894. (This club still exists, with headquarters in Paris and at Les Mureaux, a smaller town downriver.) In fact Argenteuil became well known for boating activities of all kinds—steamboat races, rowing races, water jousts, and general pleasure boating—which it promoted in local newspapers as well as posters in and around Paris. These marketing efforts paid off. The town became the official site for international sailing competitions held in conjunction with the 1867 World's Fair as well as for other prestigious aquatic events over the ensuing decades.

Fig. 2. Poster for Argenteuil's first regatta, August 1850. Argenteuil Archives

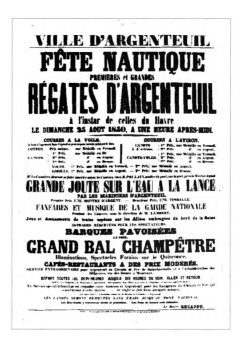

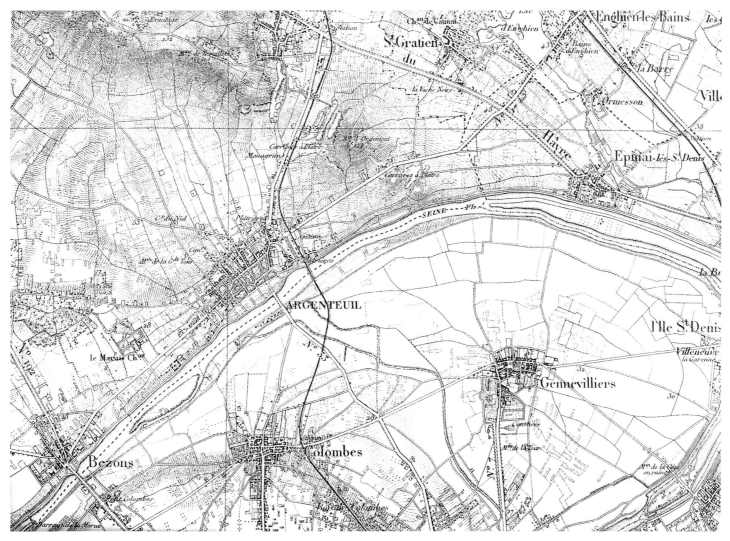

Fig. 1. Map showing Argenteuil in relation to the Seine, Gennevilliers, and Bezons

It is therefore not surprising that the impressionists focused on the Seine and its nautical offerings. They were not the first, however. Soon after Argenteuil became accessible from Paris by rail in 1851, artists began to make it the subject of their work, as evident from a drawing by Morel Fatio that is inscribed 1866 (fig. 3). Commercial artists were regularly engaged by newspapers and magazines to provide illustrations of recreation spots, including Argenteuil (fig. 4). Similar views appeared during the years Monet and his friends painted in Argenteuil.

Those who came for these boating events found much to enjoy in addition to the races, fireworks, and occasional carnival. There was a beautiful promenade along the river, popular with residents as well as visitors (fig. 5). Bordered on one side by the waters of the Seine, the well-worn path was lined on the other side by stately chestnut trees that lent shade and grandeur to the site. The promenade provided breathtaking views of the river from Argenteuil to neighboring Bezons and on to the heights of the Saint-Germain hills in the distance. A similar path ran along the opposite bank of the Seine (fig. 6). It was more modestly planted with a single row of trees and interrupted by houses, including those Caillebotte and his brother built in the 1880s. The Argenteuil promenade was spared such intrusions because it was part of the Champs de Mars, an elliptical, densely planted, public section of town (fig. 7). The Champs de Mars was defined by the promenade and by the Boulevard Héloïse, one of the town's main thoroughfares. For centuries the area had been an island, cut off from the shore by an arm of the Seine. In the 1790s this channel was the suspected breeding ground for a malaria epidemic. Community leaders decided to rid themselves of the problem and, over the next thirty years, used the town's sixteenth-century fortifications to fill it in, creating the Boulevard Héloïse in the process. Delightfully cool during the summer, the Champs de Mars was a gathering place for locals throughout the year and a site for municipal events, such as the town's food market, which came every Tuesday, Friday, and Sunday, a tradition that continues to this day.

In addition to the Boulevard Héloïse, which attracted the attention of both Monet and Sisley in 1872 (cats. 4, 5), Argenteuil had streets and alleyways that were as rich in history as they were visually appealing. This is because the town dated back to the seventh century A.D. when a wealthy nobleman, Seigneur Ermanric, and his wife received permission from Childebert III to found a nunnery in "Argentoïalium." In the ninth century Charlemagne gave the nunnery what was said to be the tunic of Christ, which made Argenteuil a pilgrimage destination for hundreds of years. In the twelfth century the nunnery was home to its most famous prioress, Héloïse, who retired there following a scandalous relationship with her Parisian tutor, the theologian Pierre Abélard (hence the name of one of Argenteuil's most important streets). Other notable residents included the fiery

Fig. 3. Morel Fatio, *Sailing Race at Argenteuil,* 13 May 1866. Musée du Vieil Argenteuil

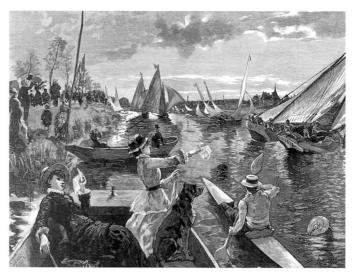

Fig. 4. Paul Renouard, "Autumn Regattas at Argenteuil," wood engraving by M. Moller, *Le Monde Illustré* (1879)

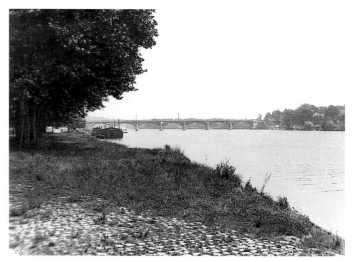

Fig. 5. Photograph of the promenade along the Seine at Argenteuil, late nineteenth century

eighteenth-century revolutionary Mirabeau, the nineteenth-century composer Ambrose Thomas, who wrote "La Marseillaise," and Monet's older contemporary, the academic painter Ary Scheffer. Georges Braque was born there in 1882.

Argenteuil developed around the nunnery following the plan of a Roman grid, with the river defining the southeastern edge. Over the years the rigor of the grid relaxed, creating a looser pattern of altered rectangles and squares that added to the town's charm. No artist, commercial or otherwise, seems to have taken much interest in these picturesque streets, or in the place as a whole, prior to Monet's arrival, although there is at least one engraving from the seventeenth century that shows the town's fortifications and a number

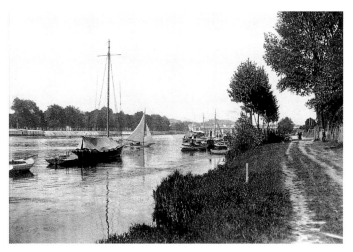

Fig. 6. Photograph of the Petit Gennevilliers promenade, late nineteenth century

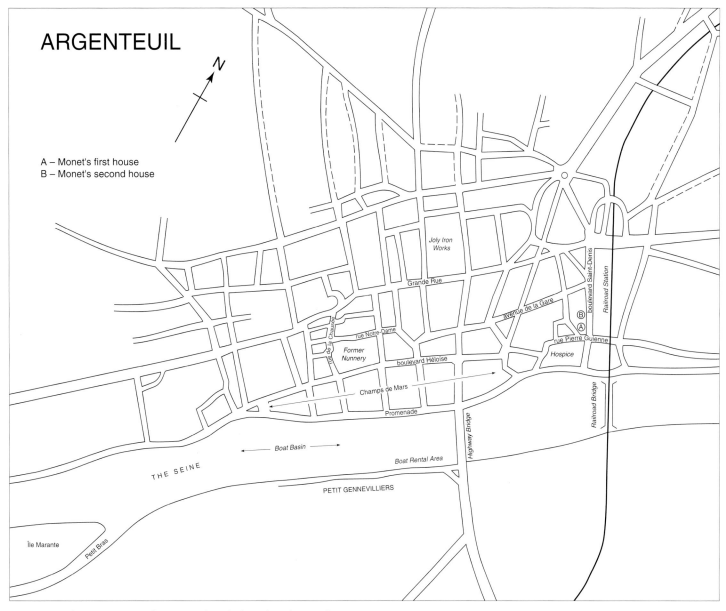

Fig. 7. Map showing streets of Argenteuil, including the Champs de Mars

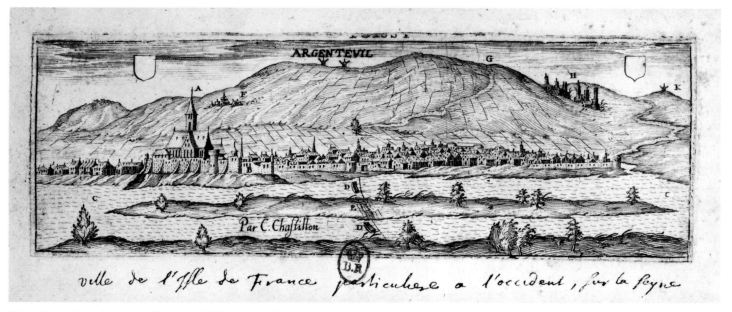

Fig. 8. Engraving of Argenteuil, c. 1610. Bibliothèque Nationale, Paris

from the eighteenth that depict it as a bucolic site (figs. 8, 9). Dozens of images commemorate the foiled marriage of Héloïse and her lover in subsequent years, as interest in this steamy medieval affair continued through the nineteenth century and impressed itself on the minds of Parisians, earning Argenteuil a permanent place in history.

Argenteuil had other reasons to be recognized and remembered. Most significant, the fields around the town at one time supported vineyards that yielded a grape of notable quality; in the seventeenth century *le vin d'Argenteuil* was selected by Abbé de Marolles under Louis XIII as one of the best wines in the Île de France.[7] Whether due to changes in soil conditions, weather, or agricultural practices, the wine descended from its once-heralded heights to a level of mediocrity in the nineteenth century, but it was still consumed and enjoyed—mostly because it was inexpensive. Monet ordered his wines from Bordeaux and Narbonne, a discerning but far more costly choice.

The town was also known for its asparagus, which, unlike its wine, improved in quality, quantity, and fame in the nineteenth century. Although grown in many locations around Paris, the variety produced in Argenteuil was consistently judged to be superior and was anointed grand prize winner at the World's Fairs of 1867 and 1878. Served at the finest restaurants in Paris, it was also exported around the globe. Manet featured Argenteuil's asparagus in a number of his still lifes.

Equally renowned were Argenteuil's gypsum deposits, which were substantial enough to have provided the town a steady income from the time of their discovery in the Middle Ages. François I used them for his vast building campaigns in the sixteenth century. In the nineteenth century the mines became ever more important, because gypsum is the essential

ingredient in plaster. With the expansion of Paris and its suburbs, construction boomed, increasing the demand for plaster walls, ceilings, and decorative ornaments. In the 1870s the town could claim four mines operating at full capacity. Although the plaster used during this period came from Argenteuil and neighboring towns, it became known as "plaster of Paris," a term still in use.

Guidebooks in the late nineteenth century generally noted these points when reviewing Argenteuil's history and contributions to the region. They also drew attention to an old windmill, the Moulin d'Orgemont, that sat on top of a hill northeast of the town near the gypsum mines. The mill had not been used in decades to grind grain, but it offered fabulous views of the surrounding area and, because of that,

Fig. 9. Jeanne Deny, "View of Argenteuil," engraving by Louis Masquelin, late eighteenth century

had been converted into a restaurant that still operates today (fig. 10). Monet painted it once from the vineyards at the foot of the Orgemont hill, and at least once in the background of a view of the Seine from Petit Gennevilliers (fig. 22). When Caillebotte painted from the same vantage point ten years later, he made sure the mill stood out against the sky (cat. 29).

Both Monet and Caillebotte climbed to the top of the Orgemont hill to take in the view and to work (figs. 11, 12). With the Seine snaking its way through the valley below, they could see Argenteuil nestled along the near bank of the river. The plains of Petit Gennevilliers stretched out on the other side to meet the fields of Gennevilliers, which then gave way to a beckoning distance and finally to a horizon broken by the skyline of Paris. The world was at their fingertips, at once graspable and elusive, open to being rendered in all its particulars or seen merely as a collection of abstract shapes and patterns. For Monet and Caillebotte the beauty of the site lay in details that were close enough to be apprehended rather than in distant forms. Like most of their impressionist colleagues, they preferred the tangible and tactile to the vague and ethereal. Panoramic views therefore do not appear prominently in their Argenteuil oeuvres, except when grounded by elements in the immediate foreground, such as the path in Monet's painting, or by man-made forms like a section of a bridge. From the heights of Orgemont the most obvious nonnatural forms were the cylindrical chimneys of Argenteuil's factories, which Monet silhouettes against the sky like the stakes in the vineyards. Their difference from the natural landscape is declared not only by their unadorned shapes but also by their undisguised activity, as dark trails of gray smoke spewing from two of them are blown across the scene, their undulations contrasting with the blotchy clouds beyond.

Argenteuil had made a conscious decision to attract businesses to its shores and establish itself as a vital commercial center. And it had enjoyed impressive success. With the sailboats, sculls, and steamboats came industries large and small: boat builders, tanneries, distilleries, chemical plants, iron forges. The most significant was the Joly iron works in the center of town. It was founded in 1823 by Pierre Joly, with two employees making iron railings and tools. By 1863 it had grown to be one of the major iron fabricators in France, employing more than three hundred people and producing enormous iron forms, such as bridge trestles and elements for the largest iron building in France: Les Halles, the central food market in the heart of Paris.

Argenteuil's municipal council did not try to limit development by designating separate parts of the town as industrial zones. Eager to have new businesses and to broaden its tax base, it granted permits for construction wherever there was space, even if that meant in residential areas, to the occasional displeasure of neighbors. With land values in Argenteuil only a fraction of those in Paris, developers and entrepreneurs were happy to invest in the suburb. Most people saw all this

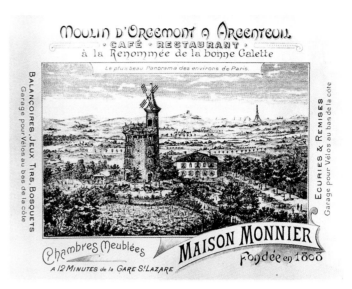

Fig. 10. Advertisement for the Moulin d'Orgemont café and restaurant. Musée du Vieil Argenteuil

Fig. 11. Claude Monet, *The Path through the Vineyards,* 1872, oil on canvas, Private Collection, Europe

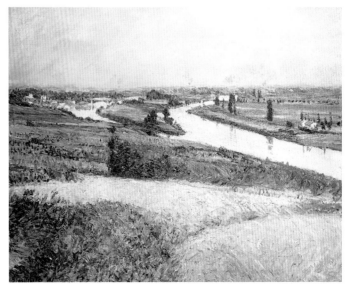

Fig. 12. Gustave Caillebotte, *The Seine at the Epinay Point,* c. 1888, oil on canvas, Private Collection

development as a positive force. It was a way for the town, having languished as a quiet agrarian village for centuries, to assume a leadership position, maximize its land and resources, and ensure prosperity for subsequent generations. People also recognized that industrialization, though still in its infancy, would be the wave of the future, and if the community were to remain vibrant and competitive, it needed to harness the power of this new beast.

Although not every municipality was as aggressive as Argenteuil, the growth of industry in the Paris suburbs in the second half of the nineteenth century was the most significant factor in the region's transformation. Popular illustrators and guidebooks—in fact, the mass media in general—embraced this change with supportive articles and startling images (fig. 13). The countryside in this view seems to have been completely overrun by industry, the skies prodded by factory chimneys belching smoke, the tillable land pushed aside by the onrushing railroad.

This was not to everyone's liking. Gustave Flaubert's Paris clerks Bouvard and Pécuchet, from his novel of the same name, set out to look for a house in the country after one received a handsome inheritance. They searched "everywhere in the vicinity of Paris, from Amiens to Evreux, from Fontainebleau to Le Havre," yet "still found nothing."[8] Like many of their contemporaries in the 1870s, when Flaubert wrote his book, "they wanted to be away from other houses," but they hesitated to buy a place "too exposed to winds from the sea, or too near some factory, or too inaccessible." They ended up far from Paris in unadulterated countryside between Caen and Falaise. Their fundamental problem was not the elusiveness of an ideal, or the fickleness of individual taste, or the inability to make a decision, but the desire to escape the pervasive changes occurring in France, especially in the Paris region. The result was they had to move a great distance from the capital. As Zola emphasized in each of his novels, Paris was the biggest, most aggressive, most creative force in France. Developments there inevitably overflowed its boundaries to affect the surrounding countryside—for better or for worse.

For all its ingenuity, appetite, and zeal, however, the capital could not have transformed the area as rapidly as it did if it had not been for the invention of the railroad. Trains transported people and products as well as ideas and political power, and they did so, as Zola described in *La Bête humaine* in 1890, like "a gigantic creature lying across the land, with its head in Paris and joints all over the line." What Zola called

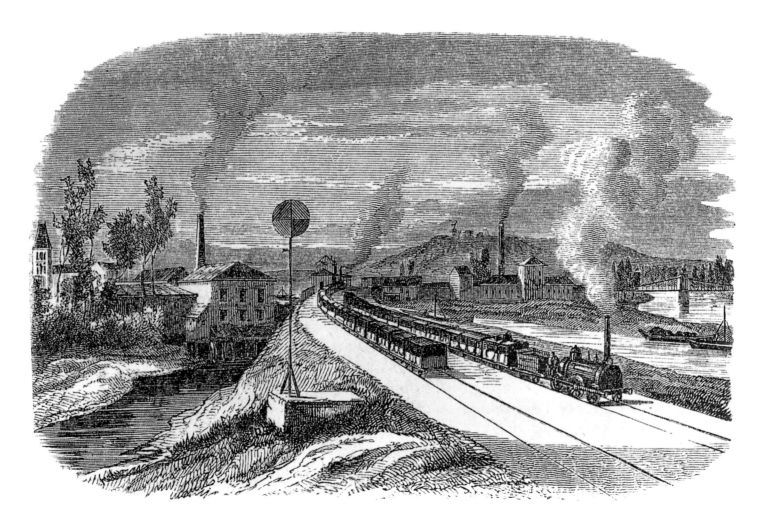

Fig. 13. "Saint-Denis Station," from Adolphe Joanne, *Les Environs de Paris* (1856), 405

this "sovereign beauty of metal beings" was directly responsible for the changes that the impressionists confronted in Argenteuil.[9] The Chemin de fer de l'Ouest, which laid the first railroad in France in 1838 (from Paris to Saint-Germain), extended the line in 1851 to the banks of the Seine across from Argenteuil; in 1863 it built a bridge over the river and brought the train straight into town, thus linking it with the capital and with a destiny that prompted the local newspaper in 1862 to assert: "If we do not paralyze its tendencies and direction, Argenteuil, by its situation and proximity to Paris, should become a populated and important city."[10] Whether one agreed or not, it was clear that once the bridge was raised the town would never be the same.

When Monet moved to Argenteuil in 1871, initiating one of the most fertile periods in his career, he made a definite choice to live among its mélange of fields and factories, picturesque streets and rumbling trains, bourgeois pleasure seekers and blue-vested workers. Of the towns in which he had lived and worked in the 1860s, none was affected by the Industrial Revolution to the same degree as Argenteuil. In fact Sèvres, Bonnières, and Saint-Michel have managed to maintain their suburban allure to this day. Argenteuil, by contrast, was willing to gamble its bucolic past on what it perceived to be a brighter, grander future.

The story of the years that Monet and his friends spent in the community, therefore, is the story of their attempt to come to terms with this decision and its consequences and to translate what they saw and felt into visual form. It was an evolving relationship, one that seemed coordinated with their commitment to render the contemporary world with all its wonders and novelties, contradictions and ambiguities. As Zola noted when these artists were emerging in the 1860s: "They interpret their epoch as men who live in it. Their works are alive because their subjects are taken from life and are painted with all the love that the artists have for modernity."[11] Argenteuil was thus the ideal place for them, at least for a while.

Site and Style: Argenteuil and Barbizon

Argenteuil's appeal to the impressionists derived mostly from its diversity, which offered something for everyone. Depending on where one looked, the town could be charmingly historical or glaringly contemporary, delightfully rustic or unnervingly progressive. Monet encountered these contrasts on a daily basis. Directly across the street from his house on the rue Pierre Guienne (his first residence in Argenteuil) stood an impressive eighteenth-century building that served as the town hospice. When he walked out his front door, he could see the newly renovated Boulevard Héloïse, the Champs de Mars, and the promenade to the right. If he turned to his left, he could see the railroad station and several

factories, beyond which stretched residential streets that led to the vineyards and the Orgemont hill with its windmill-restaurant. Everything was within walking distance, as the ads for the Orgemont restaurant assured potential patrons (fig. 10). Argenteuil was thus not only diverse, it was also malleable and alive.

In that regard, the town could not have been more different than its most famous predecessor in the history of art, the village of Barbizon, which lay about sixty kilometers south of Paris, at the edge of the Forest of Fontainebleau. Like Argenteuil, Barbizon had attracted a band of adventurous artists—Théodore Rousseau, Jean-François Millet, Charles Jacques, and Jules Dupré—all of whom, like the impressionists, had escaped the city for the country, albeit some of them just for summers twenty years earlier. But Barbizon was a poor, rural, farming village that had not changed in centuries. Its modest stone houses and traditional agrarian practices were tangible evidence of how the past had endured, unaltered and unheralded. Industry and pleasurable pastimes had no place or meaning, nor did notions of invention and advancement. Barbizon was caught in a time warp that made it homogeneous and earthbound, qualities that its dry, flat, windswept fields tended to reinforce. Although it was linked to Paris by stagecoach, the railroad never came; even today, one has to drive to get there.

The art that Barbizon yielded was therefore very different from what the impressionists plumbed from Argenteuil. Paintings by Millet and his confreres took rural traditions for their subjects, notably peasants and shepherds, goat herders and cow tenders, engaged in time-honored routines. Their solemn, heartfelt, carefully wrought views are accompanied by homages to the meticulously worked fields of Barbizon and to the many faces of nature that the region revealed. Most poetic perhaps is the attention paid to small delights—chickens in winter, ducks in summer, cows being milked, primroses in bloom—as if the medieval glories of the *Trés riches heures* of the duc de Berry were alive and well and worth recalling.

These paintings were radical for their time because they focused on humble matter and raised individuals from the lower class to heights traditionally reserved for noble figures from history, religion, or mythology. As such, they prepared the way for the more confrontational art of the impressionists. But Barbizon pictures differ from works of the impressionists at Argenteuil not only in subject, feeling, and orientation but in craft, emphasis, and style.

Barbizon artists worked from dark to light, building up their forms gradually with modulated tonalities so that the illusion of three-dimensionality was achieved by rigorously maintained relationships among the inherent values of their colors. Touch was equally controlled—no swirls of the brush, no virtuoso performances. Moreover, in keeping with the hard-won existence of their subjects, Millet and his followers used their medium sparingly. They were sensitive colorists,

able to detect the subtle range of hues that nature offered them. Their pigments were restrained, bound by a preference for earth tones and the sober side of the spectrum. Millet and his followers primed their canvases with muted colors as well, taking their cue from their sites and subjects and from more traditional art.

The impressionists appreciated the ways in which the Barbizon artists evoked nature's palette, but they felt no need to contain their enthusiasm for its glories and vitality. Monet and his colleagues lathered their canvases with rich, thick pigments, as if impelled by their own gusto and self-confidence. Like their more assertive middle-class subjects, they appeared unconcerned about the cost of such excess, or about its flashiness and suggestions of hedonism. They did not want to temper their color, because for them color was the physical embodiment of light. Their interest in capturing natural effects as accurately as possible inspired them to use pigments with a freedom that approximated nature's own. Their keen desire to make their pictures equivalents to contemporary existence led them to invest color with the abandonment and unpredictability of the modern world.

This also meant that elements in impressionist paintings did not have to conform to inherited expectations and be held in predictable compositional hierarchies. In Barbizon, traditions were so continuous and omnipresent that the artists who went there to record its way of life naturally organized their subjects in a manner that reinforced their internal logic. Argenteuil, caught in the throes of change—indeed defined by the raucous conjunction of old and new, the discarded and the reformulated—contained within its constructs an order that was entirely new. It depended on mobility and open-mindedness as opposed to Barbizon's stability and single focus; it welcomed inconsistency and clutter, ambiguity and unease, as qualities to exploit, not difficulties to be avoided.

While working in Argenteuil the impressionists therefore invented or appropriated unanticipated strategies for organizing forms, with bridges shooting into their scenes at dramatic angles and sailboat masts jutting upward from unseen sources outside the picture (cat. 28). It was an ingenious way to express the dynamics of the place and make sense out of what could otherwise seem messy and meaningless. Barbizon, with its clarity and simplicity, was more easily apprehended. Argenteuil, with its mix of the engineered and the inconstant, was more demanding. It was in tune with the times, however, which may be one reason Monet found it attractive and may explain why it provoked such novel, robust, idiosyncratic reactions among its impressionist visitors.

Like Barbizon, Argenteuil gave deep pleasure and satisfaction to the artists who worked there, particularly Monet and Caillebotte, who stayed the longest. In part, these rewards were the product of the town's physical appeal and the ways its offerings met the demands of the new avant-garde. Barbizon artists would have been lost in Argenteuil's contradictions, whereas the impressionists

viewed these contradictions as challenges, the most significant of which entailed transforming the complex into the comprehensible. Building on their initiatives of the 1860s, they were able to devise a vocabulary when working in Argenteuil that matched that of their subject or at least approximated the varied qualities of the areas of town that they chose to paint. Their broken brushwork, irregular surfaces, heightened color, and sense of fleeting impressions were not merely formal innovations to undermine the status quo of the profession or demonstrate personal virtuosity. Like their choices of what to paint and the compositional tactics employed to organize those choices, these formal elements acted as bearers of meaning. They were at once evidence of the artists' distinct personalities and testimony to the ties that bound them as a group. They were also the physical proof of the artists' engagement with the moment and their desire to give readable form to Argenteuil's amorphous character.

Another challenge concerned their willingness to put individual differences aside and constitute themselves as a legal entrepreneurial entity. This proved more difficult in practice than in intention. The artists were divided as to what model to follow, what specific statutes should bind them, what financial commitments each should make, who should be invited to join, and so on. These issues often caused discontent, revealing the political and social stances that separated them as well as the biases they held about other potential members. Many of these differences, especially the last, plagued their attempts to mount exhibitions, which was their primary reason for forming an association. The so-called first impressionist exhibition of 1874 contained as many works by mainstream artists as by those who would become known as impressionists.

Resolving these issues was no easy matter at any point during the twelve years of their informal union. Initially it required the leadership of Monet and Pissarro, who negotiated compromises, raised funds, and exercised sufficient diplomacy to produce a document they all could sign. Begun in early 1873 (Monet first mentions it in a letter to Pissarro in April of that year), the process took nearly ten months.[12] Significantly, many of the meetings were conducted not in Paris, where most of the artists lived, but in Monet's house in Argenteuil, to which everyone had to travel. The symbolism of this could not have escaped the organizers: Paris was the focus of their attention and the projected site for their activities as a collective, but this awkward emerging suburb was the planning center for what they hoped would be a dynamic new force in the nation's art. That it would originate outside the capital, in a town that was itself trying to assume a leadership role in the region, seems strikingly appropriate.

The group apparently agreed, as its preliminary plans were announced from Monet's living room. The press release came in the form of a letter dated 7 May 1873, which Monet wrote to Paul Alexis, the art critic for *L'Avenir National*. Alexis had just published an article suggesting that artists

should unite to create syndicates so that they could stage independent exhibitions. Monet's response had to have been penned with the blessings of the soon-to-be-called impressionists. "A group of painters assembled in my home," Monet wrote, "has read with pleasure the article which you have published in *L'Avenir National*. We are happy to see you defend ideas which are ours too, and we hope that, as you say, *L'Avenir National* will kindly give us assistance when the society which we are about to form will be completely constituted."[13]

Alexis took the liberty of noting that "several artists of great merit" had stepped forward to join this group, including Béliard, Gautier, Guillaumin, Jongkind, Pissarro, and Sisley: "The painters, most of whom have previously exhibited, belong to that group of naturalists which has the right ambition of painting nature and life in their large reality. Their association, however, will not be just a small clique. They intend to represent, interests, not tendencies, and hope for the adhesion of all serious artists."[14]

By the end of the year they had gathered such avant-garde artists—except for Manet—and four months later had mounted their first independent exhibition. One of the most significant moments in the history of French modernism thus belongs in many ways not to the trumpeted capital, as Zola might have wanted, nor to the fields of Barbizon, as Millet and his companions may have envisioned, but to Argenteuil and this contentious group of roughly thirty-year-old painters who gathered to endorse the notions of modernity and change as unifying principles, much as the town itself had.

On Individuality and the Collective

What struck many who saw the first exhibition is what still astonishes people today: namely, the shared interests and stylistic similarities of the core group of impressionists. "To paint what they see, to reproduce nature without interpreting it, and without arranging it, seems to be the goal of these artists of the boulevard des Capucines," remarked one critic after viewing the show.[15] So strongly have these ideas been stamped on the history of the movement and instilled in the interested public that one somewhat dazzled observer at a recent exhibition of impressionist paintings that ended with a suite of Monet's *Meules* proclaimed to a companion, "Oh look! They all did haystacks too."

This visitor most likely would not have been caught in such confusion if transported to the early 1890s when Monet completed his stack series; by then the impressionists were painting pictures quite different from one another's. But it might have been possible to mistake a canvas by Monet for one by Renoir at the end of the 1860s, when the two worked together at La Grenouillère; and it certainly would have been the case in the following decade at Argenteuil. Time and

again in the 1870s Monet stood side by side with one of his artist friends rendering the same scene: the Boulevard Héloïse (cats. 4, 5), a regatta on the Seine (cats. 30, 31), the boat basin with sailboats and sculls (cats. 32, 33), the railroad bridge, and the Petit Bras of the Seine. Sisley was the first to join Monet in Argenteuil, and they initiated this custom; Monet and Renoir, the second to visit, soon followed suit. Manet worked beside Renoir once, both of them painting Monet's wife Camille and son Jean in Monet's backyard (see cat. 21).

The impressionists also produced many pictures of each other during their stays with Monet. Renoir sketched or painted his host four times and Camille as many (see cats. 15, 16, 19, 21); Manet did two portraits of Monet painting in his studio boat with Camille at his side (cat. 39 and fig. 20) as well as the one of the whole family; Monet painted at least one image of Manet working in the garden. This habit not only deepened their friendships and avoided the expense of models, it encouraged them to support one another in the face of the challenges they had so ambitiously posed for themselves. In the process they were able to fulfill their equally important aim to base art on life, and as an added benefit, they could elevate themselves and their practice to a level of significance that affirmed their claims to history.

Although painting together required an open mind and a healthy combination of tolerance and trust, it offered a unique opportunity for mutual inquiry, for sharing information, observations, and technical tricks. The impressionists had learned the advantages of this practice as students in the 1860s, when they had worked together in Charles Gleyre's studio or on painting excursions to the suburbs and beyond. Monet was especially enthusiastic about the rewards, as he explained to Frédéric Bazille in 1864: "There are a lot of us at the moment in Honfleur....Boudin and Jongkind are here; we are getting on marvelously. I regret very much that you aren't here, because in such company there's a lot to be learned and nature begins to grow beautiful."[16]

Students usually abandoned this exercise when they left their master's studio and became professional artists. The impressionists did not. It was as if they were perennial students, with a curiosity that could not be satisfied by traditional rites of passage. They did not discount the value of working in isolation. After Boudin left Honfleur in the fall of 1864, for example, Monet wrote his mentor "I am quite alone at the present, and frankly I work all the better for it."[17] But he knew he still had much to learn, writing in the above-cited letter to Bazille in the summer of 1864 "There are some things that one cannot fathom [when] all alone," things that have to do with "what one sees and what one understands." It was not a question of perfecting technical aspects of their craft to get them right—a problem that haunted Zola's Claude Lantier—but of continuing to paint. It was work as process and discovery more than work as producing a product. The impressionists did not scrape down their canvases in the 1870s every time things went badly, as Zola's

hero did continually (to the point that he was never able to finish his masterpiece and, in frustration, hanged himself in his studio in front of his failed picture).

To be sure, the impressionists were concerned about how their paintings looked and had many discouraging moments, particularly in the 1860s when they too "struggled, scraped off, and began again," as Monet admitted to Bazille.[18] But they had to earn a living, and by the 1870s they had become enormously proficient and were willing to set things down without working and reworking them. They were not aiming to achieve a finite goal or create an ideal—the perfect sunset, the most novel figural arrangement, the most brilliant light effect. If that occurred, it was a bonus, but the norms and hierarchies that ruled the art of their time were neither the beginning nor the end of their efforts. As Zola made clear, they drew their art from life and from the endlessly fascinating drama of nature. That afforded them great flexibility and allowed them to worry less about producing a masterpiece than about building a body of work that had the integrity and significance befitting their subjects.

By placing shared goals above individual differences and common concerns before personal gains, the impressionists contradicted contemporary expectations. That is in part why visitors to their first exhibition, held in the vacated studios of the notorious Paris photographer Nadar, were so surprised by what they saw. No jury had decided what would be in the show; that was the prerogative of the participants. After paying sixty francs, each had the right to submit two works, neither of which would be rejected. (Everyone ignored this ratio and included more than two without extra charge.) A lottery was used to determine the way the paintings were hung in the exhibition. Ten percent of any sales would be applied toward the show's operating budget. No one was competing for prizes or awards; there were none to give out.

Leveling the competition to stimulate a sense of the communal ran the risk of suppressing individuality, but the united front established by this strategy had considerable value. The impressionists were attempting to lay siege to a monolithic system of making and marketing works of art, controlled by the national Salons; no one person or painting could accomplish the task alone. Most of the critics who reviewed the exhibition in 1874 recognized this; several praised the initiative, though they did not like the art.[19]

The idea for this assault on the Salon and the powers of central authority arose in the 1860s, largely from Monet, although he had plenty of input from his friends. The first stirrings of rebellion had not borne fruit, for a variety of reasons: money, timing, personal distractions, and an underlying urge to succeed at the Salon. When Monet returned to France in 1871, the country's dual disasters of the Franco-Prussian War and the Commune insurrection made any immediate action impossible. But he continued to nurture the idea and acted on it in his first two years in Argenteuil with unprecedented conviction and a few sly maneuvers.

Initially, he did what was most important; he continued to create paintings. In fact he worked as never before. In 1872 he completed more than sixty canvases (an average of one every six days), exceeding his total output for the previous two years combined. The results included still lifes, portraits, garden and boating scenes, views of smoking factories, suburban streets, clipper ships, bridges over the Seine—more settings and subjects than any group of pictures he had produced in any previous year of his career. He was evidently stimulated not only by the prospect of an independent exhibition but by his new locale and its many possibilities. He was also thrilled to be back in France, which "still has many beautiful things to paint," as he told Pissarro while in Holland on his way home.[20]

Monet may likewise have been responding to the keen interest in his work that the dealer Paul Durand-Ruel had shown. Durand-Ruel had been the premier representative of Barbizon art in France and had a huge stock of paintings by Millet, Rousseau, and others. During the Franco-Prussian War he too had left France for England, where he met Monet through Charles Daubigny, who had also gone into self-imposed exile there. Impressed with the young artist, Durand-Ruel included one of Monet's paintings in a show he staged to inaugurate a new gallery he was opening on Bond Street in December 1870. In 1872 he bought twenty-nine more, paying Monet the handsome sum of 9,880 francs; in 1873 he bought another thirty-four, for 19,100 francs. Life was good for the emerging painter; doctors and lawyers in Paris at the time made only 9,000 to 10,000 francs a year.[21]

Although the economy retreated in 1874—which prevented Durand-Ruel from buying any more paintings from Monet for nearly ten years—the dealer's first buying spree, coupled with other sales Monet was able to conclude in late 1872 and early 1873, must have led the artist to believe that the time was right to plan an independent group exhibition. It cost him dearly in terms of his art, however: he spent so much time writing letters, fundraising, and traveling to see potential group members in 1873 that he produced only thirty pictures, compared with sixty the year before. Monet was willing to make serious personal sacrifices to realize his goals, even soliciting money from people he hardly knew, although he told Pissarro "it is very difficult to ask people about this who don't know you, especially those who are not sympathetic to the cause."[22]

His enthusiasm for the project was undoubtedly heightened when his friends came to Argenteuil and painted alongside him. That was the *raison d'être* of this new group: working together to achieve larger purposes. On Sisley's visit in 1872, he and Monet both did paintings of the Boulevard Héloïse, the Grande Rue, the Petit Bras of the Seine, and the Rue de la Chaussée. The Petit Bras proved to be one of Monet's favorite places; he depicted it nine times during his first year in Argenteuil and nearly a dozen more thereafter (Renoir and Caillebotte also painted there on many occasions). But Monet never returned to the other three sites, nor did any of his other visitors.

Another attraction for all of the artists working in Argenteuil was the boat basin of the Seine. Among the liveliest areas of town, it captured the attention of anyone who was interested in the range of modern leisure activities the town offered, as the impressionists were. Many paintings by Monet and his friends are closely related by virtue of their focus on this place. Because only a few can be accurately dated, however, it is impossible to know whether certain canvases by one artist were done at the same time as similar paintings by another. Thus it is impossible to determine if they are the product of a conscious decision to work together or if they merely reflect the general appeal of the site.

Some paintings are undeniable pairs or pendants. In addition to the four executed by Monet and Sisley in 1872, there are at least five by Monet and Renoir: two from 1873; three from 1874, including a regatta scene (cats. 30, 31) and one of the most often reproduced and thus most celebrated of all such pairs, *Sailboats at Argenteuil* (cats. 32, 33). The only other paintings by Renoir that can be attributed to these two campaigns in Argenteuil are portraits of Monet, Camille, and Jean, which suggests that his working time in the town was spent exclusively with his hosts. The notion of the communal could not be more purely exemplified.

One portrait Renoir painted of Monet in 1873 was a sympathetic evocation of their shared aesthetic (cat. 19). He shows his friend as the emblematic impressionist, confident and engaged, painting outdoors in front of his motif in accordance with the long tradition of plein-air artists. So common was this practice in the nineteenth century it was even caricatured by a popular illustrator for a satirical Paris weekly (fig. 14). Of the many images Renoir may have had in mind when he began this picture, two provide salient contrasts. One was a slightly earlier portrait he had done of Monet in a more contemplative pose, reading a book and smoking his pipe (cat. 15). In many ways these are pendants, one depicting Monet as a thinker, the other as a doer; one as pyramidal, central, filling the scene; and the other vertical, pushed to one side, made modest by his surroundings. Renoir may also have been recalling a painting for which he and Monet posed: Fantin-Latour's monumental canvas *A Studio in the Batignolles* of 1870 (fig. 15). Renoir stands in the middle looking down, his head surrounded by the gold frame on the wall; Monet looks out from the right, squeezed in behind the aristocratic Bazille. Aside from Manet, who is the focus of the group's homage, the rest are writers and critics, including Zola, who stands behind Renoir. No one but Manet holds a brush or gives any indication of being an artist; they are present to look, learn, and pay court—as caricaturists took pains to point out when the picture was exhibited at the Salon of 1870 (fig. 16). In *Monet Painting in His Argenteuil Garden* (cat. 19) Renoir reverses almost everything. Monet stands outdoors instead of sitting in a studio, working alone instead of surrounded by a coterie of admirers, immersed in the contemporary world and his painting instead of looking stiffly out at us. Most important, it

Fig. 14. F. Rossa, cartoon of Sunday painters, *Le Journal amusant* (4 September 1869)

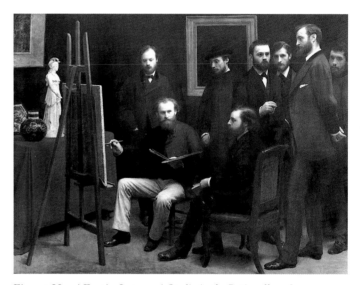

Fig. 15. Henri Fantin-Latour, *A Studio in the Batignolles,* 1870, oil on canvas, Musée d'Orsay, Paris

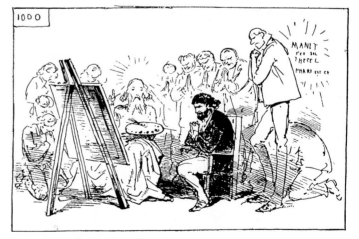

Fig. 16. Bertall (Charles Albert d'Arnoux), "Jesus Painting among His Disciples," or "The Divine School of Manet. A Religious Picture by Fantin-Latour," *Le Journal amusant* (21 May 1870), 4

is Monet rather than Manet who is being honored—a changing of the guard that Manet himself soon recognized.

In the summer of 1874, a month or two after the close of the inaugural exhibition by the "Société anonyme," Manet came to Argenteuil to work for the first time. Perhaps he was inspired by the exhibition. Perhaps he was impressed with the publicity it received, most of which was positive, though there were some bitter blasts from conservatives. Perhaps he also recognized that canvases like his Salon submission of 1873, *Le Bon Bock* (fig. 17), would no longer hold his position at the forefront of the avant-garde. His remake of Frans Hals was impressive as a bit of painting, but its ties to the past, in style as well as subject, were obvious, and its color scheme was closely linked to the limited palette of his seventeenth-century model.

As even the most conservative critics in 1874 recognized, there was no denying the novelty of the impressionists' style, especially their color combinations and sense of light. Both were daring and more intimately tied to nature than Manet's at that time. There was likewise no doubt about the power of the artists' convictions. Manet may also have been attracted to the potential of their communal assault on the Salon system, but he could not get over his distrust of their entrepreneurial methods and continued to submit pictures only to the state-sponsored exhibitions. Despite this disagreement, Manet dropped his resistance to the group and ventured out of Paris to join Monet at Argenteuil in July 1874.

Manet's move was symbolic as well as practical: the older artist coming to learn from his junior (by nine years); the quintessential Parisian bowing to the suburbs; the sophisticate acquiescing to solecism. Monet did not reciprocate; he did not take the train to Paris to work with Manet in the city, a fact that underscores their reversed positions and the significance of painting in Argenteuil. Although the town had been only modestly represented in the first impressionist show (Monet decided to exhibit a range of work, including more pastels than paintings), Manet certainly knew that Argenteuil had been critical to the realization of the group and the exhibition. He was also aware that it had the ingredients for the making of modern art. He had visited there on occasion, and he owned Sisley's *Bridge at Argenteuil* (cat. 9) as well as one of Monet's first paintings of the town, a view of the highway bridge, both of which he bought in 1872.

It is impossible to know the precise order of the works Manet began that summer in Argenteuil, but as Robert Herbert has suggested, the three with simpler compositions, palettes, and light effects probably came first. They include *The Seine at Argenteuil, Boating,* and *Sailboats at Argenteuil* (see cats. 35, 40).[23] In the second group—*Argenteuil* and *Claude Monet in His Studio Boat* (figs. 19, 20)—his palette lightens, his sense of sunlight becomes more acute, and his touch regains some of its virtuosity, as if he were now more comfortable rendering the natural effects of the moment he had chosen to paint. All of his canvases, except for a view of Monet and his family in their backyard (see cat. 21) and

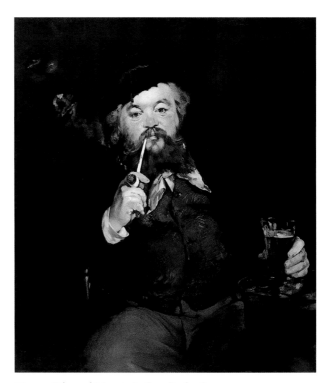

Fig. 17. Edouard Manet, *Le Bon Bock,* 1873, oil on canvas, Philadelphia Museum of Art, Mr. and Mrs. Carroll S. Tyson Collection

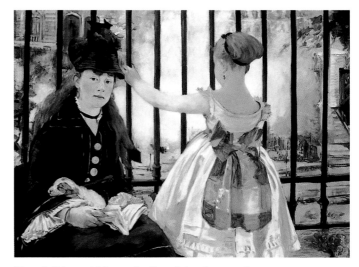

Fig. 18. Edouard Manet, *Le Gare Saint-Lazare,* 1873, oil on canvas, National Gallery of Art, Washington, Gift of Horace Havemeyer in memory of his mother, Louisine W. Havemeyer

Boating, with its indefinite setting, were done at various points along the Petit Gennevilliers side of the Seine, looking across the water to Argenteuil.

More than any of his contemporaries, Manet did not leave his urban sensibilities behind in Paris when he boarded the train to Argenteuil. Each painting he began there bears the stamp of city living and the experience of the capital's *grandes boulevards.* In *Boating,* for example, the man and woman seem completely indifferent to us and to each other, although the skipper stares at us directly while furtively touching his companion's foot with his own. The boat is startlingly close, like a vehicle rushing by on a Paris street, an effect achieved by the radical cropping of the craft and the flattened body of water in the background. It is apparent from their stylish attire that these are not local residents of Argenteuil but Parisians out for a fling in the country.

The same urban disjuncture informs Manet's *Seine at Argenteuil* (cat. 35), where we meet two smartly dressed figures that seem out of place as they stand alone on the deserted shore. With their backs to us, they appear to be in their own worlds. They are not engaged in any mutual activity; we cannot see if they are holding hands. As such, they are the suburban equivalents to the two figures in Manet's *Gare Saint-Lazare* of the previous year (fig. 18). In that distinctly Parisian scene, the young woman looks up at us with the blank stare of urban disinterest. The child is even more aloof, turning her back on us to peer through the iron bars of a fence, her body metaphorically surrounded by the steam from the engines coming and going from one of the capital's busiest railroad stations—the same one that served Argenteuil. *The Seine at Argenteuil* has a more readable and pastoral background, but this stretch of the river is occupied only by unmanned boats with masts that suggest a more casual, suburban echo of the bars of the Saint-Lazare fence. Both paintings share a lurking emptiness, as if the alienation that Paris instilled in its residents has seeped into each scene, although one was far from the heart of the capital.

Manet complicates these effects even more in *Argenteuil* (fig. 19), a picture he felt so strongly about that he selected it to be his only submission to the Salon of 1875. His sentiments were entirely justified, as the painting was conceived and executed with beguiling aplomb. Depicting two sporty figures seated on a dock in front of the Argenteuil boat basin, it contains an array of masterful ploys and enigmas. The man and woman seem at ease. They are cousins of the couple in *Boating:* ordinary and self-absorbed. Although she meets our eye, he does not respond to our inquiring glance. Behind them lie jostling boats whose masts and rigging add dramatic tension to the composition. Stretching and compressing the space, the nautical parts play games with the figures as well as with the viewer.

The bowsprit of a black-hulled boat in the middle distance on the left, for example, appears to poke the woman in the ear, while the man's hat aligns with a sail on the right

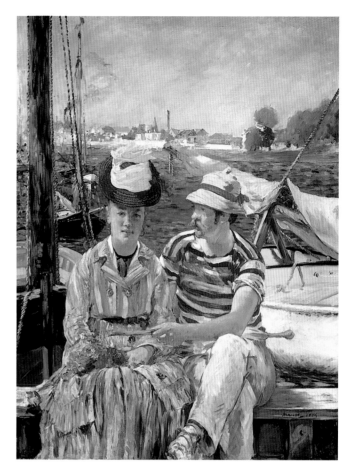

Fig. 19. Edouard Manet, *Argenteuil,* 1874, oil on canvas, Musée des Beaux-Arts, Tournai

that seems to extend to the far bank and end just where a smokestack rises. The woman sits near a forceful mast on the left whose halyards descend to her shoulder. A similar cord cuts an opposing triangle on the right side that also points to the man's shoulder. In other cunning notes, the boats behind the figures both have peachy beige parts but contrasting hulls—one black, the other white—while the furled sail behind the man is hiked up to reveal the boom. (A painting by Monet that includes the same boat [fig. 21] suggests that the sail was simply left this way.) Manet makes sure that the relationship between the figures remains ambiguous. The man holds his companion's parasol so that it ends provocatively at her midriff, while she holds a bunch of flowers in her lap. More curious, his right hand must be on the very edge of the railing or under the woman's posterior. In either case, it is suggestive, as is the Freudian presence of the mast on the left and the can-can performance of the sail on the right.

Unlike the pairs of paintings that Monet and Renoir produced in the same summer of 1874, Manet's stubbornly resistant picture resembles no canvas by any of his compatriots. Unlike Renoir and Sisley, Manet very rarely worked shoulder to shoulder with fellow artists. Although he did

portraits of artist friends and held forth in their café gatherings in the 1860s, he generally painted in the privacy of his studio. But his pictures after 1874 were affected by the impressionists' novel strategies. They moved closer to the communal than Manet had been wont to go, and they represented a distinct break from his previous work. In a dramatic role reversal, Manet was in Argenteuil as a student—at least in terms of plein-air painting, since that had not been a consistent part of his oeuvre in the 1860s.

Manet basically admits this in two revealing images from the summer of 1874, views of Claude Monet in his studio boat (cat. 39 and fig. 20). These are the aquatic versions of Renoir's portrait of Monet painting in his garden (cat. 19), as they too pay homage to the central artist of the moment. The finished canvas shows Monet nattily dressed, feet up, working under the handsome striped awning of his floating atelier, while Camille sits inside the light-filled cabin like his muse, adding intimacy to what would otherwise be a scene of insistent anonymity. Pleasure boats move across the water or bob at anchor, factory chimneys belch brown smoke, and light flickers on the surface of the river, but nowhere are other human beings to be seen. Isolated, though not completely alone, Monet is the ultimate contemporary plein-air master, right in the middle of a shifting world, confidently translating his immediate sensations into the permanence of paint.

As Robert Herbert has noted, Manet shows Monet painting a canvas that actually exists. On his easel sits his *Sailboats on the Seine* of 1874 (fig. 21), as is evident from the tree and the triangle of land on the left and the agitated group of boats on the right. Manet not only fully understood the practice of his plein-air partner but took the concept of working side by side to produce similar pictures one inventive step further. When Monet's riverscape is set alongside Manet's portrait of his friend, it is apparent that the two artists were painting the same scene: the tree and orange-roofed houses on the left; the black-hulled boat by the shore; the white one with the furled sail to the right; the factories puffing smoke. The large white sail that appears immediately to the left of center in Monet's composition peeks over the roof of the studio boat in Manet's view. These are therefore just like the pairs of pictures Renoir and Sisley made with Monet. From the way Manet has captured Monet's position in the boat, we can see that he, like his colleagues, was at his friend's side, albeit from a distance, probably from a nearby dock. But of course Monet, dashing in his black tie and yellow pants, now occupies pride of place; it is Manet the accomplished student who looks over his teacher's shoulder, as Monet and his friends had looked over Manet's shoulder in Fantin's earlier portrait. Manet was not known for his humility, which makes *Claude Monet in His Studio Boat* an even more significant tribute to the younger artist, the kind of endorsement Zola's Lantier so desperately sought. It also points out how the individual and the communal could be compatible and how two paintings could be the same and yet different.

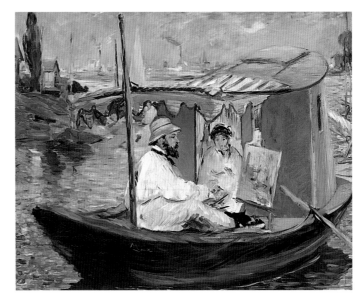

Fig. 20. Edouard Manet, *Claude Monet in His Studio Boat,* 1874, oil on canvas, Neue Pinakothek, Munich

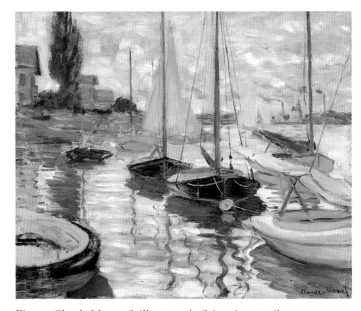

Fig. 21. Claude Monet, *Sailboats on the Seine, Argenteuil,* 1874, oil on canvas, Fine Arts Museum of San Francisco, Gift of Bruno and Sadie Adriani

This notion is borne out by several other examples: Sisley's and Monet's versions of the Boulevard Héloïse (cats. 4, 5), or Monet's and Caillebotte's renderings of the Petit Bras (cats. 50, 51). The idea may be less obvious in other pairs, but the more they are studied, the more their differences equal or even outweigh their similarities. Renoir's view of a regatta shares the same vantage as Monet's (cats. 30, 31) and includes most of the same elements, but Monet's touch is more consistent, his sailboats more readable, and the whole more thinly rendered. The two artists' canvases of boaters at Argenteuil (cats. 32, 33) differ in myriad details—sculls appear in Monet's but not in Renoir's; Monet includes fewer sailboats than does Renoir; the two figures in each are disposed differently—to say nothing of the varied, feathery touch that is unique to Renoir.[24] For all their proximity and shared concerns, none of these pictures looks exactly like its mate, underscoring the critical role each painter and his particular personality played in determining the final outcome of his work.

Notably absent from these comparisons are Pissarro and Cézanne, the two members of the group most likely to have painted in Argenteuil, given their penchant for landscape. Neither produced any work there, despite several visits, apparently finding it incompatible with his interests. Probably neither could bear the essentially bourgeois character of Argenteuil, with its pleasure boats and holiday interlopers, its regattas and new houses for commuters. Pissarro was more inclined to paint humble country folk and rural sites that bore little evidence of the march of progress. Cézanne was less interested than Pissarro in social issues but shared his mentor's love of "the magnificent richness...that animates nature," as Cézanne admitted to his son late in life.[25] For the other impressionists, such sentiments smacked of Barbizon-like romance and thus of the past. Advanced painting, to them, lay not in undisturbed nature or in the lovingly tended cabbage patches of Pissarro's backyard, but in the stresses and strains of a world in flux. In due course they would change their minds, but in the 1870s that was their conviction. And few places seemed more kindred or challenging than Monet's adopted home of Argenteuil.

Truth and Verisimilitude

In the summer of 1864 Monet informed Bazille that he was convinced one could accomplish the seemingly impossible task of translating onto canvas "what one sees and what one understands...on the strength of observation and reflection."[26] Such assertions, revealing an equal measure of confidence and naïveté, can be attributed in part to Monet's youthful ambition and inexperience: he was only twenty-three years old and had not even submitted a painting to the Salon. Less than two

decades later, humbled by his struggles before nature, he would dwell on the difficulties he encountered translating his sensations into art. Richard Shiff has laid out the practical and theoretical dimensions of this dialectic—between seeking and finding, looking and knowing—in late nineteenth century avant-garde painting and has illuminated many of its problems.[27] As he points out, no artist, Monet included, thought the program was simplistic or easily realized. "It is indeed frightfully difficult to make a thing complete in all aspects," Monet conceded to Bazille in 1864. But he was sure he was up to the task: "I have such a desire to do everything, my head is bursting."

He had lost none of his verve when he took up his palette and brushes in Argenteuil, as his productivity alone attests. Although he left no written statements about his agenda in the 1870s, it is clear from the staggering number of canvases he completed during the decade and the range of subjects he depicted that he believed he was successfully finding a way to translate what he saw and understood into art and that Argenteuil was playing an important role in the process.

These paintings are a personalized but comprehensive record of Argenteuil's offerings. Though diverse in style and focus, they confirm Monet's allegiance to the specifics of the sites he selected to paint. He faithfully recorded their physical characteristics in a manner that placed him squarely in the long and distinguished line of view painters. His impressionist visitors were similarly devoted to topographical accuracy. Despite the exaggerated color they could all employ or the breadth of their brush strokes, they, like Courbet, had vowed to base their art on the factual and observable, the physical and verifiable. This is what Zola had first found so attractive about the group, and why Claude Lantier could declare his belief in an art based on life with such fervor: "Life! Life! Life! What it is to feel it and paint it as it really is! To love it for its own sake; to see it as the only true, ever-lasting, ever-changing beauty, and refuse to see how it might be 'improved' by being emasculated."[28]

Embedded in Lantier's declaration is an essential infinitive: "to feel." Feeling is different from seeing, which is different from understanding, which is different from the physical act of painting. Thus there is an inherent contradiction in Lantier's avowal, as he is not just documenting the world around him; he is espousing Zola's fundamental philosophy—namely, that "art is a corner of nature seen through a temperament." Monet at twenty-three had more or less the same attitude, believing he could achieve his goals through "observation and reflection," through looking and thinking, inquiry and analysis.

This means that neither the painter nor the author is a neutral observer, that everything is mediated, whether consciously or not. It is for this reason that Zola could assert through Lantier with equal steadfastness: "What was Art, after all, if not simply giving out what you have inside you? Didn't it all boil down to sticking a female in front of you and

painting her as you feel she is? Wasn't a bunch of carrots, yes, a bunch of carrots, studied directly and painted simply, personally, as you see it yourself, as good as any of the run-of-the-mill, made-to-measure Ecole des Beaux-Arts stuff, painted with tobacco-juice? The day was not far off when one solitary carrot might be pregnant with revolution!"[29] Though overstated for dramatic effect, this belief, shared by each of the impressionists, allowed for and fundamentally nurtured the individualism in their collective.

This conviction posed difficulties, however. How could the impressionists paint pictures and declare them to be true or accurate? What points of reference were they using—the view painter's unflinching fidelity to what lay before him, or the modern painter's interpretive license? If the former, the painting ran the risk of becoming a mere document, competently done perhaps, but something other than "art." If the latter, it could easily compromise its relationship to the real world and descend into personal romance or folly.

The impressionists who worked in Argenteuil resolved this dilemma by allowing both approaches to coexist. As in their commingling of differences and similarities and their conjoining of the individual and the group, they opted not to choose one over the other. They insisted that their images maintain a verifiable relationship to the sites depicted, that major elements not be moved, added, or altered, that anyone looking at the paintings who might be familiar with the area be able to determine where the artist had been standing. As Argenteuil became better known in Paris, this strategy had several advantages: it tied the impressionists' works more closely to the contemporary world and gave their motifs a keen immediacy; it also increased the possibility that someone who knew and liked the place might purchase the pictures. At the same time, the artists made sure that their color choices, the amount of paint they used, the way they applied their medium, and the vantage they assumed, all bore the mark of their identity, as individuals and as a group. Truth, therefore, was relative, as it often is, just as accuracy could be broadly defined. Those who criticized the impressionists for representing "purple trees and skies the color of fresh butter"[30] were missing the point. They were fixated on reining in the power of painting and making the final products conform to certain preconceived criteria. The impressionists wanted to take their craft in the opposite direction. As Armand Silvestre recognized, "The means by which they seek their impressions will infinitely serve contemporary art, [because] it is the range of painting's means that they have restored."[31]

The impressionists' fundamental faithfulness toward the sights they depicted in Argenteuil is evident in comparing a number of their paintings. While Manet's *Claude Monet in His Studio Boat* and Monet's *Sailboats on the Seine* (figs. 20, 21) both present the same boats, houses, and tree at the left and the same factories in the background, Manet's broader view also includes a white house and trees at the right that appear

in several other canvases: his own *Argenteuil,* Caillebotte's *Richard Gallo and His Dog Dick,* Monet's *Ball-Shaped Trees* and *Studio Boat* (fig. 19, cats. 36, 37, and 38). Caillebotte and Monet both show a group of smaller trees giving way to two taller trees that are planted close enough together that they seem to be topped by a single lollipop crown of foliage. The same pair of trees appears in Boudin's view of the area from the Argenteuil side of the river (cat. 1) and at the end of the promenade in Monet's many paintings of the site from upriver (see cat. 8).

Further comparison of *The Ball-Shaped Trees* with *Richard Gallo* reveals that Monet stood to the right of where Caillebotte painted his picture. Because of the more acute angle of Monet's line of view, he situates the lollipop trees between the two houses and includes more of the Champs de Mars on the right. He also shows us the third chimney of the house on the left and more of the building's right side, whereas from Caillebotte's perspective the chimney is obscured by the roof and the right side of the house is foreshortened. Neither Caillebotte nor Monet was exaggerating the size of these structures; one still stands, and it is impressive. The two houses make the point that each artist wished to convey, which is that the place was not removed in time and space. This is emphasized in Caillebotte's scene, which includes a host of smaller buildings on the left. Monet's vantage caused most of that development to be hidden by the large houses and the trees, which occurs more decidedly in *The Studio Boat* (cat. 38), making the setting in this veritable self-portrait appear far more rural than it was.

Monet and Caillebotte were just as meticulous in rendering the highway bridge that crossed the Seine into Argenteuil from Petit Gennevilliers (cat. 29 and fig. 22). Caillebotte pulls the bridge closer to the foreground, eliminating the pleasure craft that Monet includes. But both pay close attention to structural details of the bridge: each span having two diagonal braces above the perforated outside arch, ten vertical bands linking that arch to the lower support for the roadbed, twenty beams beneath the roadbed that rest on five iron arches, all springing from stone piers that in Monet's picture are topped with projecting stone capitals. Both artists show the arches lined up with the Orgemont hill in the distance, whose rounded shape imitates that of the bridge's span. Beyond forging this obvious tie between the landscape and the bridge, both depict a horizontal stretch of land at the left, punctuated by a large building—fully visible in Caillebotte's painting, but just peeking out from behind a pier in Monet's—before the hill rises on a steep incline, then dips, levels out, and drops sharply to end just above the railroad bridge, which shoots across the background of both views. In addition to recording the unusual contour of the hill, both scenes include the Moulin d'Orgemont at the summit. It is farther to the right in Monet's composition, but it is in the same position relative to the size and orientation of the hill. Both artists also portray the same factory chimney just below the old mill.

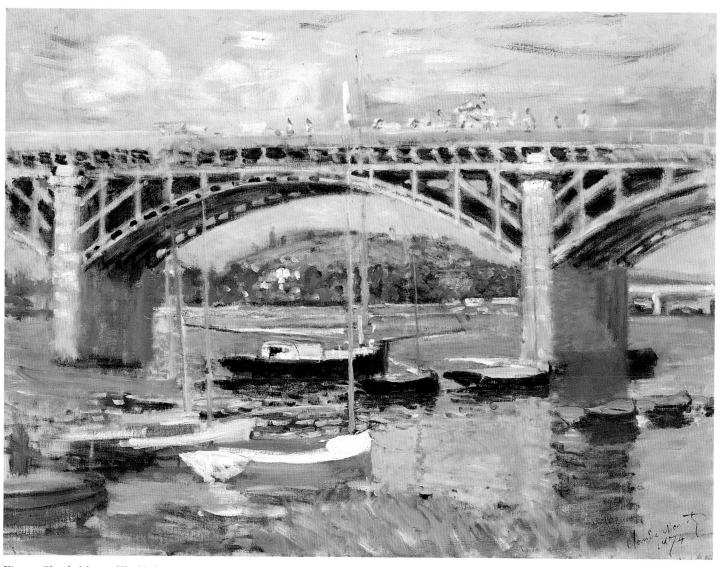

Fig. 22. Claude Monet, *The Highway Bridge at Argenteuil,* 1874, oil on canvas, Neue Pinakothek, Munich

When Monet steps back, as in *Bridge at Argenteuil on a Gray Day* (fig. 23), he retains a surprising amount of information about the bridge: the diagonal supports, the vertical bands, the posts of the railing. He again shows the railroad bridge in the background. Huddled around an ocher-colored boathouse are a steamboat (to the left of the boathouse) and an assortment of rowboats and sailboats. Monet's own studio boat is tucked in at the right side of the scene close to the shore. This is his domain, individualized but orderly, unassuming but carefully constructed. Note the way he plays the verticals of the masts off against the horizontals of the bridges and docks and how the divisions of the canvas create such clear and harmonious geometries. Other views of the site (see figs. 24, 25) attest to his faithfulness in the details: for example, the color of the boathouse (including its contrasting green shutters), the different number of windows on each side, the docks that stretch from the Petit Gennevilliers shore into the boat rental area (it was probably from the second dock that Monet and Renoir painted their classic pair of

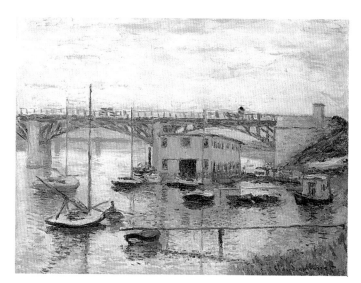

Fig. 23. Claude Monet, *Bridge at Argenteuil on a Gray Day,* 1874, oil on canvas, National Gallery of Art, Washington, Ailsa Mellon Bruce Collection

pictures [cats. 32, 33]). Monet includes his floating studio here as well. The orange-roofed houses and the large tree at the end of the Petit Gennevilliers bank on the left also appear, as mentioned above, in Manet's portrait of Monet working in his studio boat and Monet's landscape painted from the craft (figs. 20, 21) and in a number of other pictures, each time from a different angle, each time in the same relative position.

Props are equally reliable. The blue-and-white pots that Monet purchased in Holland appear frequently, first in *The Garden* (cat. 17), then in three paintings from the following year, including *The Artist's House at Argenteuil* (cat. 18). The woman in Manet's *Boating* wears the same hat as the woman in his *Seine at Argenteuil* (cats. 40, 41). Monet himself appears in the same felt-trimmed jacket in two portraits by Renoir (cats. 15, 19). Despite variations between Monet's and Renoir's versions of *Sailboats at Argenteuil* (cats. 32, 33), both artists record the rigging of the central sailboat with the precision of experienced yachtsmen, down to the eight dark rings on the mast between the boom and the gaff. They were clearly making art from life and saw little need to deviate from their model.

To be sure, there are isolated incidents in which the impressionists allowed this fidelity to lapse. In rendering the Boulevard Héloïse (cats. 4, 5), Sisley omitted the gaslights that had recently been installed along the left side of the street, whereas Monet featured them prominently. Sisley avoided the first one by moving farther down the street and beginning his view just after this modern intrusion; but he simply deleted the second one. Monet seems to have exercised similar license when representing the rue de la Chaussée with Sisley during the same first year in Argenteuil, completely eliminating the steeple of the town church that rises high above the houses in Sisley's version, as it did in reality.[32] Why Monet dropped it is unknown.

Of the many canvases completed in Argenteuil, however, only a few contain such radical omissions or alterations. Minor variations do occur. The steeple of the church is occasionally elongated; the trestle walls of the railroad bridge appear solid instead of perforated; the tops of the trees along the promenade follow dissimilar outlines in several depictions. But these differences are insignificant considering the exceptional degree to which the paintings are consistent in their details, large and small.

Monet, Caillebotte, and Manet certainly felt no need to edit out Argenteuil's industries. Factory buildings cluster at the end of the promenade and chimneys break the horizon in many pictures of that area by all three artists (cats. 8, 29, 34). Substantial industrial compounds near the railroad station are highlighted in Caillebotte's characteristically forthright image of a distillery (cat. 25). Chimneys belch smoke, particularly in Monet's works of this period, just as trains and steamboats unabashedly spew their dark exhaust across the skies as evidence of their power.

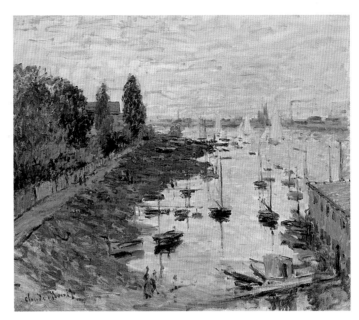

Fig. 24. Claude Monet, *The Boat Basin at Argenteuil,* 1874, oil on canvas, Indiana University Art Museum

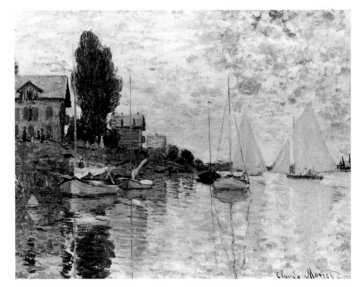

Fig. 25. Claude Monet, *Boats along the Banks of the Seine at Petit Gennevilliers,* 1874, oil on canvas, Private Collection, New York

The railroad was the primary symbol of technological progress in the nineteenth century, and Monet was the only artist in the 1870s to create such dramatic renderings as his two scenes of the railroad bridge at Argenteuil (cats. 26, 27). When Pissarro painted the railroad bridge at Pontoise (fig. 26), he nestled the structure in the middle distance and merged it with its surroundings to camouflage its modernity. Monet's panoramic view elevates the bridge high above the water as if it were an ancient Roman aqueduct. Glistening in the sun, harmoniously setting off the sailboats beneath and the sky above, the bridge and its steaming trains are a triumph of the new, an ode to human ingenuity, daring, and design.

It was not always so. In 1871 sections of the bridge lay in the water or on the ground, its trestle a twisted heap of iron, its piles crudely amputated or standing forlornly by the shore (fig. 27). The bridge had been blown up by French troops as they retreated to the capital in the face of advancing Prussian soldiers, the lifeline of the town literally ripped from its place in hopes of deterring the enemy. When Monet arrived in Argenteuil in late 1871, the bridge would have been a painful symbol of France's loss in the war. He would have seen it girded in scaffolding (fig. 28) and meticulously rebuilt. Although he could have depicted the bridge at any point in its reconstruction, he chose to wait until every brace came down and it stood restored to its former grandeur. Only then could it resume its role as the primary connection to the town and reaffirm France's resilience and continued faith in progress. Monet enhances its aura of importance by having the sunlight bleach its piles so that they look like monolithic forms and by glossing over the crisscross iron bands of the trestle, evident from photographs, so that the bridge seems weightier and more forceful. (Renoir and Caillebotte showed it this way as well, suggesting that it gave that illusion.[33]) The different treatments of the bridge in these two iconic works by Monet are a tribute to his inventiveness. His changes in vantage point dictated the distinctive framework for each composition.

Similarly, Renoir's *Monet Painting in His Backyard at Argenteuil* and Monet's *Corner of the Garden with Dahlias* (cats. 19, 20) depict the same site but from different positions. The large blue-shuttered house appears in each, together with the tall tree to its right and the rickety wooden fence. But in Monet's image the house is farther away, which allows the foliage on the right to assume a larger role—so large that it conceals the group of houses that is conspicuously included in Renoir's version. Monet's tactics make the garden seem more secluded and idyllic than it does in Renoir's hands; he shows a place where flowers and fauna abound and where modernized figures out of Watteau can wander through a lush bower. Monet's pastoral landscape is overlooked by only one neighboring structure, not a whole section of town. The point here is simple—both views may be verifiable, but the truths they tell are not the same.

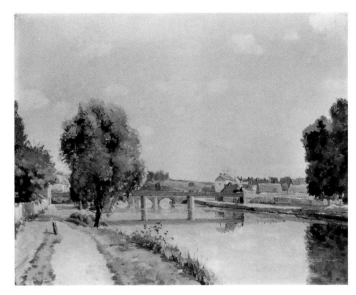

Fig. 26. Camille Pissarro, *Railroad Bridge at Pontoise,* c. 1873, oil on canvas, Private Collection, U.S.

Fig. 27. Photograph of the railroad bridge at Argenteuil, damaged during the Franco-Prussian War, c. 1871

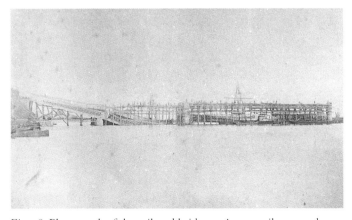

Fig. 28. Photograph of the railroad bridge at Argenteuil wrapped in scaffolding, c. 1871. Musée du Vieil Argenteuil

Working within a limited area for an extended period of time, the impressionists in Argenteuil had to be able to reinvent their subjects to avoid repetition. This would have been a particular challenge in winter for someone like Monet, who was devoted to painting outdoors. But he remained committed to depicting each scene faithfully in all its detail. Two renderings of his neighborhood underscore this resolution. In one he looks down a path toward the Boulevard Saint-Denis, which cuts through the space on a diagonal (cat. 44). He stands directly on the route to the railroad station—the destination, presumably, for at least the three closest pedestrians. If he walked down the path past these wind-battered figures onto the boulevard, proceeded about fifty paces to the

right, then turned around, he would arrive at the vantage point he assumed for another painting of the Boulevard Saint-Denis (fig. 29). The bushes on the left are part of the undergrowth in the right foreground of the former picture, which also shows the high-pitched roofs of the houses on the right more fully; the house with the large chimney is in the center of both compositions.

Not surprisingly, most of Monet's winter scenes—nearly two dozen from his years in Argenteuil—were painted close to home so that he did not have to walk far. These two views of the Boulevard Saint-Denis include his house, with its pink exterior and green shutters. The turreted one next door, like Monet's, was brand new. Both were built on speculation in

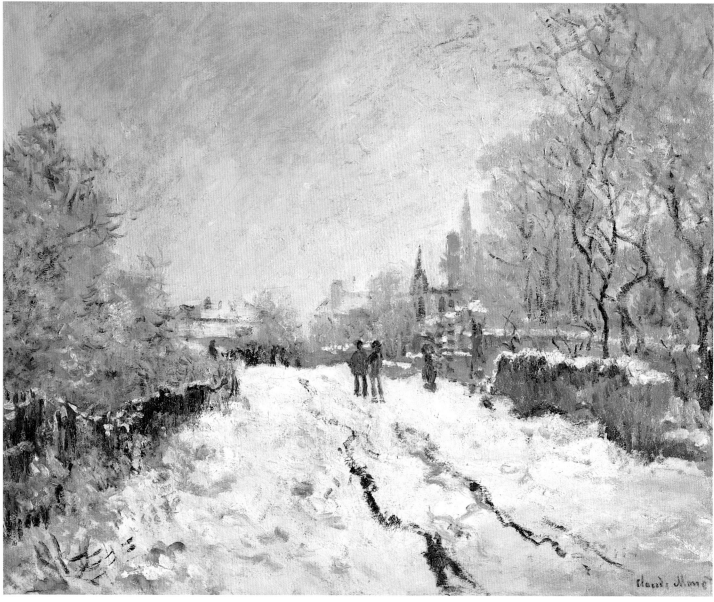

Fig. 29. Claude Monet, *The Boulevard Saint-Denis, Argenteuil,* 1875, oil on canvas, Private Collection, England

1873–1874 on land owned by the woman who had rented Monet his first house in Argenteuil. He must have seen these homes erected and must have inquired about them, for he was the first tenant in the pink house, moving in on 1 October 1874. It was more expensive than his earlier residence—1,400 francs a year as opposed to 1,000—but he was doing well, and the additional rent was not unreasonable. The property seemed to suit him; he painted its backyard some fifteen times in the summers of 1875 and 1876; only Caillebotte painted his own garden more often—nearly twenty times—but that was over a period of twelve years.

Within the considerably more limited space of his backyard, Monet had to be especially inventive to meet his customary level of novelty. But by moving around the garden or turning in one direction or another, he could change the entire prospect. Two works executed in the same summer on the same property, for instance, initially seem worlds apart. In *The Gladioli* (cat. 47) a path curves around a shimmering array of flowers to a place where Camille stands under her green silk-lined parasol in front of a second bed of flowers and a large trellis. Everything is strongly geometric; everything but the upper right quadrant is brilliantly illuminated. In *Undergrowth at Argenteuil* (fig. 30) the view is consumed by the glade of trees that created the shaded quadrant in *The Gladioli*. With the rear façade of the house in the background (it had been out of sight behind Monet in *The Gladioli*), the artist looks through a shower of sunlight that recalls visions of Zeus' descent to Danaë in a cascade of golden coins. Nothing is sharply delineated; even the shape of the house has been softened by the display of natural splendor.

Monet's fascination with the garden, nurtured by this first immersion in its potential, would lead him to create a horticultural paradise in Giverny. There, over the last twenty-six years of his life, he would pursue what he began in this rented backyard, maintaining a similar allegiance to the forms in front of him. Yet no matter how compelling his later garden paintings would be—and they are extraordinarily so—the truths they suggest are different: namely, that the world is more profound and complex, more beautiful and elusive, than one can imagine; that art is never based solely on what one sees; and that realizing the desired combination of observation and reflection can be—indeed perhaps must be—an impossibility.

One might suppose that it would have taken years of struggle and deep consideration of the consequences of looking and painting, feeling and acting, to come to these understandings. Like all of the impressionists, however, Monet was a fast learner, in part because he was a lifelong student, in part because his art was one of ongoing process. Only five years separated Monet's move from the unruly suburb of Argenteuil, which he left in January 1878, to the true countryside of Giverny, where he settled in April 1883. That ten of Monet's last fifteen Argenteuil garden views were painted in 1876, to the exclusion of all other pictures of the town, is significant. It suggests that amid their dazzling light effects and verisimilitude lay other truths that led to the end of an era in Argenteuil and to the formulation of another ideal farther from Paris.

Time and Change

One of the central concerns of the impressionists, which they refined in the 1870s at Argenteuil, involved the idea of "instantaneity." Unlike their conservative, academic counterparts, Monet and his friends believed they could capture a moment in time—passionately, and presumably on the spot. They were intent on making this a pillar of their movement for many reasons, chief among them being their desire to challenge the academy's demand for timelessness in art, with its implications of discipline, order, and eternity. Loyal to the realities of nature, the impressionists insisted on painting the fleeting and spontaneous, because they believed such effects were more truthful to the ephemeral world around them.

Fig. 30. Claude Monet, *Undergrowth in Argenteuil,* 1876, oil on canvas, Private Collection

Interest in the instantaneous long predated the impressionists, as artists had always wanted to set down their ideas quickly before the specifics slipped away on the wings of fleeting inspiration. Most believed that these rapidly noted images needed to be refined, to be shaped by the mind, given greater clarity, put to the test of hard-earned techniques: drawing, modeling, composition. Sketches on their own were interesting for their insights but were not deemed worthy of assuming the higher ranks of art. The French Academy nonetheless encouraged sketching, as it developed an artist's eye and hand, forced him to think and act quickly, and revealed the depths of his creative potential. It was on the basis of sketches that candidates for serious prizes were judged and great works of art were constructed. Thus the impressionists—by elevating what most of their contemporaries would have seen as a sketch to the level of a finished picture, and by putting special emphasis on the instantaneous in all its unrefined frankness—were undermining the very foundations of French art. Little wonder they provoked such strong negative reactions. They were held guilty of stopping the process of art making at its nascent stage, of being committed only to observation without reflection, acting without thinking, painting without understanding.

This was not the case of course. The impressionists were exceedingly self-conscious. Willing to embrace the accidental or the unexpected, they approached their work with rigorous intelligence and highly developed skills. They differentiated between finished pictures and what they themselves considered sketches, and they were scrupulous about labeling the latter as such when they exhibited them. They also sold sketches for less than finished paintings.

Yet the idea that they could capture an instant in time was riddled with complications. The impressionists knew that no one moment was exactly the same as the next, that everything was in a constant state of flux. Light varied from second to second; clouds were never stable; water was forever moving. How could they lock a single moment into paint that would be meteorologically convincing, particularly when working outdoors with its attendant distractions? Simply the time it took to rough in a composition would compromise their faithfulness to the moment that had inspired it.

It is therefore not surprising that the notion of time, like that of truth, was somewhat elastic. Monet or Renoir might start out rendering a specific site at a specific time—they might return to the same place at the same time over the course of many days—but by necessity they would have to invent or recreate certain natural phenomena in the process of completing the picture. It was the impression of instantaneity that was most important, the appearance of spontaneity, not actually capturing the moment in a flash. That was clearly impossible.

This realization led all of the impressionists to complete their "finished" canvases in the quiet of their studios, not *en plein air.* They needed to add harmonizing brushwork or passages of color and light to make the painting whole. For decades Monet asserted that nature was his only workplace, but in fact he maintained a studio in Paris during most of his years at Argenteuil. Renoir rented a studio near his Montmartre apartment beginning in 1876. Pissarro devoted a room in his house in Pontoise to completing and storing pictures, as did Sisley in his house in Marly.

Caillebotte was the most wedded to applying traditional studio practices. He usually began not with painted sketches but with drawings, or sometimes photographs of the subject from which he would then make drawings. When he arrived at the disposition of the forms he desired, he squared the drawing and transferred the image to canvas, which itself was often already divided according to strict geometrical proportions: halves, quarters, golden sections, *rabatments,* and so on. It is largely for this reason that many of his paintings look so different from those of his fellow impressionists.

Manet was not as compulsive as Caillebotte, as he generally worked *alla prima,* without any preliminary drawings or sketches. But he completed his major Argenteuil paintings in the studio, not on the banks of the Seine. The size of his *Argenteuil* canvas (fig. 19) alone would have dictated this choice; measuring nearly 152 by 122 centimeters, it would have been impractical to lug to the site every day. Manet even had friends and relatives pose for the figures in this work and in *Boating:* his brother-in-law Rudolphe Leenhoff sat for the males in both, while a nameless but apparently well-known model posed for the woman in *Argenteuil.*[34]

Many of these impressionist paintings of Argenteuil thus project a quality that is at odds with how they came into being. This is not to say that some were not painted on the spot in one session. Manet's sketches for *The Seine at Argenteuil* and *Claude Monet in His Studio Boat* (cats. 34, 39) were most likely produced that way, given their rapidly brushed surfaces and reduced palettes. The same is true of a handful of landscapes by Monet (see cats. 14, 41, and fig. 21). Large sections of *Woman with a Parasol* (cat. 46)—the sky in particular—seem to have been set down in a single sitting. But most of Monet's pictures from Argenteuil were built up over the course of several working sessions. This is also true of scenes by Renoir, Sisley, and Caillebotte.

Ironically, these seemingly spontaneous paintings that were realized in days or weeks thus possess two contradictory temporal constructs, one momentary, the other extended. Both are embedded in the surfaces of the canvases. The first is apparent in the deceiving quickness of the artist's touch and in what seems to be the direct transposition of paint from palette to picture. The second is sensed in the complicated patterns those marks create and the many ways in which the medium is bent to the artist's whim and concern. These opposing constructs and our experiences of looking at them parallel the way we experience time itself—the instant appearing with all of its immediacy, then suddenly passing to become a memory that can be prolonged indefinitely, either

in isolation or more often in conjunction with those moments that came before and after.

The impressionists devised their new picture-making strategies in part because they did not want to imitate their seventeenth-century Dutch forebears or the recent Barbizon painters (although most had done just that early in their careers). More important, they wanted their art to be consonant with their times. Millet and Corot were still alive when Monet moved to Argenteuil—both died in 1875, Diaz passed away the next year, and Daubigny two years later. But the Barbizon artists were of a generation that had very different values, experiences, and expectations. The impressionists were raised at a time of tumultuous change, when nothing seemed sacred, secure, or systematic, except change itself. Argenteuil had been a microcosm of that upheaval, which had been part of its initial appeal.

How reassuring the town must have been to someone like Monet, who had left France during one of its darkest moments. Returning in the fall of 1871, he found his beloved Paris ravaged. The Tuileries Palace lay in ruins as did the Hôtel de Ville, the Cour des Comptes, the Légion d'Honneur, the Palais de Justice, the east end of the rue de Rivoli (fig. 31). Stories of starvation, confusion, and killings abounded: more than 160,000 French and German soldiers had died during the war and the siege of Paris; 20,000 residents of the French capital died during one bloody week in May 1871 when the French army swept into Paris with the blessings of the Prussians to suppress the Commune. The facts were brought home to Monet with jarring reality, as one of his best friends, Frédéric Bazille, had been killed in the battle of Beaune-la-Roland; and one of his mentors, Gustave Courbet, had been arrested and condemned to six months in prison.[35] Like almost every other suburb of Paris, Argenteuil had not escaped unscathed. Its railroad bridge and train station had been destroyed along with sections of its highway bridge; its houses had been occupied by the Prussians, its residents forced to pay 15,000 francs indemnity, its hills transformed into batteries for enemy cannons (fig. 32).[36] But Argenteuil, like the rest of France, had set its sights on a brave new future

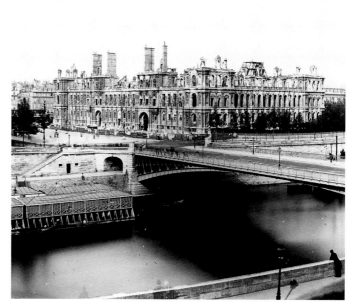

Fig. 31. Photograph showing the destruction of the Hôtel de Ville in Paris, c. 1871

as it tried to put the frightening twelve months behind it. As Zola exclaimed to Cézanne in the summer of 1871, "Never have I had more hope or a greater desire to work...for Paris is born again."[37]

When Monet moved to Argenteuil in December 1871, its bridges were being rebuilt, its factories were running again, its stretch of the Seine was being restored to its prewar splendor. Just after he arrived, he depicted the highway bridge under construction, and a year later, the railroad bridge gleaming in the afternoon sun (cats. 2, 27). In both he was rendering tangible proof of France's vigor and dedication as much as he was attempting to capture a moment of diurnal time. The paintings resonate with heartfelt nationalism because of the larger era in which they were realized, one

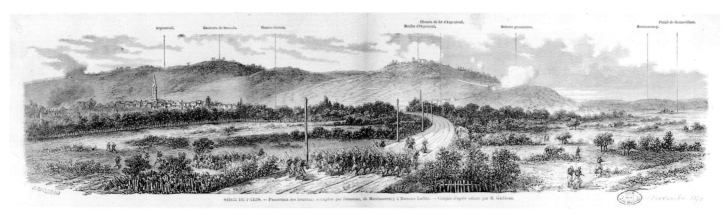

Fig. 32. Engraving of Argenteuil during the Franco-Prussian War, November 1870

beyond the confines of clocks and hours. Like so many of his canvases from these first years in Argenteuil, they are infused with the widely shared faith that everything was possible and that, like the phoenix, France would rise from the ashes of its defeat. To Monet and his impressionist colleagues working at this time of inspiring vitality, the world—with all of its contradictions—was indeed worth immortalizing in boldly applied paint.

Monet's own life at the time paralleled these developments, contributing to the sentiments his paintings convey. He had rented a substantial new house with a beautiful garden, which he shared with his new wife (he and Camille had married in 1870) and young son. He was making more money and producing more pictures than he probably ever expected. It could hardly get better. His paintings of Argenteuil are thus a portrait of his life as much as of the town or specific times of day: Camille and Jean appear in more than forty of these works, his studio boat in eight others.

Life was not perfect in his new suburban home, however. Monet regularly spent more money than he made, despite earning what were fabulous sums for the time—between 9,000 and 24,000 francs a year (the average laborer in the town earned a mere 2,500). Confrontations with creditors were resolved mostly by borrowing money from friends or selling paintings at discounted rates. (He kept a strict accounting of his debts and paid his friends back promptly, although some merchants were treated differently.) Monet rarely paints Camille as the object of affection. Instead, she assumes the role of the disengaged Parisian or the stranger whom one encounters unexpectedly and awkwardly. Or she is the precious flower in the garden, tantalizing but untouchable. Jean occupies the same nebulous realm; sometimes he is quizzical, more often aloof. It is hard to know whether Monet was simply posing his wife and son in evocative positions and endowing them with such attitudes in order to make modern pictures, or whether he was revealing his family dynamics. Given the consistency of the images and his overwhelming allegiance to other subjects that he rendered in Argenteuil, it is more than likely that these works contain a measure of truth.

Argenteuil itself also became more problematic for Monet. Its rich array of offerings, which had been so attractive to him in the beginning, grew less and less appealing as the years elapsed. The number of paintings in which he depicted the town is suggestive: in his first year there Monet featured it thirty-five times; by 1876 only seven; and in 1877 the number had fallen to four. Something seems to have gone awry.[38] It was not that Monet had exhausted his options; he could have continued to find new motifs. Nor had he become bored with the place. In a letter to Georges de Bellio in July 1876 he expressed his hope of staying in his house "where he had worked so well."[39] But a year later that was no longer the case. In October 1877 he invited another collector, Victor Chocquet, to come to his studio in Paris, informing him that "starting tomorrow, I will always be [there] from one o'clock to four."[40] Two and a half months later he left Argenteuil for good.

The problem had become Argenteuil. During the time Monet lived there, it changed dramatically. Between the census of 1870 and the end of the decade its population rose from 7,148 to 9,752, or more than thirty-six percent.[41] This was a formidable leap. While many Paris commuters had moved in, most of the population increase was due to the broadening economic base that the town's industrial expansion had created. Its industries had grown exponentially. In addition to the Joly iron works, there were two distilleries, two chemical plants, two crystal factories, a tannery, a saw mill, a gas works, factories that made cartons, dye, starch, machine-made lace, and embroidery, as well as a new iron plant. This ultimately meant the town was becoming more working class. It also meant that more open land was being converted to commerce and housing, which in turn meant the loss of agrarian traditions and any romantic relationship with the past.

Critics in 1877 recognized that the impressionists had generally not indulged in the nostalgia-evoking strategies of their Barbizon predecessors. Charles Bigot noted that "it is not true nature that they have looked at and have tried to render, but rather the nature that one encounters on outings in the great city or its surroundings, where the harsh notes of the houses, with their white, red, or yellow walls, and their green shutters, clash with the vegetation of the trees and form violent contrasts with it."[42] One need only recall Monet's *Houses at the Edge of the Field* (cat. 24) to see what he meant. Bigot's preference lay elsewhere, which he was happy to admit: "How much better have…our modern landscapists, the Rousseaus, the Corots, and the Daubignys, understood how to express not only the poetry but also the truth of nature! How much better have they represented the countryside, with its waters, its woods, its fields, and its meadows, with its distant and calm horizon!"[43]

Argenteuil was becoming ever more distinct from "the countryside." Initially, Monet had found that exciting. It was confirmation of the nation's claims to greatness after the war and the Commune. It demonstrated with aggressive clarity the ways in which contemporaneity was reshaping the world; and it relied on the same brazen abandon that the impressionists were using to rewrite the rules of art. But by 1876 the transformation of the town had lost its *frisson* for Monet; he spent most of his time painting inside the walls of his garden, as did Zola's Lantier during his retreat to the country, lacking the desire if not the will to deal with the complex problems of the larger world. In 1877 Monet tried to reinvent himself, returning first to Paris to paint twelve views of the Gare Saint-Lazare and then that summer to the promenade along the Seine, one of his favorite sites. But in what must have been his final depiction of the town, *Argenteuil, the Bank in Flower* (cat. 52), he displayed in no uncertain terms the unsettling facts of his adopted town. The work is divided into two parts,

the lower half dark and mysterious, the upper half filled with a golden glow. While the foreground flowers seem twisted and ominous, the background appears to hold promise. In contrast to the many light-filled views of the promenade that Monet produced in 1872 (see cat. 8), this picture evokes alienation and disharmony. Although people have still come to boat on the river or sit on the banks, the earlier charm of place has faded for Monet.

Argenteuil's town fathers were of a different ilk. They were convinced that more factories meant more jobs, which meant more progress, which meant more advantages. It was a well-intentioned policy. It was just antithetical at some point to those like Monet who wanted to maintain a meaningful relationship to nature and strike a balance between the bounty of change and the beauties of the environment. Argenteuil had tipped the scales in one direction. It was not just a question of the town's myopic focus, however. Other forces were at work as well, mostly emanating from the capital. In 1869 Paris officials had begun siphoning off more than a million gallons of city sewer water and pumping it into an irrigation system that fertilized some ninety acres of the

plains of Gennevilliers (fig. 33). A novel idea, it had an immediate impact. Vegetable crops grew extremely well, and land rentals rose five hundred percent in a year.[44] But the operation essentially portended the conversion of the seemingly idyllic fields in the backgrounds of paintings by Monet and Caillebotte into municipally controlled cesspools.[45]

The pollution of the river was worse. When Baron Haussmann laid fifty-seven miles of new streets through Paris, opening the overgrown medieval city to light and air in the 1850s and 1860s, he laced the capital with sewer pipes that could begin to relieve its mounting waste and unbearable stench.[46] Ingenious but primitive, this vast system of pipes collected fetid material and carried it to two locations north of the city, one in Asnières, the other in Saint-Denis.[47] The two were just upriver from Argenteuil. Together they handled "154,000 tons of solids and 77,000 tons of dissolved matter" a year, which meant they simply pumped them into the river. During the first years of its operation, the system seemed commodious, but by the 1870s material had settled on the bottom of the river and had begun to infect the water. The mayor of Argenteuil registered a formal complaint in 1872: "Between the highway

PLAINE DE GENNEVILLIERS. — BASSINS DANS LESQUELS EST OPÉRÉE L'ÉPURATION CHIMIQUE DES EAUX D'ÉGOUTS DE PARIS.

Fig. 33. Engraving by V. Rose showing the irrigation of the plains of Gennevilliers, from *Assainissement de la Seine,* ed. Gauthier-Villars (c. 1875)

bridge and the floating laundry houses that are along the promenade, sludge has built up all along the banks....The water for a rather long distance no longer moves...[and] traffic on the promenade becomes unpleasant." In 1874 the mayor wrote again: "Before long, maybe in several days with the heat, the water level is going to drop again and expose a considerable area of choking, smelly slime." By 1878 the mayor wrote directly to a government lawyer: "The pollution of the river is complete....If the complaints are less lively and less frequent, it is because people are tired of complaining uselessly....The left half of the river [opposite Argenteuil], which seven or eight years ago was a little cleaner than the right, has become just as thick with material of all kinds."[48]

In the 1860s Zola claimed that Monet loved "with a particular affection nature that man makes modern." Monet had demonstrated the truth of that assertion during his years at Argenteuil. But by 1877 he had had enough. The changes in the town over time were incompatible with his aims as a landscape artist. After several months in Paris he resettled in Vétheuil, to the north of Argenteuil, some sixty kilometers from the capital. Three years later he moved to Poissy, which he abhorred. Then in 1883, desperate to find a more sympathetic locale, he discovered Giverny. It had no industries, pleasure seekers, housing developments, or pollutants. Its 279 residents were primarily farmers, their houses and barns quaintly nestled against a hill that afforded beautiful views of the upper Seine valley. No Paris skyline loomed on the horizon; no factory chimneys broke the harmonious rhythms of the earth. For the next forty-three years, from April 1883 until Monet's death in November 1926, Giverny was home. There, among the spectacular water and flower gardens he constructed, he could still be engaged with time and change, but the terms were dictated by nature, not by the progressive-minded powers of modernity.

Meanwhile, Caillebotte and his brother built two houses on the banks of the Seine near Petit Gennevilliers, directly across from Argenteuil, just a year before Monet settled in Giverny. The region had clearly not lost all of its allure. Six years later Caillebotte declared Petit Gennevilliers to be his primary residence. With his resources, he could have lived anywhere. That he chose this humble community attests to his lack of pretension.[49] It also says something about the way a place could appeal to various people at different times. Unlike Monet, Caillebotte was a passionate yachtsman. Beginning in 1880, he was one of two vice presidents of the Cercle de la Voile de Paris, which had its headquarters in Argenteuil. Living a stone's throw from his boat and a short walk to one of the best boat makers in the region was attractive to Caillebotte, whereas it had little relevance to Monet. Caillebotte could participate in regattas every weekend merely by walking out his door. Moreover, being a true Parisian, he liked those areas that "man makes modern" and would have felt out of his element in Giverny.

Fig. 34. Auguste Renoir, *The Petit Bras of the Seine,* 1888, oil on canvas, Private Collection, New York

This is not to say that Caillebotte disdained unadorned nature. After views of boats on the Seine, the subject he painted most often was the Petit Bras (cat. 51), a site that remained secluded, beguiling, and undeveloped. Renoir came to visit Caillebotte often and emerged with canvases that attest to the lasting charm of the spot (see cat. 49 and fig. 34). Neither of these two artists was as inclined as Monet was toward pure landscape; both preferred the figure, which enabled them to tolerate changes in the area more readily than their friend did. Who but Caillebotte could have painted laundry fluttering in the breeze or one of the biggest factories in Argenteuil billowing smoke (cats. 10, 25)? Even rendering the fields of Gennevilliers (cat. 23), he focused on cultivated land, as if to reveal the hand of human beings more than the vagaries of nature, something one senses in the artist's own tight brushwork and his meticulous application of paint.

When Caillebotte died in February 1894, his funeral was held in Paris, not in Petit Gennevilliers. He was a man of the city. He was laid to rest in Père Lachaise, the ultimate city cemetery. All the impressionists attended the funeral; he had supported them continuously over the years, forming an extraordinary collection of their work that he willed to the nation. Hundreds of others came to pay their respects, among them his neighbors in Petit Gennevilliers. His love for the suburb and all that it offered had been amply communicated to them at the same time it had been immortalized in paint. Appropriately, it was four sailors from Argenteuil's sister town who carried Caillebotte's casket. It was the final alliance of a remarkable place with an unparalleled group of painters.

Notes

1. Emile Zola, *The Masterpiece* (1886; Oxford, 1999), 29, 139.

2. Zola, *The Masterpiece,* 231.

3. Emile Zola, "Mon Salon. IV. Les Actualistes," *L'Evénement Illustré* (24 May 1868).

4. Paul Hayes Tucker, *Claude Monet: Life and Art* (New Haven and London, 1995), 166 n. 77.

5. Monet spent as many as sixteen months away from Argenteuil during these years. His actual working time there was closer to four years and eight months, which means he painted more than three paintings every month, or one every ten days.

6. Boudin may have played a role in introducing Monet to Argenteuil, for he worked there in the 1860s. He also was living near Monet in Paris in December 1871 and subsequently wrote about seeing him frequently. See Charles F. Stuckey, *Claude Monet, 1840–1926* (New York, 1995), 196; and Tucker 1995, 53.

7. Paul Hayes Tucker, *Monet at Argenteuil* (New Haven and London, 1982), 23 n. 4.

8. Gustave Flaubert, *Bouvard and Pécuchet* (1881), trans. A. J. Krailsheimer (Harmondsworth, 1976), 33.

9. Emile Zola, *La Bête humaine* (1890), trans. Leonard Tancock (Harmondsworth, 1977), 58, 154.

10. Tucker 1982, 17 n. 19.

11. Tucker 1982, 19 n. 30.

12. Monet to Pissarro, 17 June [1871], w. 59 in Daniel Wildenstein, *Claude Monet, Biographie et catalogue raisonné* (Lausanne, 1974), 427-428.

13. Monet to Paul Alexis, 7 May 1871, first published in *L'Avenir National,* 5 May 1873; then as w. 25 in Wildenstein 1974, 428.

14. Paul Alexis, *L'Avenir National* (1873), 309.

15. E. Drumont, "L'Exposition du b.d.C." *Le Petit Journal,* 19 April 1874, 2.

16. Monet to Bazille, 26 August 1864, w. 9 in Wildenstein 1974, 420, cited and trans. in John Rewald, *The History of Impressionism,* 4th ed. (New York, 1973), 111.

17. Monet to Boudin, October–November 1864, w. 13 in Wildenstein 1974, 421, cited and trans. in Rewald 1973, 112.

18. Monet to Bazille, 26 August 1864, w. 9 in Wildenstein 1974, 427-428, cited and trans. in Rewald 1973, 111.

19. Tucker 1995, 77.

20. Monet to Pissarro, 1871, w. 59 in Wildenstein 1974, 427–428.

21. Tucker 1982, 10 n. 4.

22. Monet to Pissarro, 5 December 1873, w. 74 in Wildenstein 1974, 429.

23. Robert L. Herbert, *Impressionism: Art, Leisure, and Parisian Society* (New Haven, 1988), 313 n. 40; Juliet Wilson-Bareau has suggested that Manet began *Boating* in 1875. See "L'Année impressioniste de Monet: Argenteuil et Venise en 1874," *Revue de l'art* 86 (1989), 28–33.

24. See Herbert 1988, 244, for further disparities.

25. Cézanne's letter to his son Paul, 8 September 1906, cited and trans. in Herschel B. Chipp, *Theories of Modern Art* (Berkeley, 1968), 22.

26. Monet to Bazille, 15 July [1864], w. 8 in Wildenstein 1974, 420, cited and trans. in Rewald 1973, 111.

27. Richard Shiff, *Cézanne and the End of Impressionism* (Chicago, 1984).

28. Zola, *The Masterpiece,* 86.

29. Zola, *The Masterpiece,* 41.

30. Albert Wolff, *Le Figaro,* 3 April 1876.

31. Tucker 1995, 77.

32. Tucker 1982, 28.

33. Ironically, it was the stripped-down design of the bridge that some people in Argenteuil found offensive in 1863. The editor of the local newspaper called it "a heavy and primitive work…a wall of iron…a tunnel without a roof." Another prominent figure in Argenteuil felt the bridge needed embellishments: "the [piles] should have been surmounted by carved capitals instead of the bulging blobs that sit there now….The [trestle] should have been adorned with some cast-iron decorations, which would have broken up this relentless straight line." Short of that, "the mounds of earth at the end of the bridge which cut off the view of the plains of Gennevilliers [should] be planted with trees whose foliage will reach beyond the rails and close off the horizon more agreeably." Ten years later trees stood at either end of the bridge, as evident in several of Monet's pictures (cats. 26, 27), performing the function this detractor desired.

 The reactions of these two residents were not unexpected, to the extent that the bridge design was novel, but what added to their disappointment was the fact that their own Joly iron works, which had fabricated the trestle, had been obliged to follow someone else's design; if the firm had been commissioned to "draw up the plans…we would not be criticizing the design today." Local pride ran deep. See Tucker 1995, 73–74.

34. Jacques-Emile Blanche suggested that the skipper in *Boating* might have been Baron Barbier, a prominent yachtsman and a friend of Manet's. See *Manet, Portraits of a Lifetime,* trans. and ed. Walter Clement (London, 1937), 39.

35. Courbet was prosecuted a second time after his release from prison in March 1872 and fled the country in July 1873, taking refuge in Switzerland, where he died in ignominy four years later.

36. Tucker 1982, 61.

37. Zola to Cézanne, 4 July 1871, in *Correspondance,* vol. 2, ed. H. B. Bakker (Montreal, 1978–1991), 293–294.

38. In terms of overall output, too, Monet produced more than fifty paintings in 1872 but fewer than twenty in all of 1877.

39. Monet to Georges de Bellio, 25 July 1876, w. 95 in Wildenstein 1974, 431.

40. Monet to Victor Chocquet, 25 October 1877, w. 109 in Wildenstein 1974, 432.

41. Tucker 1982, 15.

42. Charles Bigot, "Causerie artistique. L'Exposition des 'impressionistes,'" *La Revue politique et litteraire* (28 April 1877), 1,045–1,048.

43. John House, *Landscapes of France: Impressionism and Its Rivals* (London, 1995), 23.

44. David H. Pickney, *Napoleon III and the Rebuilding of Paris* (Princeton, 1972), 141.

45. Tucker 1995, 153.

46. Most apartments in the capital did not have running water until the turn of the century, which means waste material was dumped, burned, or removed by hand; in 1871 more than 10 percent of Paris buildings had no legal disposal service. See Pickney 1972, 70, 145.

47. Pickney 1972, 132.

48. Tucker 1995, 176, 178–181.

49. Caillebotte ran for a seat on the town council in 1888, was elected, and served until December 1891. See Anne Distel, *Gustave Caillebotte: Urban Impressionist* (Paris, 1995), 318.

I

Eugène Boudin
The Seine at Argenteuil
c. 1866
oil on canvas
29.9 × 47 (11 ¾ × 18 ½)
Collection of Mr. and Mrs. Paul Mellon, Upperville, Virginia

Late in his life, when he was established, wealthy, and grateful—a rare combination for an avant-garde artist—Claude Monet paid the ultimate compliment to the far less successful Eugène Boudin, his teacher in the 1850s. In an interview that he gave to Boudin's biographer, Georges Jean-Aubry sometime in the early 1920s, the arch-impressionist declared his debt to the older painter in a way that he had been hesitant to do before, unabashedly admitting, "If I have become a painter, I owe it all to Boudin." Why Monet was so forthcoming at this point—he was in his eighties—remains unclear. What is undeniable, however, is the impact that Boudin had on the aspiring artist at the outset of his career.

Boudin had distinguished himself by becoming the first landscape painter in France to focus attention on contemporary life in Normandy, specifically on the invasion by the urban bourgeoisie of the coastal towns of Deauville, Trouville, and Le Havre, where he was born. Boudin developed this interest in the 1850s, perhaps under the influence of popular illustrators who were beginning to document sites along the coast of the English Channel that were being transformed from maritime ports to places for leisure activity. With a bias toward change and an openness to novelty that were essential to the development of a modernist sensibility, Boudin proclaimed his seminal aesthetic without compunction: "The peasants have their painter...but do not those middle-class people strolling on the jetty toward the sunset have the right to be fixed upon the canvas, to be brought to light? They are often resting from hard work, those people who leave their offices [and] consulting rooms. If there are some parasites among them, are there not also those who have fulfilled their task?"

When the famously unassuming Boudin formulated this utterly novel notion in the 1850s, the leading avant-garde landscape painters in France were Jean-François Millet and Gustave Courbet, both of whom were attempting to carry their compatriots beyond the work of Théodore Rousseau, Charles Daubigny, Narcisse Diaz, and Camille Corot, who had formed the revolutionary School of 1830. These remarkable older painters had brought tremendous changes to landscape art over the previous twenty years with their heartfelt views of rural France, but by the middle of the century their work had become predictable if not mainstream.

In an effort to push the genre of landscape even further, Millet monumentalized the peasant and anointed the agrarian practices of France with a kind of religious aura. Courbet in contrast deftly revealed the contradictions of country life on canvases of immense proportions, which he proceeded to cover with painterly bravura. Although Boudin could have found material similar to either of these artists, he opted instead to paint something even more modern: middle-class pleasure seekers enjoying the light and air of recently developed seaside resorts far from Millet's Barbizon, Courbet's Ornans, and the teeming capital of Paris.

It is often said that Monet did not appreciate the work of Boudin when he first encountered it in Le Havre, where Monet's family had moved when he was five. If this assessment was even accurately reported, it was made when Monet was around sixteen and it was most likely colored by his own youthful sense of things. By the end of the 1850s he certainly thought differently, as he encouraged his teacher to come to Paris where he had gone to immerse himself in its art and history. After visiting the annual Salon at the Palais de l'Industrie in 1859, he wrote to Boudin urging him to abandon the smaller Norman market and try his luck in the larger fray. Monet was not writing to a novice, however. Boudin had lived and worked in Paris every year since the 1840s. He sold his paintings through a gallery in the capital, and he had submitted a picture to the same Salon that Monet saw, after having shown his work during the previous decade in Rouen, Bordeaux, Marseilles, and Le Havre.

Boudin's connections to Paris are worth reviewing, because he is characterized so frequently as a Norman painter dedicated to rendering its beaches for a local audience. Clearly that was not his exclusive focus. This little-known, completely unprecedented painting, which is startlingly fresh yet meticulously rendered, is perhaps most striking for its date: approximately 1866. This indicates that Boudin had come to Argenteuil nearly five years before Monet and his colleagues and that he had painted the same site as his youthful contemporaries—the promenade along the Seine—long before they descended on the place.

Why Boudin went to Argenteuil remains a mystery. There is no written record of his visit and no other painting of the town from his hand.

This picture provides plenty of evidence of Boudin's significance to impressionism, as it contains all of the essentials that the younger painters would exploit in the following decade: tangible light, heightened color, broken brushwork, and modern subject matter—contemporary men and women

boating or strolling along the banks of the river. There is an immediacy about the scene as a whole that suggests it was painted on the spot, which would have conformed to Boudin's general practice. At the same time, elements have been closely observed: the trees along the promenade, the laundry houses in the distance, the highway bridge over the river, and the figures in the foreground.

The figures are all in stylish costumes and are synonymous with those that populated Boudin's contemporaneous scenes of Normandy—elegant, well-off, seemingly carefree. He includes more than a dozen of them here, in at least four separate groups. It is not clear whether those in the rowboat on the right are of the same social rank as those on the bank; in various short stories, Guy de Maupassant eloquently described boaters as a slightly rowdier sort. But their presence here emphasizes Argenteuil's multiple attractions.

Boudin suggests its appeal not only through the pleasurable activities and the natural charm of the landscape but also by the way he has arranged his scene. Viewed from a slightly elevated position, the bank spreads generously across the canvas, creating a graceful, continuous arc. This allows the Seine to appear quite wide before it turns to the right and exits the picture, more so than in most of Monet's depictions of the area. Given the height of the figures, the trees along the promenade also seem substantial. Most impressive is the sky. Although its facture is restrained by impressionist standards, it is rendered with many small overlapping strokes of color that make it wonderfully textured and visually engaging. Its sheer size in relation to the rest of the picture encourages one to believe that the site is spacious, airy, and desirable—precisely the kind of place Boudin's middle-class office workers went to ease the tensions of the city and enjoy the rewards of their hard work.

Whether Monet or his colleagues ever saw this understated, modestly proportioned painting is unknown. But it more than justifies Monet's praise of his less well known mentor. As with his views of Normandy, this work demonstrates that Boudin was one step ahead of the next generation, applying his significant talents to this soon-to-be-discovered suburban town with formidable acumen and characteristic foresight.

Detail, cat. 1

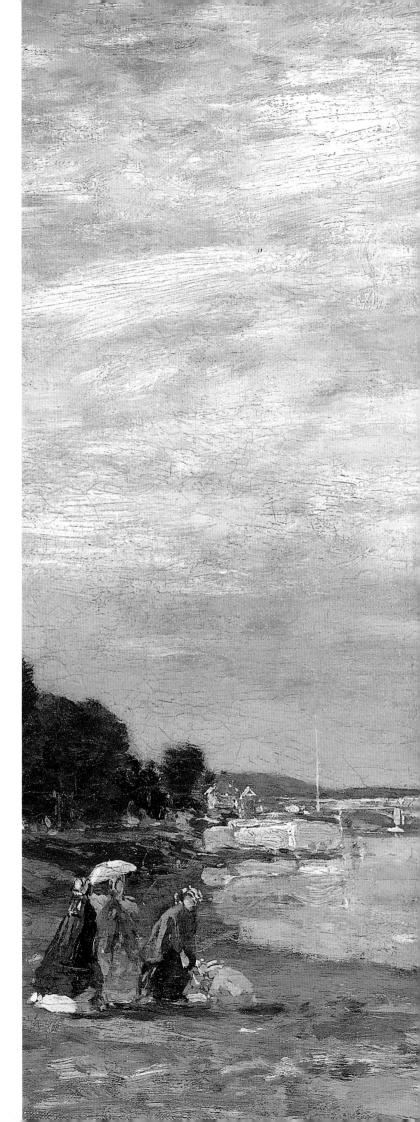

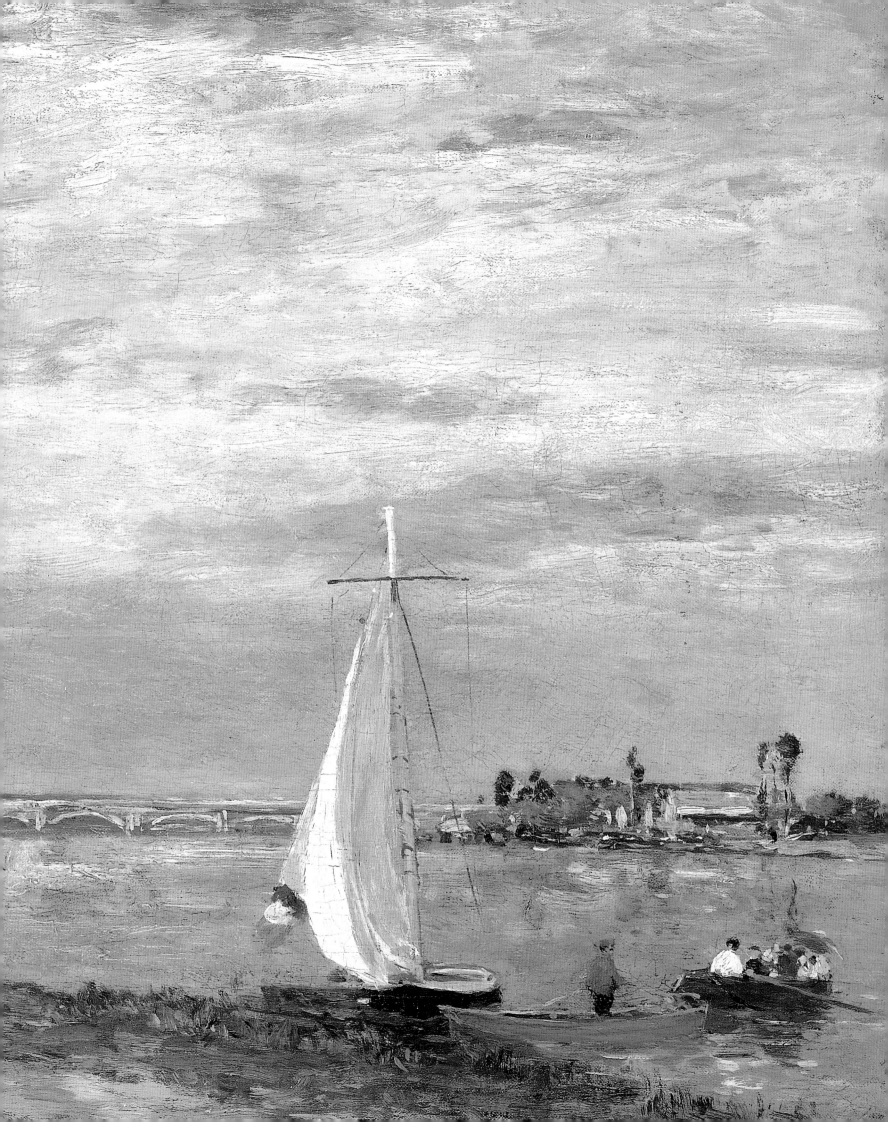

Claude Monet
The Highway Bridge under Repair
1872
oil on canvas
60 × 80.7 (23 ⅝ × 31 ¾)
Private Collection, on loan to the Fitzwilliam Museum,
Cambridge

At first glance this picture seems strikingly simple. A broad stretch of the Seine occupies most of the lower half of the view, its surface as smooth and unmodulated as the corresponding rectangle of blue-gray sky above. Jutting into the scene from halfway up the left side is an intricate web of scaffolding, behind which rises the darker form of Argenteuil's highway bridge. Like a sculpture by Sol LeWitt, the horizontal and vertical timbers of the scaffolding create a series of open geometric structures, which lead to the town on the opposite shore. A steamboat headed downriver has just entered the wooden maze, its bow obscured, its prominent smokestack emitting a billowing cloud of steam that rises to the top of the canvas and is reflected in the still water below. Silhouetted above the bridge and continuing to the right are the tops of an irregular line of trees, which end just beyond the point where the bridge reaches the shore. Two simple buildings on the far bank are punctuated by single rows of vertical windows.

As is generally true with Monet's work at Argenteuil, this painting is the product of close observation and is more complex than it initially appears. The considerable traffic on the bridge suggests the area generated more activity than the placid waters of the Seine might imply. The scaffolding, which is only partly constructed, begins on the left with long horizontal beams that give way after the second arch of the bridge to an almost indecipherable pattern of lines and shapes.

The tall, boxlike forms closest to the bridge represent the completed section; their lower counterparts to the right lack a second level and a crisscross support system. Each timber is carefully articulated, however, with strong contrasts of dark and light, and the ends of many beams are highlighted with yellow caps that appear to have been cautionary markings applied by the construction company that erected the scaffolding. Monet's attention to such details is an indication of his commitment to rendering the world with the kind of accuracy that Gustave Courbet—the founder of Realism and one of Monet's mentors—would have admired.

Work on the scaffolding began in November 1871 after several spans of the highway bridge were destroyed during the Franco-Prussian War. The intention was to create a separate structure across the Seine during the bridge's reconstruction. This was not done for safety or efficiency alone; the bridge was owned and operated by Argenteuil, which gave the town the right to exact a toll from everyone using it. But the town fathers also had to maintain the structure, which meant that they were obliged to repair the damage from the war. The longer the bridge was closed to traffic, the more money the town stood to lose. It therefore contracted with a private company to guarantee a continued revenue stream. The temporary structure was completed in February 1872, although it was not officially opened to traffic until September 1872, when repairs began on the main bridge. That work was finished later the same year, and the temporary bridge taken down soon after.

It is difficult to know whether Monet has represented the highway bridge when the second structure was being built or dismantled; the former is more likely on stylistic grounds, given Monet's restrained handling. In any case, he has clearly elected to paint a scene that is distinctly contemporary and layered with meaning. He appears to confirm his interest not only in the material facts of the world around him but also in the patriotic notions of progress and recovery after the disastrous war and Commune of 1870–1871. The reconstruction Monet depicts in this painting offers evidence that these humiliations were over and a new day was emerging for his beloved country. The peace and calm of the Seine, like the rigor and strength of the scaffolding, thus assume significance beyond their apparent realities. They are tangible and metaphorical proof of the nation's determination to reassert its stature—deliberately, soberly, and convincingly.

Photograph of the highway bridge at Argenteuil flanked
by scaffolding, c. 1871. Musée du Vieil Argenteuil

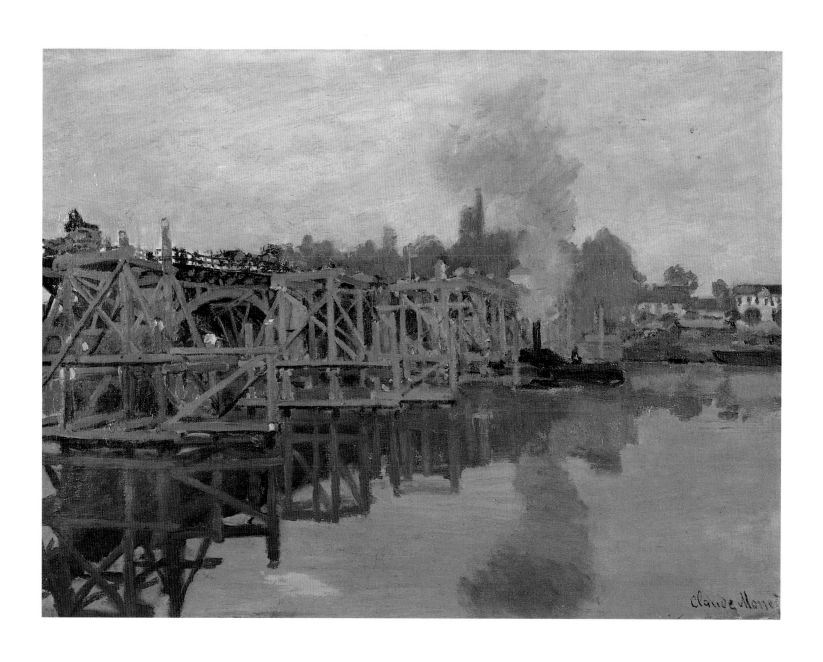

3

Claude Monet
The Petit Bras of the Seine
1872
oil on canvas
52.6 × 71.8 (20¾ × 28¼)
The National Gallery, London

A soft, lilac haze hangs over this limpid scene, one of the most restrained the artist created during his years in Argenteuil. Rounding the edges of forms and cushioning color contrasts, the delicate atmosphere evokes the wistful beauty of the place while enriching the innumerable harmonies Monet discovered in the landscape. Quiet and poetic, the painting stands in Monet's oeuvre as a unique foil to the more impassioned canvases that would follow and as a reminder of the arch-impressionist's essential roots.

The setting is as gracious as it is reserved. The horizon remains well below the middle of the canvas, allowing the land to recede gradually, logically, and reassuringly. Like many more traditional landscape painters, Monet provides unimpeded access to the site by stretching the riverbank across the width of the immediate foreground. Sloping gently down from the left, the bank is textured by a tawny, yellowish green covering that parts like a stole to reveal the purple brown earth underneath. Monet orchestrates similar undulating bands of this ground cover and soil up to the crest of a hill in the background, near which rise two rows of poplars. The first row runs parallel to the scalloped ridges of the land; the other advances along the near bank of the river. Curiously, Monet reverses the Renaissance norm in the second group and depicts the more distant trees at increasing heights. He follows a related strategy in defining the river; it widens in the middle ground and narrows as it draws closer to the viewer.

The strong recession established by the denser row of poplars on the right counters Monet's subtle reversals. Arranged as a forceful though porous triangle, these trees animate the picture through their projection into space, their thin, twisting trunks, their delicate screen of leaves, and their shimmering reflections in the river. At once dynamic and elegant, the gauzy foliage and irregular trunks stand out against the enormous sky, with its unity of tone and texture. They also provide a poignant contrast to the slighter, sparser trees on the left. Without this cultivated row of poplars, the painting would seem more rural, perhaps even desolate. These trees, however, did not grow naturally along the bank; they were planted there as a crop to be harvested, as is clear from their consistent height and spacing. They therefore suggest that the painting is not merely a picturesque view of an unknown body of water.

The poplars are not the only sign of human intervention in the area. Monet includes a large house on the right and two figures on the left. It is not certain what the two figures are doing: one reaches forward with both arms as if he were casting (though he does not appear to hold a fishing pole); the other is

just below the lip of the bank, either in the water or by its edge, and raises one arm as if to inspect something. Their cryptic actions aside, the figures keep the painting in the present. They are not idyllic peasants working the fields or mythological staffage. They are part of Monet's world and thus underscore his allegiance to rendering the suburban environment as he saw it, not as he imagined it or wished it to be.

That said, it is important to note that no jarring elements appear here to remind us of the tensions of modern life. Despite the presence of the house, trees, and men, the scene does not seem suburban. On the contrary, it recalls the art of the Barbizon painters who preceded Monet, particularly Charles Daubigny and Camille Corot. Their views of meandering streams and quiet glades are the references for this image, just as their retreat from Paris into the surrounding countryside—like Monet's to Argenteuil—was essential to the advancement of modern French landscape art. Monet would always hold their achievement in special esteem. It was the Barbizon artists who taught their successor the value of looking at humble bits of nature and of allowing their special, unassuming poetry to be part of the elevated world of art.

It is therefore perhaps not surprising that Monet would have walked to this slightly backwater site to paint this picture, one of the first he completed on moving to Argenteuil in the winter of 1871. It was an opportunity to reaffirm his origins in that noble past and to begin to find his way in the complexities of his competitive present.

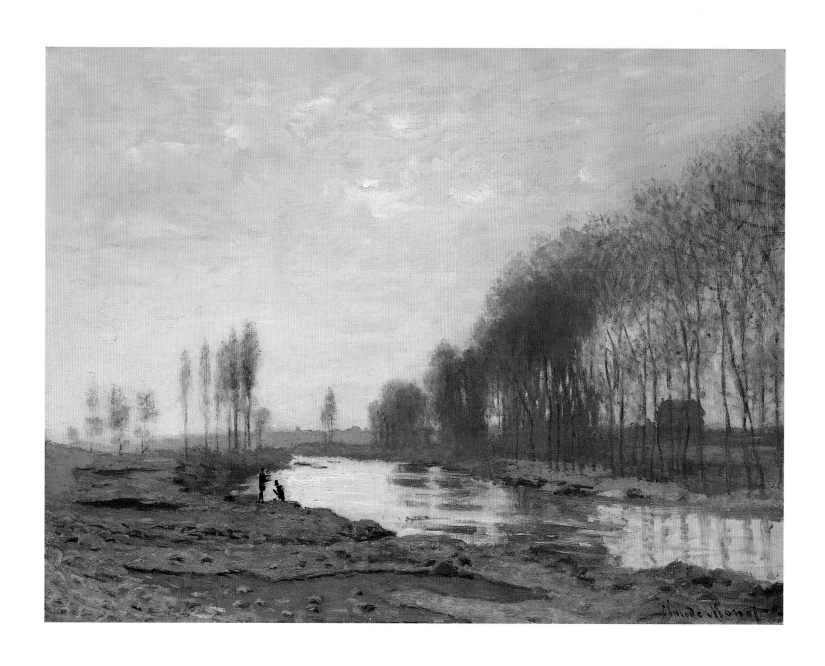

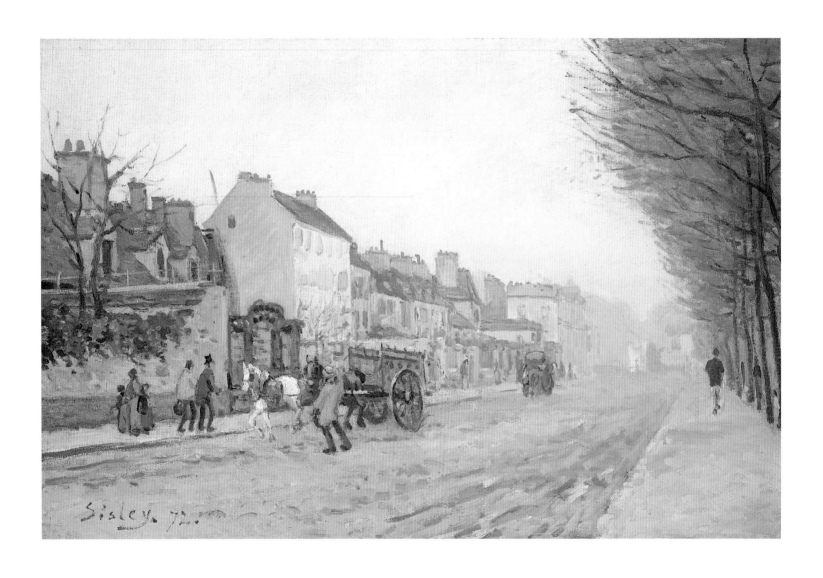

4

Alfred Sisley
The Boulevard Héloïse, Argenteuil
1872
oil on canvas
39.5 × 59.6 (15 ½ × 23 ½)
National Gallery of Art, Washington,
Ailsa Mellon Bruce Collection

When Sisley came to visit his friend Monet in 1872, he was attracted to the streets of Argenteuil as much as he was to its stretch of the river, a predilection that no other impressionist who joined Monet in his new suburban home demonstrated to the same degree. Only Caillebotte also focused on the town itself, and that occurred more than five years after Monet had left. The present view, depicting one of the main streets in Argenteuil, testifies to Sisley's refined feeling for the dampness of the day and the penetrating gray atmosphere. It also reveals his keen eye for the particularities of the site and the ways they could be configured to convey larger meanings.

Sisley painted the scene from a position on the sidewalk by a row of trees, part of the wooded area of town leading to the promenade and the river, which lay to the right. In the fiction of the picture he is like the pedestrian on the sidewalk in front of him, a man merely going about his business. The converging edges of the sidewalk establish a rapid recession in space, reinforced by the descending line of foliage. The towering trees make us feel small, while their uniformity contributes to the anonymity of the place.

The boulevard, more than twice the width of the sidewalk, increases these sensations as it rushes by, pulled by the diagonal lines of its curbs and the parallel strokes that define its surface. Sisley's position on the sidewalk therefore appears safer and more stable, something its more integrated, horizontal brush marks tend to reinforce. Yet the figures in the scene all walk away from us, adding to our sense of isolation, and although the horse-drawn carts head toward us, they are separated from one another and from us by considerable space. This is not a rural village where everyone knows each other and is engaged in everyone else's lives. Sisley has accurately gauged and presented the urban character of this street, with its breadth, coolness, and detachment.

The houses along the avenue contribute to this feeling of aloofness. While individualized in size and design, they have no one at the windows, no laundry hanging outside, no children at play. Mainstream artists would have added such details to humanize the view, but Sisley begins his picture on the left with a long, tall wall that dwarfs the figures in front of it and offers no entrance or break in its insistent lines and planes. Even the two leafless trees behind it seem forlorn.

Sisley's business was to look and record, a task he appears to have performed faithfully; the painting seems convincing and authentic, as if we are on the street with him witnessing its tempos and accents. The more we study the work, however,

the more Sisley's detachment becomes evident, stressing the fact that he was merely a visitor, with scant connection to the people or the place he was depicting. All the elements could be considered charming, but he relieves them of that burden, presenting them as ordinary and unpretentious. A large part of the meaning of the picture lies in this deflation, in the emptiness the artist found there, and in the resulting disjuncture. Sisley, like the other impressionists, wanted his painting to speak on a higher level about the complexities of the world. This canvas and one that Monet completed of the Boulevard Héloïse at the same time (cat. 5) are proof of the artists' ambitions for their art. Underscoring the contradictory feelings that both artists had for this town, they embody some of the fundamental contrasts that permeated modern life—security and alienation, confidence and vulnerability, connectedness and separation.

These two paintings represent one of the first instances in the decade when two leading avant-garde artists stood together to render the same scene simultaneously. The painters adopted different vantage points, with Monet in the middle of the street focusing the whole scene at the center of his canvas, while Sisley orients his view to the right. Sisley makes the contrast between the trees and the houses greater; Monet opts to break the line of trees, making the two sides of the boulevard less consistent. Sisley even omits altogether the lampposts that play a prominent role in Monet's composition. The artists emerged with two quite distinct paintings, though both tell essentially the same story. This attests to their independence while emphasizing their shared concerns. It was a combination that would serve all of the painters well who came to work in Argenteuil, just as it would the advancement of modern art in France.

View of the Boulevard Héloïse, early twentieth century

Claude Monet
The Boulevard Héloïse, Argenteuil
1872
oil on canvas
35 × 59 (13 ¾ × 23 ¼)
Yale University Art Gallery, Collection of
Mr. and Mrs. Paul Mellon, B.A. 1929

Monet set up his easel in the middle of the Boulevard Héloïse so that its hard-packed, earthen surface fills the foreground of his view. Stretching from one side of this modest-sized canvas to the other, the street has the look and feel of a city thoroughfare, not a country lane, an impression heightened by its orderliness. It is bordered by sidewalks—a rarity for the time—and it recedes sharply into the distance. The dark edges of curbs on either side act like railroad tracks or the orthogonals of a linear perspective system, converging just to the right of center. They achieve the compelling illusion of deep space, an effect enhanced by other diagonals—the roofs of the houses, the walls along the sidewalk, the row of trees, the ruts in the street—all of which lead to the same vanishing point. That point becomes the focus for the entire painting, as it is where the sky, street, houses, and trees begin or end.

This undisguised convergence of discrete parts makes the scene seem simple and direct. But the view is complicated by a number of enigmas, beginning with the emptiness in the foreground. The bottom third of the canvas contains no forms or incidents; no people or carts, no lighting effects or distractions relieve the lurking sense of isolation. Townspeople in the middle ground only increase the aura of alienation, as they do not acknowledge Monet's presence and they generally appear alone. Everything seems correct and proper, but nothing is intimately related. The regimented line of trees breaks abruptly for no apparent reason, shrinking from a sizable group in the foreground to a much smaller one in the background. On the opposite side of the boulevard two trees poke up from behind the first long wall, one short and squat, the other tall and thin. The first is more contained within its yard; the second leans out into the public realm beyond the wall. Each house varies in size, design, and location vis-à-vis the street, although all maintain a stately reserve.

The biggest contrast is between these houses and the trees on the right. The latter are a product of group decisions and town ordinances. Evenly spaced and rigorously aligned, they form a homogeneous unit that closes off the view softly but emphatically. The houses also conform to town codes, but they are highly individualistic. They sit on their lots differently, rise to staggered heights, and have variously aligned walls. Nonetheless, Monet maintains an evident aesthetic order: consider the Rothko-like rectangles on the walls along the sidewalk, or the way the nearest lamppost divides the space

between the two trees, bisects a window of the third and smallest house, then rises to the roofline of that house precisely where it joins the chimney of the next.

The ordering extends even to the positions of the figures. A man on the right stands between two tree trunks, another in the space between the two groups of trees. A woman on the left walks in front of a horizontal green rectangle, her child in front of a vertical gray one. Behind them a woman is silhouetted against a light beige panel that separates two darker shapes. The driver of the cart overlaps the edge of the house behind him. Similar coordination occurs throughout the picture.

Such care is typical of Monet during his years at Argenteuil, as he probes the place for its internal rhythms and metaphors. For instance, each side of the street has ironically assumed characteristics more associated with the other. One would expect nature to be the more unpredictable; trees in a forest setting would not grow as uniformly as they do here. Similarly, one might think the houses would be more regular. Instead the human structures have appropriated the diversity of nature, while nature has been forced to conform to the strictures of human society.

These inversions were typical of what was occurring in modern France as the powers of progress reshaped the nation. As a landscape painter and new member of suburbia, Monet was sensitive to the latent meaning of these changes, finding, like his impressionist colleagues, the outskirts of Paris to be a revealing microcosm of the new world order. Monet describes that emerging reality with poetry and specificity in this seemingly straightforward image of his newly adopted home. Although the muted light and muffled atmosphere make the scene appear spontaneous and unpremeditated, nothing could be further from the truth.

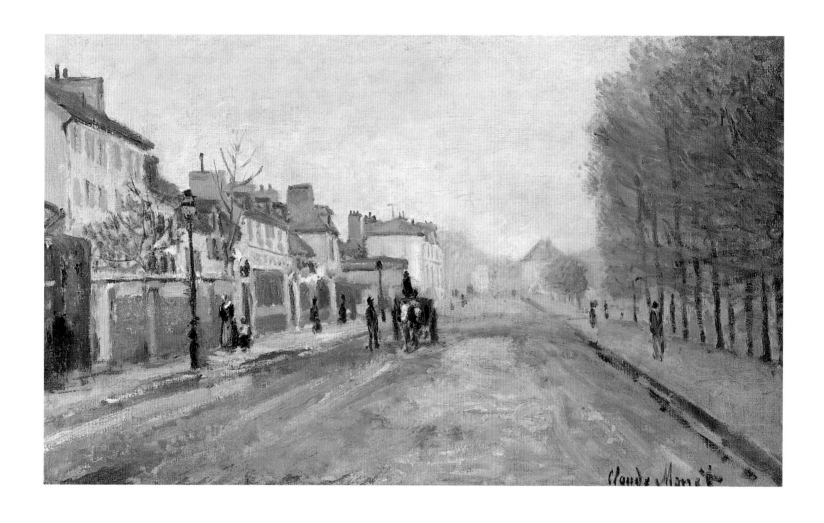

6

Alfred Sisley
La Grande Rue, Argenteuil
1872
oil on canvas
65.4 × 46.2 (25¾ × 18⅛)
Norfolk Museums Service (Norwich Castle Museum)

Sisley does not appear to have ever visited Argenteuil prior to coming to stay with Monet in the late winter or early spring of 1872, some six months after his friend had moved to this conveniently located suburb of Paris. How long he remained and how many pictures he painted during his stay is difficult to determine. But a canvas such as this is easy to identify as a product of his time there, as it represents one of Argenteuil's main streets.

The Grande Rue ran east-west through the center of town and was heavily trafficked because of its commercial activities. It terminated in a square in front of the local church, which is marked by the spire in the background of Sisley's picture. The buildings that lined the street were old and varied, standing at different heights and distances from the sidewalk. This is not a Haussmann-planned boulevard like those just built in Paris. Rich in incident, though relatively consistent in color value, this painting reflects Sisley's sympathetic engagement with the site and his interest in recording its textured, lived-in character.

Sisley painted this scene while standing in the street near the intersection of the Grande Rue and the Avenue de l'Hôtel Dieu, which enters on the left. Despite its modest presence, the Avenue de l'Hôtel Dieu plays an important role in the picture, as it expands what would otherwise be a confined foreground and widens what is still a relatively narrow march into space. The immediate area around Sisley is empty, which contributes to the effect of openness, but the thoroughfare fills up quickly as it moves toward the church. Large carts have stopped along both curbs, blocking significant parts of the view. Each rises nearly one story and takes up almost half the width of the passage; other vehicles would have trouble squeezing by. A number of men and women occupy the sidewalks, while nearly as many walk in the street. They all add to the appeal of the place, although there is little interaction among them, making what might be merely a quaint scene slightly aloof, as if Sisley sought to preserve the town's urban qualities as much as he wanted to indulge in its old-time allure. We are strangers here. Only the white horse on the right looks directly at us, but from some distance.

That coolness is communicated as well by Sisley's restrained palette. Dominated by closely coordinated browns, beiges, and grays, the painting projects the subdued tonalities of an overcast day where light filters through a blanket of thick clouds, allowing for little warmth and no bright spots. That democracy, or evenness, while perhaps truthful to the conditions Sisley chose to render, works well with the lack of pretension that he intended. Only the church steeple emerges as more important

than other elements, and even that appears to be the logical outgrowth of the buildings on the left: its base is locked into the last structure, its color is the same as most of the other buildings, and its vertical thrust is preceded by the chimneys silhouetted against the sky.

Monet also painted this busy street during his first year in town, suggesting that it was one of those urban spaces a landscape painter new to the area could not resist. Steeped with the enchantment of the past and yet thoroughly *au courant,* it was the kind of scene that had been depicted so often it had become a cliché. Sisley tried to raise his work above the commonplace by giving it a modern cast. Not only did he make objects in the picture seem plastic and immediate, not only did he focus on the lack of interaction among the figures, he also emphasized the physical evidence of his artistic decision making. The sharply defined curbs, cornices, and window treatments all stress the recessional pull of the picture. The simplification of the façades of most buildings, too, draws attention to their planar geometries and abstract qualities as opposed to their peeling paint or stucco, which might have interested a lesser artist.

Note as well how much Sisley relies on thick independent strokes of paint. The immediate foreground is depicted with a remarkable array of diagonal touches, some zigzagging and snakelike, others flat and heavy. The sidewalks are generally more broadly painted, the houses more broadly still, although the façades are enlivened by many smaller, abbreviated touches. The different surface treatments remind us of the artist's hand and mind at work. They also make us aware of the visual stimuli the site offered Sisley and how sensitive he was to their variety. By adapting a range of painted marks, Sisley makes the surface of the canvas much like the scene itself, highly idiosyncratic and unfixed, but genuine and palpable. His strategy extracts his painting from the clutches of the traditional and ensures its physical and metaphorical stance in the present.

Gustave Caillebotte
The Promenade at Argenteuil
1883
oil on canvas
65 × 82 (25 ⅝ × 32 ¼)
Private Collection

This painting is a vivid touchstone for impressionism's dedication to the proposition that light, atmosphere, and particular moments were worthy subjects for high art. It is also a rewarding reminder of the movement's uncompromising intelligence and novel achievements. It has the mark of an original, appearing truthful and unembellished in every respect. Anticipating the work of twentieth-century artists such as photographers Paul Strand and Walker Evans, it appears to be informed simultaneously by the accomplishments of Renaissance masters like Giovanni Bellini and seventeenth-century view painters such as Gerrit Berckheyde. Like all of the impressionists, Caillebotte had one eye cocked on the past and the other trained on the future.

The painting crosses centuries and media as easily as Caillebotte traversed the Seine from his house in Petit Gennevilliers to render this site, which he selected with keen appreciation for its nuances. It seems both unimportant and brimming with significance, a place that people would pass by without stopping and at the same time one that held special meaning. The beauty of this ambiguity is that the artist refuses to resolve it; we are obliged to explore the picture and decide for ourselves. Caillebotte makes sure that we can begin that process readily. He clears the foreground of any impediments and links the tree-studded area on the left with the street on the right by color, light, and texture. Only the segregation of the shadows and the darkened curve of the curb in the center indicate that the two are separate—another subtle touch. Caillebotte enhances the impression of openness by reducing

the number of elements elsewhere in the scene, while minimizing action or movement. Everything seems distilled, weighty, locked into position: the trees on the left have clearly been planted by municipal order, a wall beyond them closes off the scene with cool authority, and buildings assuredly fill the background on the right.

The buildings are wonderfully solid. Highly geometric, they seem immutable, either resisting or absorbing the intensity of the unfiltered noonday sun. So strong and consistent is the sunlight that it bleaches the colors of the façade and makes the hand-lettered advertisements—Chuffart Maconnerie, Buvette du Marché, Ecurie et Remis—almost appear to melt. If the owner is not asleep or away, the light has likewise caused him to close the shutters, their green slats making the yellow-baked walls of the house seem only hotter. No wonder the two men on the left sit on a bench under the shade of the trees and the woman in the foreground carries a parasol. The sun is blindingly bright and probably oppressive, which may also explain the relative emptiness of the site.

Normally the area would have been livelier. Caillebotte stands in an opening in the wooded promenade near the Seine looking northwest toward the Boulevard Héloïse, one of the most important streets in Argenteuil, which runs on a slight diagonal across the canvas. By limiting the number of houses and commercial buildings shown along the street, the artist reduces the urban character of the scene. This is the opposite of what Monet and Sisley did when they painted the same thoroughfare from farther west near the end of the promenade (cats. 4 and 5). They maximized the city feeling of the boulevard, using the straight lines of the curbs and long rows of houses and trees.

By taking a simpler and more circumscribed approach, Caillebotte makes his picture equally complex, especially in terms of details. The three trees on the left, for example, are different in age, height, and shape. The wall along the street varies markedly from one point to the next, alternating between solid and open sections, grillwork and pillars.

There is every reason to believe the scene existed just as Caillebotte has depicted it; the buildings still stand today and attest to his accuracy (see photograph at left). This implies that he was attracted to the site at least in part because of its straightforward but peculiar qualities. These are epitomized in this odd pair of buildings. The primary structure is turned to the side so that its entrance does not face the street. Then its addition is shoved right into the middle of its façade, blocking what would have been windows on the upper story and

View of the Boulevard Héloïse, 1999

the door and windows on the ground floor. The roof of the addition slices into that of the main structure, descending on an angle that ignores the original roof. The windows of the addition are of a different design from those of the first house, even sporting orange shutters, the complementary contrast to the green ones on the left.

Contrasts abound in the picture. The left side contains trees and figures, while the right is virtually empty. The left is activated by shadows, while the right is quiet and uninterrupted. The right also claims more sky than the left. Among other, more cunning distinctions, the figures are divided by gender and position, with the men sitting in the shade between two trees in front of a series of pillars, and the woman standing in the sun close to one tree, her back to us and her upper torso and parasol superimposed on the largest section of unbroken wall in the background. At the far right Caillebotte includes two fluttering flags, but he crops them so radically that we do not see the pole to which we presume they are attached. He makes the absence of that pole more acutely felt by planting a tall slanting pole in the middle of the scene. This pole likewise holds two flags, but while one flies energetically like the two on the right, the other hangs limply on the opposite side halfway up the staff.

Caillebotte finds ways to mitigate some of these contrasts. As the pole gently leans to the left, it overlaps the corner of an upper-story window so that the limp flag hangs just below the edge of the roof. The pole bisects that section of the roof before rising to the same height as the tree to its left. The tree's foliage repeats the triangular shape of the roof. On the right the orange shutters recall the clay liners of the chimneys of the main house, while the gray lintel above the newer windows extends to the left and meets the darker gray cornice of the original structure. The isolated woman is linked to the men by a shadow that runs along the edge of their bench to intersect her at the waist. Finally, the daring arc of the curb in the center echoes the curving shadow above it. The curb also begins at a point along the bottom that is on axis with the house above. And it ends on the right in line with where the gate begins. That gate ends where the shadow below it stops.

These minutely constructed relationships hold the painting together much as do the intense light and the omnipresent evidence of the artist's hand on the surface. All bear witness to Caillebotte's mastery of his craft and his impressive ability to suggest the multifarious aspects of modern life in a scene of deceiving simplicity.

Detail, cat. 7

Claude Monet
The Promenade at Argenteuil
c. 1872
oil on canvas
50.4 × 65.2 (19⅞ × 25⅝)
National Gallery of Art, Washington,
Ailsa Mellon Bruce Collection

When Monet began this serene, light-filled painting of the tree-lined promenade at Argenteuil—sometime in the late spring or early summer of 1872—he had been a resident of the town for less than a year. Having left Paris for the pleasures of the suburbs in the early winter of 1871, he had not painted many views of the place he would call home for most of the coming decade. He was only beginning to acquaint himself with its charms, as one senses in this meticulously ordered scene. It possesses the air of contented discovery and seems to be the product of a focused individual in tune with the world around him. It is in many ways a picture of perfection.

There is nothing extraneous in this painting, nothing that disrupts the flow of one area to the next, nothing that seems out of position. Even the light appears to be measured in just the right amounts. The composition too could not be set down with more rigor or sensitivity.

The sandy path along the Seine leads into the scene past a feathery bush on the left and a grassy bank that slopes down to the water. The outline of the path is irregular, with the left side bending out, then in, then out and in again, mirrored in its movements by the tufted grass to its right and by the natural curves of the shoreline. The right side of the path follows a straighter line, implying greater municipal attention, as does the formal row of trees. A turreted house in the background seems a storybook ending.

The trees stand tall and stately, beginning at the right edge of the canvas and stopping where the promenade meets a raised section of the bank. Although uniformly vertical and rather densely foliated, the trees are spaced sufficiently to allow several bands of light to sneak through the screen and stripe the path. Monet must have been dazzled by this horizontal/vertical configuration and the contrast of light and dark, for he indulged himself and used a rich impasto to make these strips of light the most eye-catching elements in the painting. They are rendered in extraordinarily lush yellows and pinks.

The bands of light modulate the recession of the path, but the borders of the promenade converge on the house and the smaller buildings to its right. For today's viewer, this might seem unusual, for the smaller structures are part of a business, a fact that is made undeniable by the industrial chimneys silhouetted against the sky. Mimicking the turret of the house and the trunks of the trees, the smokestacks remind us that this site was distinctly modern. It was a setting where labor and leisure, work and pleasure coexisted. Monet may have opted to depict the scene on a Sunday, the only day of the week when work ceased, for the chimneys are not puffing smoke. They fit almost ideally into the landscape, framing the house and rising alongside the turret spire to define a triangle that ends at the point of the peninsula on which they stand.

The placid, glasslike wedge of the Seine echoes the triangular promenade; together they complement the nearly square expanse of sky, allowing heaven and earth to be sublimely balanced. On the river two boats are under sail, both poised in front of the soft green stretch of trees on the Île Marante, which was encircled by the Petit Bras of the Seine. The boats and the calm sky reinforce the beauty of the moment Monet has captured and the glories of the area.

That Monet painted this site soon after he first arrived in Argenteuil makes considerable sense. It embodied everything one might want from suburban living. He included several figures among the trees to the right to reaffirm that point. And he returned nearly half a dozen times during that initial year and again in the last summer he spent in the town (see cat. 52). It clearly held special meaning for him, as is amply evident in this iconic canvas. It may have affected his dealer Paul Durand-Ruel in a similar way, as the painting was part of a group of works that this farsighted supporter of the impressionists purchased in 1872 barely after the pigments had dried.

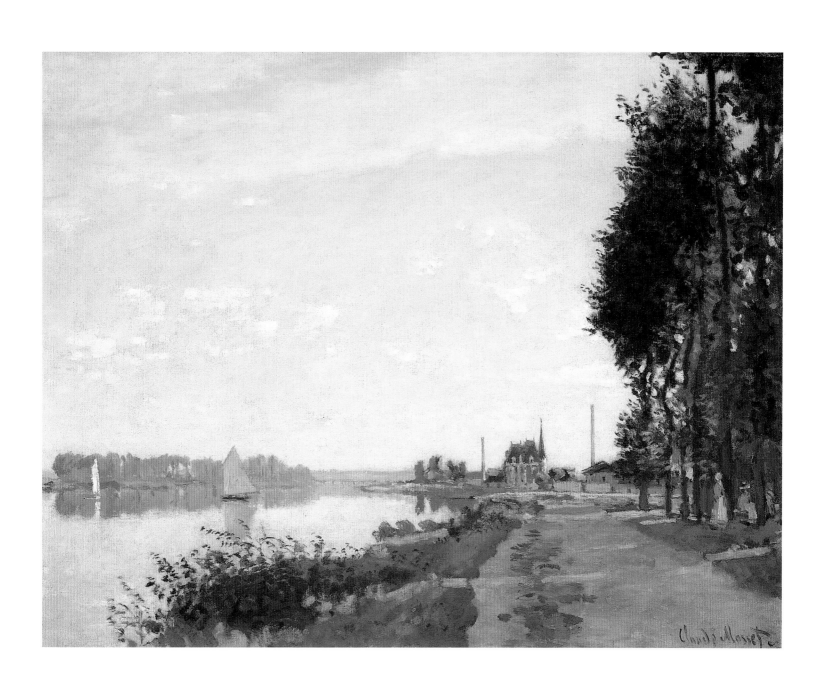

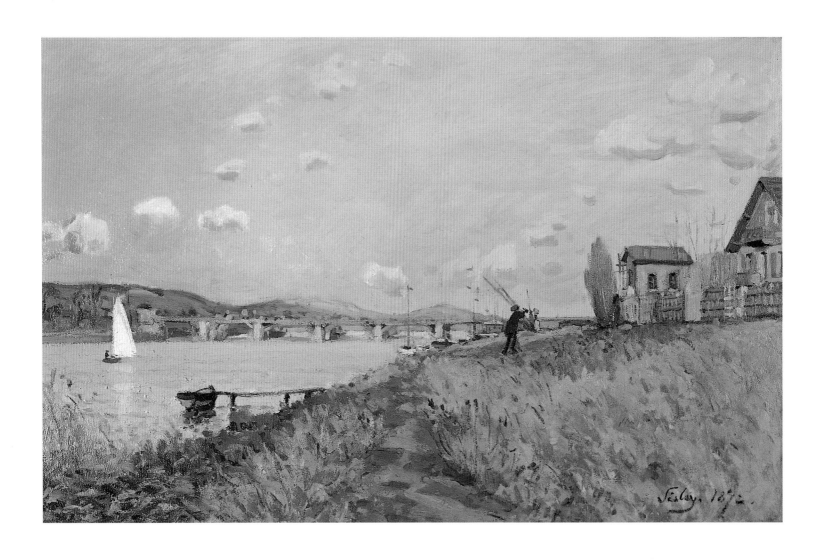

Alfred Sisley
The Bridge at Argenteuil
1872
oil on canvas
38.7 × 61 (15 ¼ × 24)
Memphis Brooks Museum of Art, Memphis, Tennessee,
Gift of Mr. and Mrs. Hugo N. Dixon

Understated and unassuming, this view down the Seine to the highway bridge at Argenteuil is an image of great delicacy. Both immediate and timeless, the painting invites us to relish the specific while celebrating the general. It suggests multiple possibilities—about life and looking—and strikes innumerable poetic notes, but it is thoroughly grounded and materialistic. It draws us into the scene yet reminds us of our isolation, just as it underscores the allure of nature and at the same time upholds the human presence in the landscape. It is a fine example of how the past can inform the present and how modernist art arose from a considered investigation of the craft of painting and a sympathetic immersion in this developing Parisian suburb.

Compositionally, the picture could not be simpler. It is almost evenly divided between earth and sky. The land is an integrated patchwork of triangular shapes rendered with a lively brush but a restrained palette. Sisley fills the foreground with the waving, unkempt grass of the riverbank at Petit Gennevilliers; Argenteuil is across the Seine to the left. He places a pathway in the middle of the scene, its undergrowth flattened by foot traffic, leading the viewer into the distance with the orderliness of a classic Renaissance perspective system. The path then bends to the right just before it meets a white-hulled sailboat that lies at anchor by the water's edge, encouraging us to continue down the river. We encounter other boats as well as the boat rental house, which is neatly locked into the conjuncture of the highway bridge, the river, and the bank. Superimposed on this intersection is a man walking up the bank toward two houses on the right carrying a set of oars. He appears on the *rabatment,* a vertical line that defines a square with the left side of the canvas, locating him and this nexus of forms in consummate harmony with the rest of the painting.

Such artful alliances occur throughout the work. The man's oars angle to the left to define a triangle with the bank and various masts by the boathouse; they then descend to the right, appearing to touch a man and woman who stand in front of a low-lying building. That structure, continuing the line of the bridge and the boathouse, meets a sizable poplar—the largest vertical element in the scene so far. Behind a wooden fence to the right rise two houses that are visually connected by a screen of background trees linking the rooflines and by a lighter-colored gate that overlaps the corner of the left house but serves the more substantial house at the right.

Note also how Sisley has the dock parallel the bridge and end near the bow of a rowboat that itself parallels the bank and points upriver like the path. If an imaginary line were drawn across the painting connecting the tops of the hills on the left with the fence on the right, it would touch the top of the mast of the white-hulled boat at the end of the path, which bisects the arch of the bridge behind it before just nudging the right side of the cloud above. This is sensitive picture making by an accomplished artist.

The sky also bears the mark of Sisley's artistry. It is so gently painted that it appears to have been breathed onto the canvas, setting the tone for the soft light that fills the landscape. But it is the clouds that make this sky a worthy descendant of Perugino's. Beginning on the left, an arabesque of cottony clouds just above the horizon rises, falls, then rises again in response to the rhythm of the hills and houses below. Four smaller clouds that soar above the third cloud on the left form an open parallelogram, a configuration of parts more often associated with stars in a constellation than celestial vapors. The hazy scrim of clouds in the center of the sky helps to pull the background forward and to make the almost impossible set of clouds more or less believable.

What is finally most distinctive about this picture is its play of light. While the whole scene enjoys the warmth of the sun, which is behind us to the right, Sisley does not indulge in a particularly dramatic use of its powers. Thus it is surprising to notice the strokes of orange yellow paint on the crests of the first two hills in the background and the same hue, though of greater intensity, on the middle spans of the bridge. Sisley is consistent in his distribution of highlights and shadows, engendering an authenticity that is evident in his brushwork as well, a tangible testimony to the intangible interaction of his hand and mind.

Carefully wrought yet completely forthright, classically imbued but loyal to the realities before him, this painting identifies Sisley as an artist determined to find a way to shape the elements of his era into a narrative of significance. Edouard Manet, one of the most forceful personalities of his time, appreciated these efforts. He purchased this painting directly from Sisley and kept it until his own death in the early 1880s.

Gustave Caillebotte
Laundry Drying
1892
oil on canvas
105.7 × 150.8 (41 ⅝ × 59 ⅜)
Wallraf-Richartz-Museum, Cologne

Standing on the Argenteuil side of the Seine and looking down the town's celebrated promenade and Champs de Mars, Caillebotte depicts a strictly aligned row of trees on the right and a broad stretch of river on the left. A line of laundry rises then falls as it moves through the scene to end in the distance. A bench on the grass in the middle parallels the dusty walkway along the Seine and the two green-shuttered washhouses that float at the water's edge. The landscape is uninhabited. There are no boats or people, indeed no birds or even clouds in the sky. It is middle to late morning; everyone is presumably at work, as is Caillebotte, who appears to relish his solitude as he paints.

On one level this painting is all about the light of this particular day and the ways that Caillebotte makes it manifest. It begins with color. He paints the two earthen paths with high-value beiges that stand out from the vivid lime green of the grass in between. He employs a creamy white pigment to define the façades and roofs of the laundry houses, which makes them appear so boldly illuminated that they become insistently planar. The sky is charged with an equally consistent glow, emanating from the amount of white that he has mixed with his blues, while the darker foliage of the trees is etched with a deeper shade of the same lime green as the grass below.

Caillebotte is particularly attentive to the framing power of the majestic chestnut trees and how they interact with the light. He radically crops the first tree on the left, leaving only a

sliver of its trunk and a few individual branches. The leaves on these branches catch the light and cast a dappled pattern on the trunk. The denser canopy of foliage on the right pulls the light into its recesses so that variations in color transform its sculpted forms, notably in a splash of the darker lime green just above the path. Light bathes the stolid trunks of these trees on the sides that face the river, descending to form pools at their feet.

The laundry provides Caillebotte with the ultimate vehicle for suggesting the mysterious presence of this light. Like a foil to the rigid planes of the washhouses and the land, the seemingly continuous band of drying shirts arcs like a streamer or a bleached snakeskin sail. The tops of the shirts and their fluttering arms receive the greatest amount of light, almost appearing to have been starched by the sun. This effect is increased by Caillebotte's decision to begin the clothesline in pale blue shadow on the left and to have it rise to its greatest height to the right of center where the last shirt is entirely illuminated. Curiously, the pure lead white of the shirts is maintained into the distance, just as their size drops immediately after the first tree on the right and stays the same to the end instead of becoming progressively smaller in accordance with perspectival realities. They remain independent touches of paint with no claim to description and no identity other than being unmixed color.

These white touches are in essence unfiltered light, but they are set in context and given their brilliance by the deep shadows throughout the scene, particularly in the canopy of foliage on the right. Similarly, the dark green and purple shadow that runs across the canvas in the immediate foreground provides a strong contrast to the sunlit paths and grass beyond; the shadows under the bench intensify the light that strikes the seat; and the façades of the laundry houses gain their prominence from the darker brown band of their hulls. The water and sky jointly benefit from the olive green of the trees on the Île Marante across the river.

Just as the light is measured by its opposite, so too is the charm of the place made plain by its emptiness. With no one present, we can freely explore—as Caillebotte does—its many delights. By including very few elements in the picture, Caillebotte invites us to concentrate on each one, endowing each with its own color and shape. The single tree on the left seems distinct from the other trees, though they are all one species; the two paths are also related but individualized, as

Gustave Caillebotte, *Le Pont de l'Europe,* 1876, oil on canvas, Musée d'Art Moderne du Petit Palais, Geneva

are the two laundry houses; the bench stands completely alone, with no duplicate. Even the shirts, although supposedly alike, are slightly different one from the next.

Caillebotte is just as calculating when he composes the painting. Although he divides the scene into what initially appear to be large simple sections—paths, grass, river, trees, and sky—he alters or interrupts each part. The nearest pathway, for example, is crossed by the horizontal shadow in the immediate foreground, then divided lengthwise by the staccato strokes that mark the laundry's shadows, which extend into the middle ground to meet the darker horizontal shadows of the chestnut trees. The latter inexplicably stop where the laundry ends, allowing the path to continue as a light-filled form. This path is not exactly triangular; it jogs to the left after the first tree. In like fashion the bench interrupts the continuity of the path by the shore, while the washhouses break up the shape and flow of the river.

It is not that Caillebotte was out to avoid purity and precision in this painting. On the contrary, one senses those concerns throughout, from the crisp edges of his forms to the almost mechanical quality of his brushwork in certain areas, especially in the grass. It is most apparent in the physical divisions of the canvas: the river begins on the left at the midpoint of that side; the path ends at the same point on the right. The midpoint on the right is also the vanishing point for the various orthogonals in the scene: the borders of the grass, the line of the bench, and the roof of the first laundry boat. Even the laundry itself seems to lead to that point, as if it were both mocking and supporting the highly regulated lines of Caillebotte's traditional perspective system. Caillebotte does not permit those waving shirts to float through the scene without similar control. The point at which they peak marks the *rabatment,* an imaginary vertical axis that forms a square with the left side of the picture.

These relationships and adjustments were highly conscious. Caillebotte worked them out in at least three studies that preceded the painting. Smaller, less rigorous, and seemingly done on site, they affirm Caillebotte's reliance on traditional methods of constructing finished pictures from trial essays. Together with the imposing size of this canvas, they also confirm that Caillebotte, now in his early forties, wanted to produce an ambitious painting along the lines of some of his masterworks of the 1870s when he was in his twenties. He must have had *Le Pont de l'Europe* of 1876 especially in mind (see illustration on p. 64), as it shares a variety of compositional devices with this work and offers a close relationship of height to width, although it is slightly larger in both dimensions. *Laundry Drying* could have been its suburban pendant.

Judging from its many incomplete passages, however, and the lack of a signature, we know that this impressive picture was not finished, which may explain why it was never exhibited or sold during Caillebotte's lifetime. Despite this fact, the painting amply reveals the artist's ingenuity in isolating one of the central tenets of impressionism—light—and raising it to a startlingly new level of vivacity and meaning: this painting is not just about the power of the sun; it is about the ways the sun illuminates a more complicated world.

This site is a place of work as well as pleasure. We do not see the laundry house employees at their tasks, but the results are obvious. Comparison with *Le Pont de l'Europe* makes it clear that the strong perspective lines and sense of anonymity so often associated with Paris are equally operative here, giving the picture an urban quality that its natural setting would otherwise belie. The notion that laundry could be beautiful and merit elevation into the realm of high art poses another contradiction, one that other impressionists—Degas, Morisot, and Pissarro—had embraced in previous years by depicting it on various occasions. People did not come to Argenteuil to see laundry hanging along one of its most picturesque pathways, but it was there.

Caillebotte celebrates these contradictions, as he does the light. They defined modern life—and a thriving suburb like Argenteuil—just as they were essential to modern art. It is their energy that makes contemporaneity so vital and that offers painters like Caillebotte and his impressionist friends the opportunity to reconsider the fundamentals of their craft. It is in pictures such as this that Caillebotte asserted their heartfelt intention to make art from life, and to allow the moment to be eternal.

Detail, cat. 10

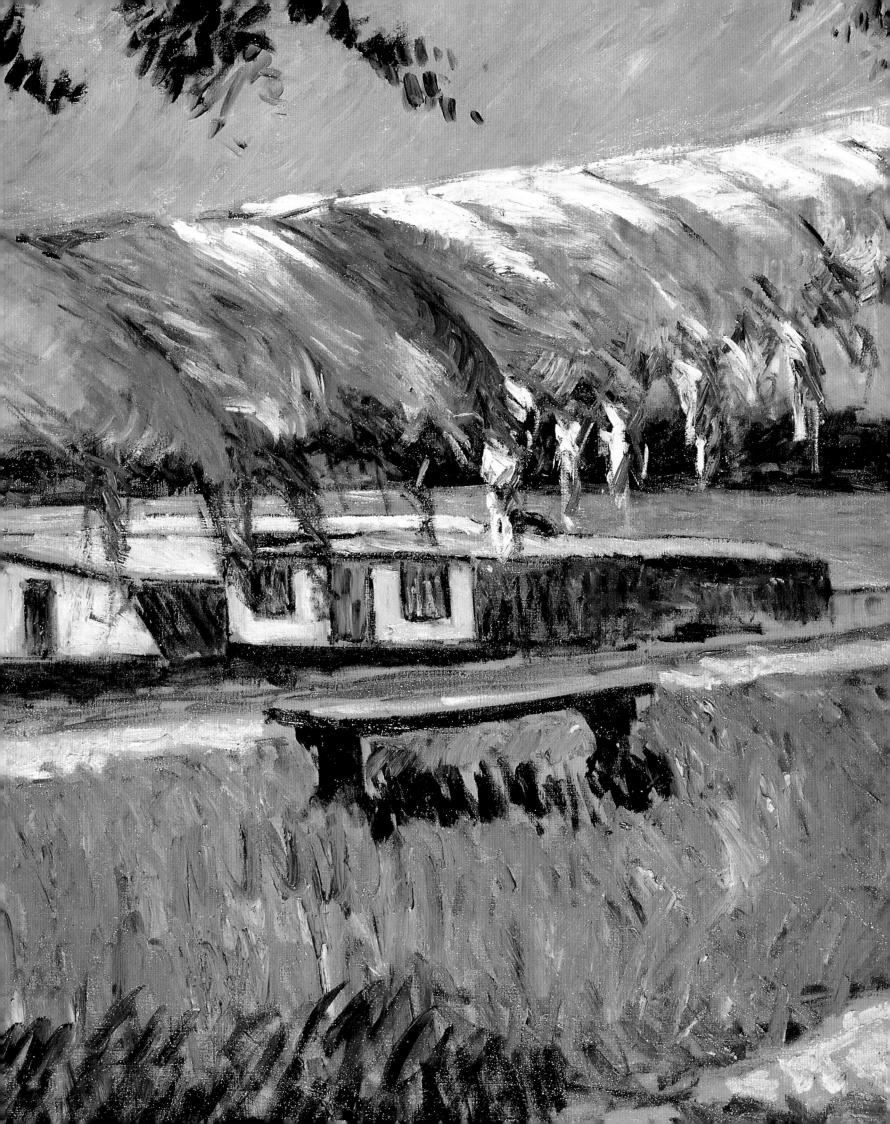

11

Claude Monet
The Boat Basin at Argenteuil
1872
oil on canvas
60 × 80.5 (23 ⅝ × 31 ⅝)
Musée d'Orsay, Paris, legs du comte Isaac de Camondo, 1911

From his position on the main promenade at Argenteuil under a brilliantly lit, cloud-filled sky, Monet presents all the delights of the modern suburban landscape. Men, women, and children stroll up and down the sun-striped path beside an elegant row of chestnut trees, while others lounge on the grass; sailboats skim across the blue and white waters of the Seine, skirting steamboats that spout streams of smoke; ladies with parasols negotiate a gangplank to the bathhouse at the right, while a sailor waves from a rowboat by the shore. Everything is glorious, charming, and desirable.

Each element in the painting is painstakingly arranged and scrupulously rendered, underscoring Monet's powers as an artist and the humanly imposed rationale of the place. The path leads logically into the scene, its clearly defined, irregular borders complementing the carefully spaced light and shadow that Monet distributes along its inviting expanse. So guileless is the path's recession into space, it could have been formulated by a Renaissance artist discovering the powers of perspective. The grassy bank and boat basin serve as counterbalancing shapes. Together with the path, they create a pattern of interlocking parts, above which hangs a broad sky.

Nowhere is Monet's compositional acumen more apparent than in the way he links the left and right sides of the scene, employing the horizontal shadows across the path and bank, the line of the bridge in the background, and the sublime sweep of the trees. The trees recede to a point that joins the end of the curving shoreline, thus forming a continuous arc on the picture plane that extends from the upper left to the lower right. Monet reinforces the latter connection by making the foliage on the trees cover approximately as much area as the grassy bank and by echoing the curve in the clouds.

Monet's enthusiasm for Argenteuil is not only expressed in the rich collection of pleasurable pastimes he depicts in this seductive painting, it is also implied in the dazzling light that enlivens the scene, in the heightened palette, and notably in the densely textured surface of the work. The path and bank are defined with overlapping horizontal strokes of dry, matte pigment. The foliage on the trees is suggested with dabs of paint that have no consistent orientation, appropriate for the fluttering leaves they describe. The clouds are the most broadly rendered, with large arcing strokes that contribute to the strong sculptural presence of these evanescent forms. More striking yet is the top left region of the sky. Initially it appears to contain distant, thinner clouds that drift high above the cumulus ones. But it is merely the primed canvas and a few beige, white, and spare blue strokes. This unpainted section continues along the top edge in a narrow band all the way to the right corner, where Monet abandons even the dragged blue pigment.

Such sketchiness is in keeping with our inherited sense of impressionism as a fresh, direct, spontaneous style, but it is inconsistent with the rest of the painting. Monet's decision to contrast one procedure with another in the same work was highly conscious. Not only does the less finished area add depth and diversity to the sky, but it draws attention to the intensity of everything else in the scene. More important, it underscores the fact that, despite the impression of a captured moment, the painting is an artful construct that requires us to suspend our disbelief and submit to the cunning of the artist.

In 1872 when Monet painted this picture, he believed in the illusion of its discrete parts creating a kind of perfect whole, repeatedly proclaiming its validity in other equally measured images. Although conscious of its conceits, just as he was of his own artistic inventions, Monet had come to Argenteuil to settle down, raise a family, and enjoy the benefits of his developing talents. This painting is his testimonial to the potential of the present and to the novel vision he had for French art. It is grand and generous, open and celebratory, exemplifying Emile Zola's description of Monet's affection for "nature that man made modern."

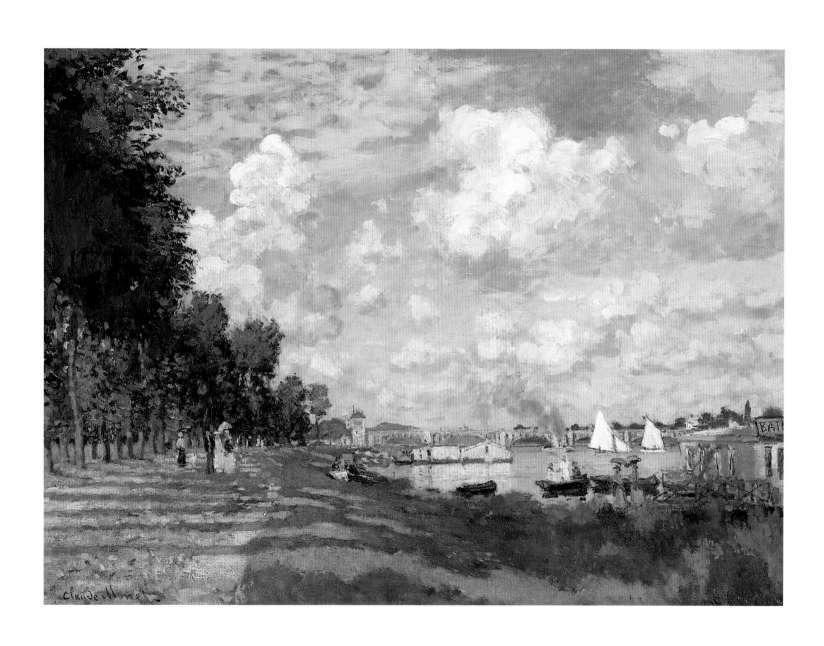

Gustave Caillebotte
Boats on the Seine at Argenteuil
1890
oil on canvas
60 × 73 (23⅝ × 28¾)
Private Collection, U.S.A.

They sit quietly but restlessly at anchor, these pleasure craft—restrained but poised for action. Sailboats dominate the lot; four fill the foreground, varying in size and design. Their colorful reflections ride the ripples of the calm but flowing waters of the Seine to the bottom of the view, while their masts soar upward and out of the picture at the top. The bowsprits of two of the boats stretch beyond the right edge of the scene, linking the four craft as a group to three of the four boundaries of the canvas.

Behind these interlocked vessels sits a packet boat, distinguished by its stubby but substantial smokestack, which offers a contrast—in shape, form, and color—to the long, slender masts of its wind-dependent mates. It is visually held in place by the outstretched boom and erect mast of the sailboat on the left. Behind the packet boat are two other sailboats whose masts flank its cream-colored stack. A tighter fleet edges its way into the picture at the far left, its masts silhouetted against the sky like those of its foreground counterparts, establishing a syncopated rhythm that activates the view.

Caillebotte was an avid boater, so it is not surprising that, even after seven years of living and working in Petit Gennevilliers and Argenteuil, pleasure boats such as these would be the focus of his picture. Similar craft are featured in no fewer than thirty-five of the paintings he completed between 1882, when he first moved to the area, and 1894, when he died in the house he built on the shores of the Seine, a two-minute walk from the vantage he assumed to paint this stunning canvas.

As can be sensed from this lively image, human activity on the water was a subject close to Caillebotte's heart. Every element in the scene appears immediate and physical, whether it is the boats and their reflections, or the water and its movements. Even the light seems tangible. These effects are aided by the moment Caillebotte has chosen to render; it is nearly noon, and the sun is so strong and the air so clear that the light bakes all of the forms, heightening their plasticity. The sides of the masts turn buttery yellow; the façade of the house on the right becomes stark white, just like the building to the left of center; the turreted structure farther to the left is almost sculpted by the rays of the sun. The furled sails of two of the foreground boats are also conspicuous in their brilliance, while the deck of the one in the center glows with intensity.

Caillebotte's engagement with his subject is apparent from his sensitive alignment of certain details. The sailboat on the left, while cradling the packet boat, seems to stabilize this vessel with the angled form that supports its own boom and that ends where the hull of the packet boat disappears behind the furled sail. The mast of the same boat coincides with a corner of the turreted house in the background. The bowsprit of this boat arcs out and appears to nudge the stern of the boat to the right.

Caillebotte repeats this subtle linkage elsewhere. The bowsprit of the black-hulled sailboat in the middle ground, for example, seems to touch the mast of the larger boat in front of it, which in turn contacts the stern of the orange boat behind it. The masts of these three right-hand boats are almost evenly spaced, as evident in the rectangles of sky that they carve out and in their reflections in the water; moreover, the one on the left overlaps the white structure in the background by as much as the one on the right misses the last house in the scene.

To underscore these relationships, Caillebotte has the mast and bowsprit of the largest boat in the middle cast a triangular reflection like that created by its companion to the left, although larger, like the boat itself. The hypotenuse of this reflection is bisected by the reflected mast of the orange boat, which also cuts through the barrel-shaped buoy. The bowsprit of the middle boat returns the compliment, piercing the reflection of the orange boat's hull. Finally, the mast of the orange boat falls on the *rabatment,* forming a square with the left side of the canvas; and the bowsprit of that craft exits the painting at precisely the midpoint of the right side.

An almost mesmerizing web of stays among the foreground boats draws attention to Caillebotte's draftsmanship and the apparent accuracy of his rendering. But it also introduces some enigmas. Note the vertical line to the right of the orange boat's mast, which descends from an unseen source. In fact it is attached to a crossbar near the top of the mast, which is cut off by the top of the picture (a similar arm is visible on one of the boats at the far left). The stay on the orange boat runs not only parallel to the mast but directly along the corner of the background house, an alliance that may seem fortuitous but was clearly planned. Like the scene as a whole, it testifies to Caillebotte's sagacious eye and his desire—like Monet's before him on this very site—to stitch together the disparate elements of modern suburbia to create an ideal place, one that could still satisfy the urges of an increasingly demanding public.

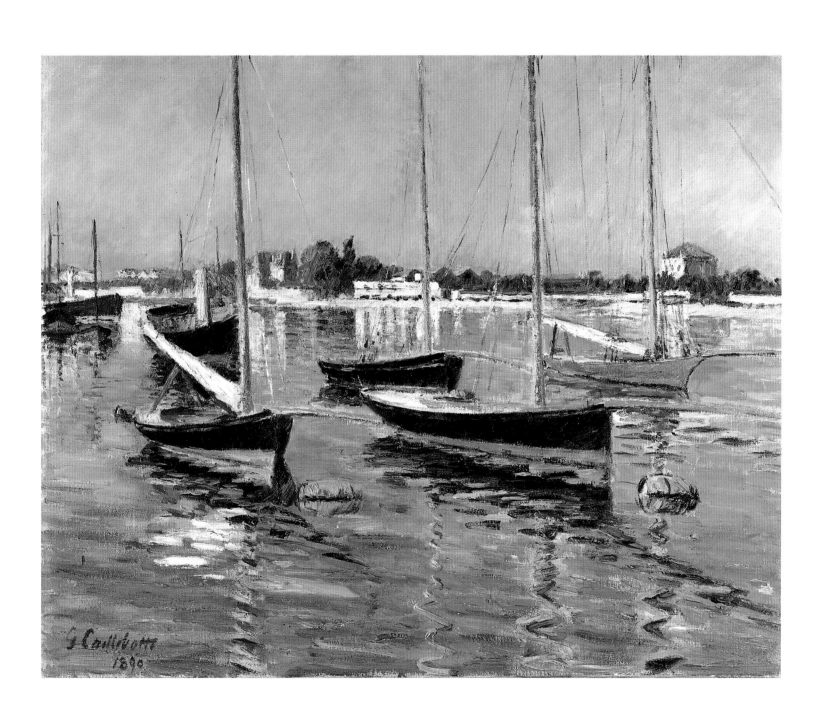

13

Alfred Sisley
Banks of the Seine at Argenteuil
1872
oil on canvas
38 × 56 (15 × 22)
Private Collection

Deceptively simple, this fastidious painting conveys the artist's innocence as a first-time visitor to this appealing site as well as his sophisticated understanding of compositional strategies. Combined with the exquisite color harmonies and the soothing arrangement of forms, these qualities attest to the ways that Argenteuil could both inspire and instruct. They also explain how Sisley transforms a place of ordinary charms into a celebration of the benign and the beautiful.

Light falls evenly and consistently throughout the scene, warming the façades of the buildings on the right, filling the sail of the boat on the river, and molding the clouds that hang so weightily just above the horizon. The blues of the sky beyond these clouds seem to exude a kind of internal glow, as does the edge of the left bank where the light catches the ragged underbrush and silhouettes it against the cool blues of the water.

But it is the composition that is particularly satisfying here. Like his seventeenth-century Dutch counterparts, Sisley lowers the horizon, which makes the land seem to recede deep into the distance and the sky to become enormously expansive. Despite its spaciousness, however, the landscape appears intimate. Despite its diversity of forms, the whole seems justified, complete, and authentic.

In large measure these effects derive from Sisley's vantage point and his decision to spread the bank generously across the foreground. We are able to enter the picture on an even keel because he makes the land appear relatively flat and parallel to the horizon. He also places the pathway virtually in the center of the scene, another traditional device of his Dutch forebears. The path draws us quickly into the space, its bending, wedge-like shape adjoining an analogous area of grass. Suddenly, it is clear that the land is not level, that instead it slopes gently but decidedly down to the river, following the arc that Sisley establishes from the horizon on the left to the lower right corner.

At the center of that arc a man is standing next to a woman who is seated in the grass. As one of the few vertical elements in the picture, the figure of the man echoes the poplars on the left and the boat on the right, suggesting a harmony of the human and the natural. He is located so that his head rises midway between two distant shores of the river. This propitious balance is evident elsewhere—the red-roofed houses on the left emerging from the land, or the clouds above the sailboat dipping at the mast and then rising again over the structure on the right, their lyrical movement following the profile of the poplars whose tops rise and fall with a similar cadence.

Those poplars and the red-roofed houses stand by the Petit Bras of the Seine. The hills in the distance therefore are those of Saint-Germain, where the river bends to the right to form its third loop on its way north from Paris to the English Channel. If Sisley turned around in this painting, he would have been looking back toward the highway bridge and the boat basin, the focus of his equally distilled view of Argenteuil from this same visit with Monet (cat. 9). These two paintings are thus pendants in many ways, a relationship one senses not only in their shared location but in their kindred compositional tactics, handling, and effects. In each Sisley includes a single sailboat navigating the Seine, a spareness not found in most impressionist paintings of the site. But most other depictions also capture a more boisterous mood, which suggests that restraint and tranquility may have been particular characteristics of the Paris-born Sisley. Argenteuil clearly encouraged a wide latitude. As a breeding ground for individuality and novel thinking about art, it could not have been a more fertile environment, and Sisley responded warmly with these images of hushed sublimity.

14

Claude Monet
The Seine at Petit Gennevilliers
1872
oil on canvas
47.9 × 63.5 (18⅞ × 25)
The John M. and Sally B. Thornton Trust

To most people of Monet's day who lived in Paris and the suburbs, Argenteuil was a site for weekend leisure, for strolls along the town's winding streets and riverbank or boat rides up and down its unparalleled stretch of the Seine. They could go on excursions to the outlying fields, which produced various crops, including grapes that were used to make an extremely modest wine, *le vin d'Argenteuil.* Asparagus grew there as well. It was hailed as the best in the region and was one of Argenteuil's most celebrated exports.

Few people would have taken the train from the Gare Saint-Lazare to Argenteuil (or walked to the town, as some hearty souls were wont to do) to see a place such as that depicted in this unusual painting. Sweetly scented air and vacation enjoyments seem far from its primary offerings. While boats bob on the water at the river's edge, they appear displaced or nonfunctional, their intended use as pleasure craft significantly compromised by other forces.

This impression is partly generated by the absence of humans in the scene. It is also the result of the slightly gloomy, overcast sky, which is rendered in long, loaded strokes of blue and gray that rush on diagonals out of the picture. And it is advanced by the steamboat in the background, which spews out a spiraling trail of coal blue smoke. A deeper shade of the ominous clouds above, the smoke twists toward the foreground as if to proclaim the takeover of the river by newer, mechanized craft with associations to industry and labor. This fact is asserted once again by a second cloud of smoke that emerges from behind the tip of the peninsula and just breaks the horizon. The waves of light and dark in the Seine, which are described, like the sky, in broad swaths of opaque pigment, also contribute to the sense of unease. They seem to roll anonymously by us, suggesting a kind of passing.

Yet the scruffy bank is what ultimately confirms the implication that other, nonpicturesque forces are at work. It appears to possess nothing that would interest the contemporary pleasure seeker; there are no trees, grassy areas, or places to sit. There is not even a path to entice a visitor to walk somewhere else. In addition, it is described with a mixture of drab colors—browns, grays, and olive greens—all laid down with a heaviness that denies the joy Monet found in other areas of Argenteuil. Extending into the scene as a narrow but ponderous triangle, the bank looks like the tail of a large water beast, floating motionlessly on the river, dividing earth and sky.

That Monet chose a nondescript, nontraditional site for this painting reinforces his willingness to take risks, as it was novel and daring to immortalize such a place. The work also bears ample evidence of his intelligence. He organizes the elements on the bank, for example, with a care that their apparent disorder disguises. Consider the humble structure that sits on the left. It lies so low to the ground and its walls and roof look so flimsy that it seems to be near collapse. But the angle of the roof parallels the streaking clouds above, as underscored by the timbers that hold down its tin or cloth covering. Its apex is also securely located in the middle of the tall, rust-colored structure behind it, while its right side ends just where the façade of that house and a boat on the bank begin.

In front of the shack lie various scraps of wood, their vagrant lines mimicking the light patterns on the river. Behind it hovers a more open extension, while above it protrudes a triad of long poles silhouetted against the sky. The poles mark the conjuncture of the shed and the red house, whose taut lines and erect stance make the shed appear more ruinous while at the same time lending it support.

Just to the right of the house rise the masts of other boats, presumably afloat on the other side of the point. Monet carefully aligns them with the edge of the house. He also has the mast of the boat on the water in front of the shed divide a second, smaller background house in half, falling precisely between its two purple chimneys. This mast cuts the whole scene into two parts with its continued reflection in the water. Monet repeats the vertical thrust of this mast in the distant poplar to the right and again in the mast of the boat at the end of the bank, whose triangle of stays is itself echoed in the boat at the far right of the canvas.

In the disarray of the site Monet has clearly found rationale, in the motley, something beautiful. The combination of opposites is particularly appropriate in this painting, which shows a boatbuilder's shop near the end of the boat basin at Argenteuil (the house in the middle ground belonged to the builder, the poplars in the background identified the start of the Petit Bras of the Seine). The boatbuilder's labors are manifest in the boats moored along the shore as well as others pulled up on the bank, all of the latter without their masts. His workplace, depicted in roughly handled paint and less-than-alluring colors, is where new pleasure boats were repaired or produced, such as those that populate so many of the impressionist paintings

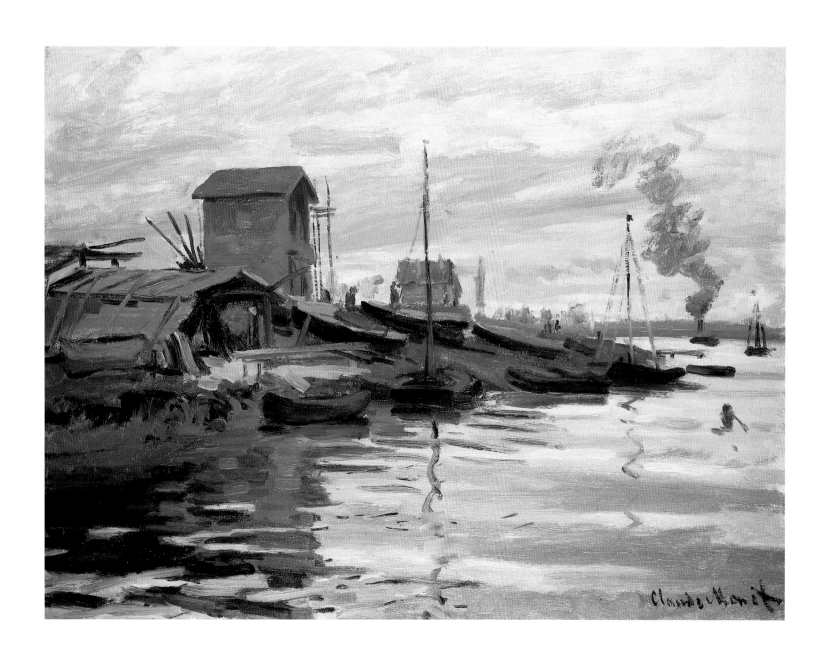

of Argenteuil, a transformative process not unlike Monet's own task of taking dissimilar elements and shaping them into a desirable and orderly whole.

Like his impressionist colleagues, Monet constantly invites us to experience that process, as he openly declares his painterly means, simplifies his compositions, and extracts harmonies where they may not appear to exist. But in a painting such as this, he reveals those aims with an uncharacteristic forthrightness, which is as welcome as it is reaffirming.

Detail, cat. 14

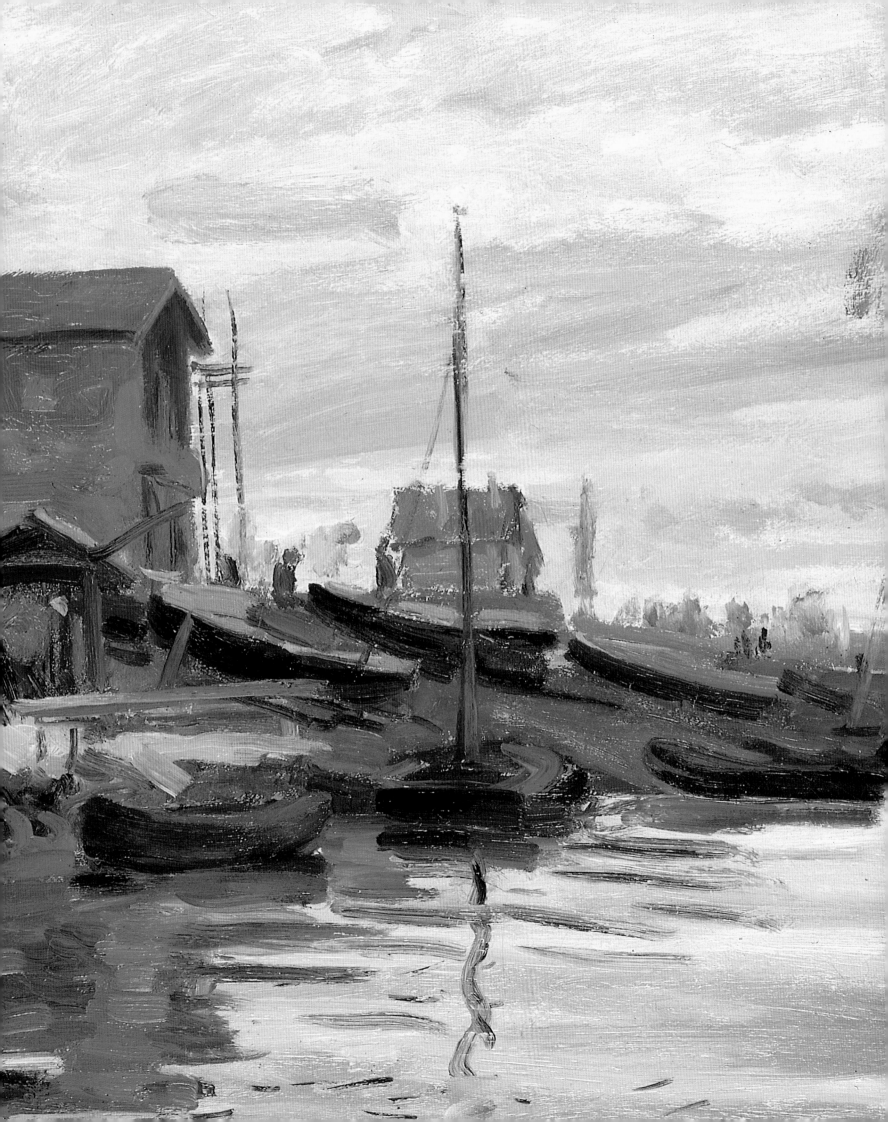

Auguste Renoir
Portrait of Monet
c. 1873
oil on canvas
65 × 50 (25⅝ × 19⅝)
National Gallery of Art, Washington,
Collection of Mr. and Mrs. Paul Mellon

He sits at a desk or table reading a book, his head and upper body bent forward over his text. Nothing disturbs his concentration. Nor does anything distinguish him as the heralded impressionist painter who, with his adventurous colleagues, was in the process of radically altering the course of French art. The thirty-one-year-old artist merely puffs on his pipe, seemingly absorbed in a book.

The simplicity of the image is deceiving, however, as the portrait reveals much about an individual whom all of the impressionists admired. It is as prescient as it is legible, as much a metaphor for Monet the avant-garde artist as a likeness sensitively rendered by the former porcelain painter he had called a friend for nearly a decade.

Renoir has marshaled the various elements in his painting, completed sometime during Monet's inaugural year at Argenteuil, to considerable effect. First, he locates his transplanted Parisian confrere in the middle of the view, parallel to the picture plane, allowing him to fill more than three-quarters of the area. With little else in the scene, Monet is the unmitigated focus of attention. He is also substantial. He rises like a pyramid from the narrow rectangle of the table, his arms almost touching the sides of the canvas and his head reaching nearly to the top. There is no teetering, no lack of conviction. Monet is clearly someone to be reckoned with.

His formidable character is conveyed by his sheer bulk and by his simplified silhouette, which greatly increase the power of his presence. Renoir uses both the blocky outline of Monet's heavy black jacket and the lighter, bluish background to set off his figure and make him appear more sculptural. He also contrasts his handling of paint, rendering the jacket with big, bold strokes and the background with shorter touches of a less-loaded brush. The amount of paint on Monet's jacket grounds him and contributes to our sense of his engagement with his text, whereas the thinner, more ethereal background suggests the expansiveness of his thoughts.

It is difficult to determine how spacious that background is. No chair, floorboards, or architectural elements calibrate the recession. A shadow on the right implies that there is not much room between Monet and what one assumes is a wall behind him. But the shadow itself is mysterious. Given its sharp angle, it does not seem obviously related to Monet. Yet nothing else in the picture could have cast it. Cézanne would have appreciated this lack of resolution.

Equally obscure is the form on the table to the left. Is it a scarf or the end of a tablecloth that has been pushed aside? Is it the shadow of some object outside the picture? The latter seems unlikely because of the color Renoir has laid over the dark shape. There is something vaguely humorous about the image, as it recalls a shadow-puppet animal with a large snout and open mouth or a medieval gargoyle.

Regardless of what it may be, the cryptic form is related to the shadow on the wall. Both are enigmatic, one entering the scene from the lower left, the other exiting toward the upper right. They thus create a diagonal across the surface of the canvas. A more subtle connection between them begins where the left form touches Monet's bent arm. This is precisely where the lighter edge of his cuff meets the table. That edge arcs up to join the similarly colored lapel of his jacket, which itself meets the curve of his beard. The line of his beard continues along the curl of smoke coming from Monet's pipe, which leads to the highlights on his left shoulder, which themselves angle upward to meet the shadow emerging from behind his back. Why these shadowy forms are linked is as curious as their presence in the picture, but Renoir was too purposeful for them to be there by accident.

Among other ambiguities is the position of Monet's left hand. It could be under his right forearm or under the book, but it could also be resting on the table or tucked into his chest. And what about the book? The raised page appears smaller than the others, just as the right half of the book seems to be out of proportion to the left. The rough edges of the pages identify it as a popular publication, which accords with the simple wooden table, the unadorned background, and the spare, compressed setting. It also suits Monet's informality, his unkempt hair and beard, even his clay pipe, a type favored by artisans, sailors, and workers, not the middle or upper classes. It was in relation to such popular culture that Monet defined himself.

The book, which emanates light, has captivated Monet. That he ponders its words and implications is indicated by his furrowed brow, focused gaze, and the tilt of his head. He seems to be looking and thinking at the same time—as he does when he is painting, a process we generally do not see, and a discipline not often associated with impressionism. In the 1870s critics thought that the impressionists were only concerned with the superficial and the spontaneous and that their art was a

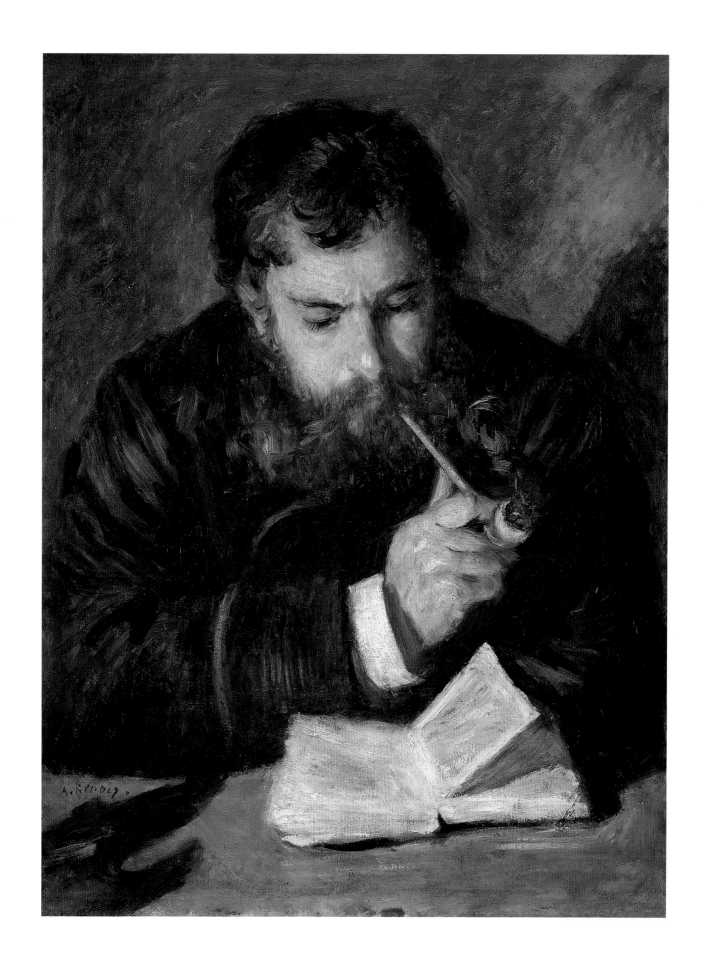

Auguste Renoir
Portrait of Camille Reading
c. 1873
oil on canvas
61.2 × 50.3 (24 ⅛ × 19 ¾)
Sterling and Francine Clark Art Institute,
Williamstown, Massachusetts

mindless reaction to the exterior world. The seriousness of the exploratory-evaluative process Renoir depicts here is ultimately that which produces culture, with all its stops, starts, and unknowns. Renoir emphasizes that questioning in the dramatic play of dark and light throughout the picture, particularly on Monet's face and jacket.

We move back and forth between these highly calculated moments in the painting, just as the impressionists vacillated between acceptance and denial, partisanship and independence. Renoir suggests this activity in the pipe and smoke: on the right the smoke curls out of the bowl of the pipe in idiosyncratic forms; on the left, from the corner of Monet's mouth and the dividing line of the pipe's slender stem, the exhaled smoke comes out in a completely different mode, having been reformulated by the artist as he sits and thinks.

This brings us back to the two shadows and the meaning of this painting of a painter immortalized without a single tool or product of his profession in evidence. The first shadow, a protosurrealist form, may be a metaphor for the artist's imagination, an announcement of his persona or imminent arrival. In the nineteenth century such flights of fancy had to be put to the test. Forms or experiences had to be studied, analyzed, and adapted to some rationale, like a dream or a vision that an artist, or writer, wanted to express. That process occurs here in the middle of the canvas, involving the book, the pipe, and Monet's intensity. Out of the book come ideas, just as the pipe emits its genielike smoke. In the end, they are absorbed and translated into other forms—in the case of the shadow on the right, ones with strong geometric biases, much like the book itself.

Given Monet's tendency in the early 1870s to reformulate the world into a series of harmoniously related forms, Renoir was perhaps being remarkably perceptive. But such harmonies are inexplicable, as an artist is never sure where an idea may lead or how the world will be reshaped into art. Renoir suggests that Monet was not only aware of that dilemma but fully willing to engage its complexities. In this insightful portrait Renoir could not have paid his friend a more fitting tribute.

From some of the earliest writings on impressionism comes the often-repeated assertion that the artists who made up this avant-garde group were penniless. We are reminded time and again that this was because they were rejected by critics and the art establishment, which forced them to survive more on their personal devotion to their art and the companionship of their fellow painters than on the contemporary art-buying public.

Various facts support these claims. The radical new painting that the impressionists developed in the 1860s and 1870s did not receive immediate, broad-based approval; clients did not flock to their studios to purchase their canvases; and newspapers did not devote space to their ideas. Money therefore was often in short supply. Some artists, like Renoir, took advantage of parental largess, living or eating at home. Others, like Monet, moved in with more successful or privileged friends, such as Frédéric Bazille. There was plenty of credit ducking, borrowing, and fretting, Monet being the most vocal and most resourceful about these concerns, especially during his years at Argenteuil.

What, then, are we to make of this ravishingly beautiful painting of Monet's wife, Camille, and its revelry in luxurious materialism? Nothing would seem further from the inherited histories of the movement. Poverty is unthinkable; worries absurd. Charles Baudelaire's poetic evocation of *luxe, calme, et volupté* is realized here with unabashed abundance.

Camille reclines on a sumptuous divan that is covered with a richly decorated material. So ornate and tactile is the fabric that it almost appears to have been embroidered. With its two huge pillows and generous expanse, the divan occupies the largest amount of the space in the painting. It looks soft and inviting, just the place to lounge and read a book, as Camille is doing.

With her feet crossed and dress neatly spread out, Camille leans back against a pillow that has been raised higher against the wall to accommodate her pose. She seems fully at ease and completely a part of the setting. The fabric of her dress is as elaborate as that of the divan and equally floral, while the blues of her sleeves and skirt are taken from the color of the background. Renoir heightens the impression of her immersion in the space by aligning the left side of her gown with the end of the pillow on the floor and her decorative hem with the top of

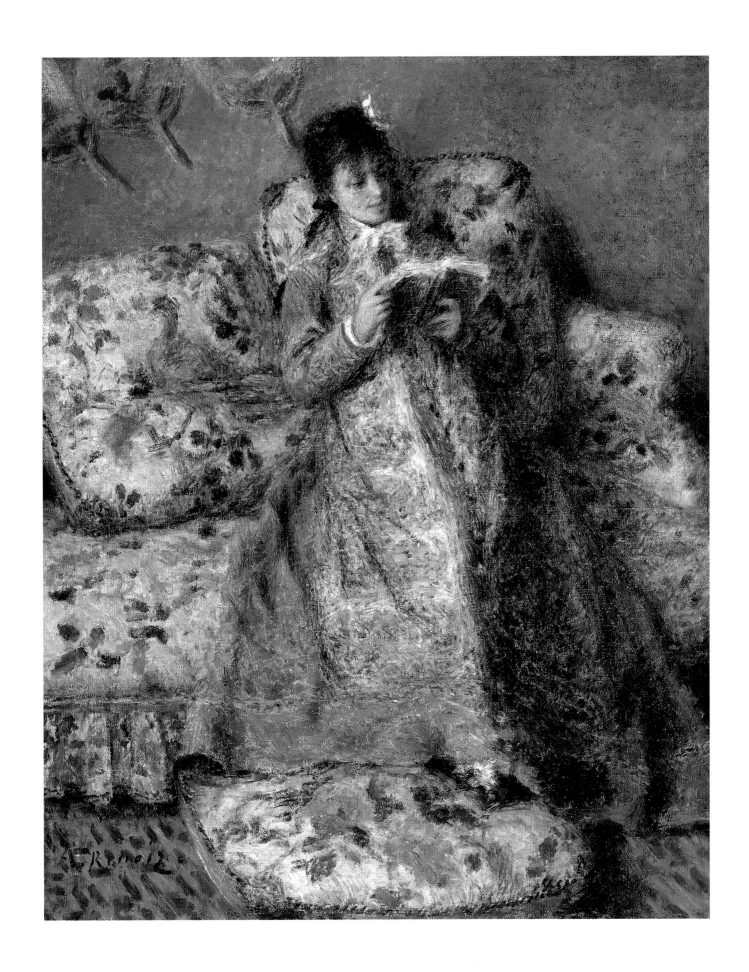

the divan's ruffle. The dark piping on the pillow behind her extends up from her right arm and turns just in line with the hair falling across her forehead, an arabesque that is mimicked in the curve of the book.

If there are worldly concerns that haunt her husband or the friend who is painting this portrait, they are not in evidence. The mood seems relaxed and casual. The pillows are scattered informally, one even serving as a footrest; the divan is cropped and asymmetrical; Camille is placed off-center, her dress slipping out of the picture on the right side. Most carefree of all, three fans on the wall appear to float into the scene like untethered balloons, turning so that their handles are oriented in slightly different directions.

Camille seems oblivious to her surroundings, so engrossed is she in her book. But how do we reconcile her self-indulgence and Renoir's visual feast with the recorded tales of the impressionists' hand-to-mouth existence? How do the plush divan and Camille's elegant dress accord with Monet's supposed poverty? In actuality, by 1873, when Renoir painted this picture, Monet had begun to earn significant sums. The Paris dealer Paul Durand-Ruel bought numerous paintings from Monet in 1872 and 1873, which, when combined with other sales the artist realized in those years, raised his income to 12,100 francs and 24,800 francs, respectively. These were substantial figures. During his six years in Argenteuil Monet continued to earn an average of somewhat more than 14,000 francs a year, permitting him to live very comfortably, despite his periodic cries for help.

The rich gown Camille wears in Renoir's painting was her own and was probably purchased with this windfall. She wears it in two other portraits Renoir did of her the following year, both of which also include a similar divan, which must be the same piece of furniture seen in the present work. In addition to the divan, the fans and the rope rug appear to have belonged to Monet. He depicted various fans in his *Japonnerie* of 1876, including the one on the right in this painting by Renoir. These objects testified to Camille's (and the artists') cosmopolitan interests and the current rage for things from the East, which began in the eighteenth century with *chinoiserie* (implied in Renoir's depiction of the divan fabric here) and moved from Chinese to Japanese influences in the late 1860s. The fans were cheap throwaways, called *uchiwa* fans, which makes their presence a little incongruous in a work that is filled with such sophisticated trappings.

The fans may have been a token of Renoir's appreciation for Monet's hospitality, as it was customary to hang three together as a housewarming present. But the most common place they appear are in *ukiyoe* prints of Japanese courtesans. This adds a note of impropriety to the image Camille projects, an intimation that is repeated in the informality of her pose. Instead of merely being modern decorative elements, the fans assume more Freudian overtones, their handles pointing toward Camille and casting shadows on the wall that emphasize their sculptural quality. Although Camille is buttoned up,

the long blue spine of her dress can become equally suggestive, drawing attention to the sensuous contours and weight of her gown. Renoir's caressing brush and the intricate skeins of paint on the custard yellow section of her costume contribute to this sense of intimacy. So does the heron depicted on the pillow beside her. At once exotic and common, the heron can be easily mistaken for a crane, a widely recognized symbol of promiscuity.

How are we to understand a painting that began as an adoring portrait of Monet's wife and ends as something else? Renoir poses but does not resolve the enigma, leaving us with an image that is at once clear-cut and contradictory, much like modern life, much like impressionism's apparent histories and agendas.

Detail, cat. 16

Claude Monet
The Garden
1872
oil on canvas
63.5 × 79.4 (25 × 31 ¼)
Private Collection

This delicate, poetic picture breathes the air of great contentment. It also embodies many of Monet's painterly concerns of the early 1870s. Chief among them are the evocation of strong natural light, the sense of pure serenity, and the impression of immediacy. All of these are realized with assurance in this unassuming view of Monet's Argenteuil backyard, where they become mutually reinforcing, a balance that is rare in art, as it is in life, particularly in the later nineteenth century.

Monet addresses these concerns with a combination of subtlety and forthrightness, beginning with the brilliant light that streams into the scene from directly overhead. Clear and forceful, the light endows everything it touches with warmth and vitality, making this reserved, spatially circumscribed painting a paean to its powers. The flowers and foliage are transformed, their petals and leaves seeming to sway to internal rhythms that suggest the intensity of the moment and the beauties of the day. The path in the right foreground and the grass in the center provide a solid footing for their revelry, while the azure blue sky, dotted with only a few faint clouds, shimmers overhead.

Although this celestial expanse gives the sense of infinite space, it occupies less than a quarter of the view. Most of the canvas is devoted to two flowering lilac trees standing in front of a thicket of green that extends unbroken across the scene on a slight diagonal. Like the two elegant women who sit placidly between them, the lilac trees are at the same time different and alike. The one on the left has a wider, stouter trunk and a fuller top. The one on the right appears more youthful and energized, its thinner trunk twisting as if engaged in a dance; it rises in the middle of a circular bed that has been carved out of the lawn. The arching branches of these trees form parentheses around the women before reaching up to meet the sky and catch the full benefit of the light. The bowerlike recesses underneath are cast in shadow, although patches of scattered light find their way into even the deepest pockets of this undergrowth.

The two women are both dainty and substantial, a complement to the lilacs and the potted plants. They are boldly painted, with peach beiges and light blues that make them stand out against the lime green of the grass. The yellow hat of the woman on the left and the bright white parasol of her companion attract particular attention, as they contrast so strongly with the shadowed area behind them. The women also humanize the landscape, making clear that these trees have been cultivated for aesthetic reasons, much as were the flowers in the ceramic pots. The pots themselves were among the half a dozen that Monet purchased during his self-imposed exile in Holland in 1871. With their floral designs and soft bluish white backgrounds, they imitate Chinese export porcelains and are reminders of Monet's worldliness, interest in the decorative arts, and desire to make his backyard a diverse aesthetic environment.

The pots are casually arranged. In addition to their irregular spacing, all boast unique designs and plants that have flowered differently. The two on the ends have lush blossoms, while the one in the center does not, echoing the lilac trees on either side of the green undergrowth in the background. Monet unites them by having them stand like sentries along the curve of the path. Behind them the two women sit on the ground rather than a bench or chair, underscoring the informality and intimacy of the scene. No middle-class woman concerned with her station in life would have been caught in such an unladylike position. Yet the women appear prim and appropriate, like the well-tended flowers that surround them.

The connection between the figures and the garden is essential to the picture, as it recalls the long-standing feminine character of nature while suggesting the desirability of this suburban setting. The garden's appeal would have had particular resonance in 1872, given the disasters of the Franco-Prussian War and Commune insurrection. The peace Monet has captured, the restraint of the women, even the needlework in which one of them is engaged affirm a return to the grace and gentility of France that was so lacking during the previous *l'année terrible,* as Victor Hugo called the horrors of 1870–1871.

In addition, these thoroughly contemporary figures evoke associations with the women who populated the eighteenth-century *fêtes galantes* of Antoine Watteau and his followers. And they occupy a space that is like a modern *hortus conclusus,* or closed garden, which is traditionally associated with the Virgin Mary. While Monet provides a potential exit on the right, he enhances the site's splendid isolation through the

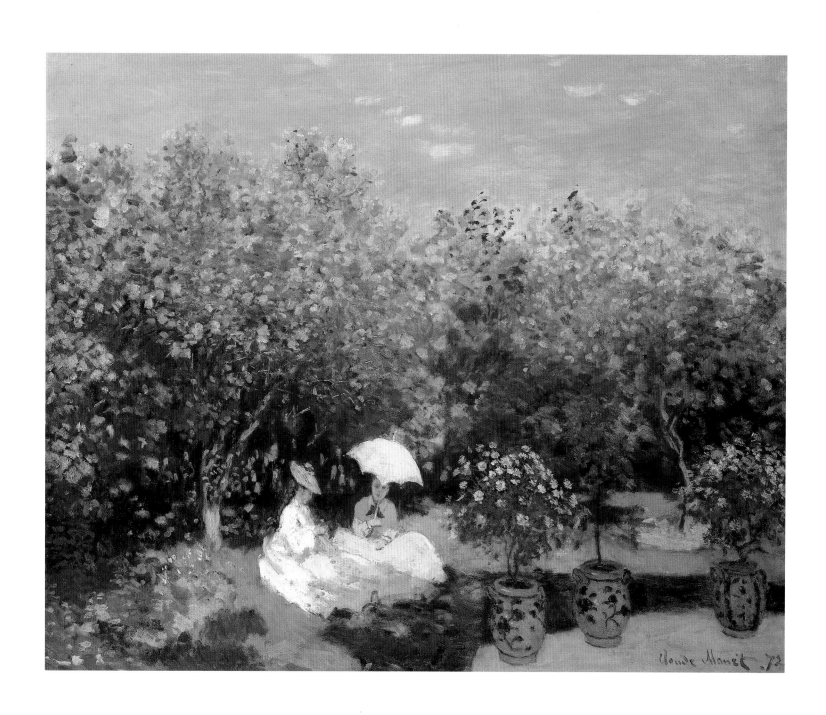

mass of the foliage behind the figures and through the absence of intrusions. The women themselves exude an innocence that hearkens back to their sacred counterpart. But we are made to feel excluded from this gathering, as the women do not acknowledge our presence.

This painting was one of Monet's first views of his Argenteuil garden. Settling down after almost a decade of itinerant existence, Monet found wonder and satisfaction in this unpretentious backyard. He could afford such comforts, for he was earning more than Parisian doctors and lawyers in 1872 and he plowed much of his income back into his garden, a consistent source of renewal during his years at Argenteuil. When he moved to Giverny in 1883, he constructed the ultimate earthly paradise, but the garden at Argenteuil was where it all began, something one senses in its dazzling mixture of simplicity and sophistication, confidence and naïveté.

Detail, cat. 17

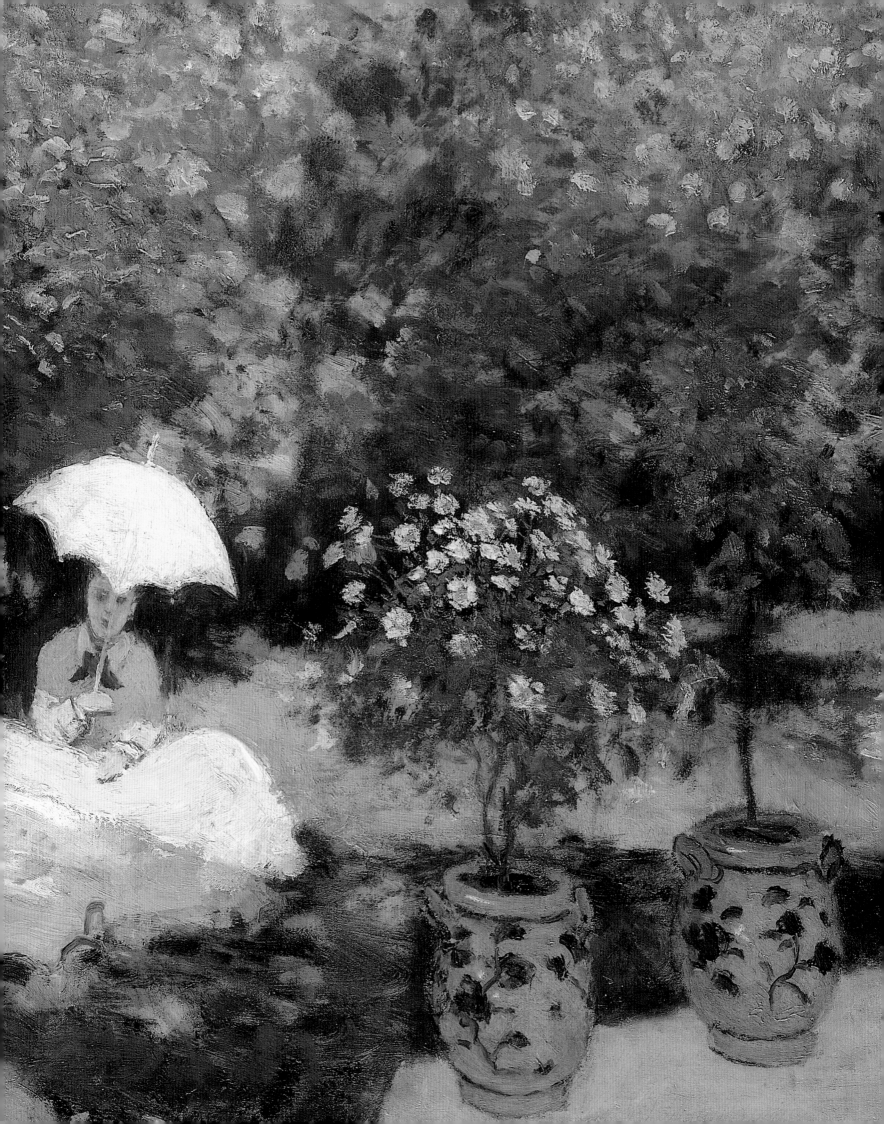

Claude Monet
The Artist's House at Argenteuil
1873
oil on canvas
60.2 × 73.3 (23 ¾ × 28 ⅞)
The Art Institute of Chicago,
Mr. and Mrs. Martin A. Ryerson Collection

To say that light was a staple of the impressionists is to state the obvious. No other group of painters so relentlessly pursued this fickle phenomenon; therefore no other movement is as closely identified with its broad range of effects. Even during the flowering of impressionism at Argenteuil in the 1870s, light was widely recognized as the artists' defining concern.

It is nonetheless surprising to encounter this candid view of Monet's backyard. Completed in the summer of 1873 and depicting the grounds of his first home in Argenteuil, located on the rue Pierre Guienne, this work radiates an almost palpable luminosity. So vivid are the colors that it seems as if Monet consciously plumbed each for its most intense physical components, then wedded one with another in a manner that allowed each hue to stand forcefully on its own. As a result, few canvases from the period equal the simple yet stunning effects he achieved here. Ironically, few are quite as inscrutable either: the forms can be easily read, but their meanings are elusive.

Monet graciously invites us into the scene, with its spacious foreground embracing a wide beige stone dust path that is interrupted only by the artist's signature at the right. With its hard-packed surface and crisp, converging edges, the path defines a broad trapezoidal shape that runs the length of the house and closes in a boldly illuminated bed of flowers. Only at the far end of the garden and along the left side of the yard does sun strike directly. Most of the path and the entire house are cast in shadow. Monet even mixes various blues in the beiges of the path to decrease its luminosity. Yet he fills the space with so much light that the upper story of the house, with its warm, soft yellows, acts as a kind of substitute for the sun.

Other inversions are just as curious. The stone dust path, for example, is essentially a stage, but Monet has emptied it of virtually all incident that might capture the eye or stir the imagination, aside from his son, Jean. The boy is the sole actor on this proscenium, standing startlingly alone, his back to us. He holds a hoop in his hand, but he is as motionless as the flowerpots on either side (trophies from Monet's self-imposed exile in Holland in 1871 during the Franco-Prussian War and the Commune).

Except for Jean and the trapezoid of stone dust, the garden teems with life. Flowers stretch forward, leaves tremble on the trees, ivy scales the façade of the house and spreads out in either direction, eventually climbing over the eaves and disappearing from the picture. In their profusion, these vines almost obscure a woman at the door who steps outside, presumably to check on the child. An expansive blue sky hangs over the scene, fluffy clouds filling its lower reaches, more wispy ones soaring to the top, seemingly buoyed by the purity of the air and the clarity of the light. The small cloud directly above Jean is particularly lively, as if it possesses the spunk that the boy suppresses.

Jean's stillness seems strange. Why is he so removed? Should we read his stance as a rebuff? Or has Monet simply depicted an instant when his son has stopped what he was doing and contemplates his next move? Has the woman at the door told the boy something he did not want to hear? Has he become bored posing for his father? The painting as a whole prompts other questions. Can it be merely coincidental that the smallest trees with the thinnest foliage stand just at the end of the house, the most massive element in the picture, allowing the sky to show through? Why do these delicate saplings lean to the left when the older, larger tree leans to the right? And why has one Delft pot been separated from its mates and isolated on the left?

These questions, like the scene itself, seem to involve relationships—human, natural, and aesthetic. The painting offers certain nineteenth-century ideals of beauty, harmony, and material splendor from which one might create a longed-for union, but something is missing. In the emptiness of Jean's space, even in the distilled perfection of the shapes and forms of his surroundings, a tension tugs at these ideals, pulling desire away from fulfillment and pitting intimacy against independence. Monet's notions are both clear and cryptic, which suggests that he may be asking what is real and how art can bear witness to the tangible as well as the mysterious aspects of life, particularly modern life that has been so complicated by the forces of change.

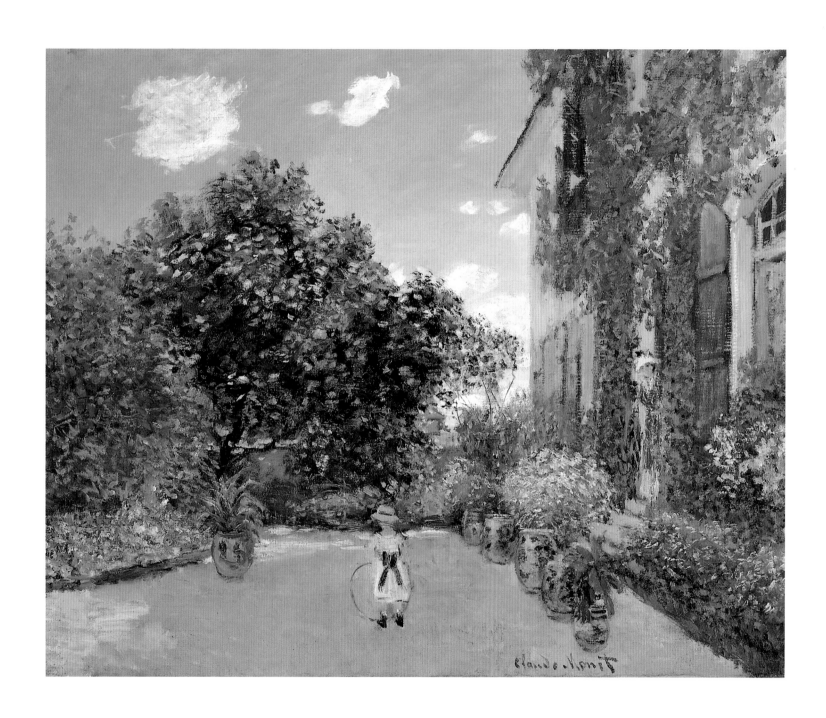

Auguste Renoir
Monet Painting in His Argenteuil Garden
1873
oil on canvas
46 × 60 (18 × 23 ½)
Wadsworth Atheneum, Hartford, Connecticut,
Bequest of Anne Parrish Titzell

He stands before his easel, his back slightly arched, his feet firmly planted, his right arm extended toward his canvas with a brush delicately balanced between his thumb and forefinger, about to touch its surface. In his left hand he holds a host of other brushes like a bouquet of unruly stems. On his forearm he balances his palette, locking it between his thumb and the crook of his elbow. Below his three-legged easel lies an open paint box and a thin white triangular form, most likely an umbrella to block the sun. He is the model of the plein-air painter—in the world, fully engaged, completely equipped, concentrating, erect, in charge.

It appears that Monet is painting a subject on the other side of the picket fence, perhaps the dahlias. These magnificent flowers begin at the left in a frothy wave that crests just after passing a multistory, blue-shuttered house in the background. They then descend toward Monet with lively impatience, their blossoms stopping in the middle of the scene, while the tangle of green continues on past him, touching the top of his easel.

Monet's brush is pointed toward the upper reaches of his canvas, however, which suggests he may be rendering something higher in his sight line than these flowers: the house perhaps, or the sky. In any case, the region beyond the fence is more stimulating than the relatively empty space he occupies. Renoir emphasizes its allure not only by the subtle alliance of the dahlias and the easel but also by the fence, which cuts the scene in two. The humble, seemingly hand-hewn pickets barely restrain the energy of the opposite side, separating yet uniting the two realms. Indeed, the foliage spills over this boundary to tumble into Monet's space and engulf one leg of his easel. The fence then continues toward the right to intersect Monet at his waist, literally pinning him in place— a helpful ploy given his position so far from the center of this asymmetrical composition.

Monet's space is stripped of distractions or visual interest; it is a place of work, not leisure or play. Monet is dressed for work. Always inclined to a certain stylishness, he sports a round black hat and a dark jacket trimmed with velvet at the collar and wrists. The jacket is cut short, not like the frock coats most middle-class men wore indoors or out. Monet owned a more elegant coat; he was photographed in it when touring Holland only two years earlier. But the jacket he wears here resembles the traditional blue smocks of the working class.

His unpretentious dress emphasizes Monet's seriousness, a quality evident as well in his intense focus on the subject he is painting. He is unfazed by the wind that blows through the scene, for example, although it causes the foliage and flowers to bend while lifting the corners of his jacket in a humorous but naturalistic way. Likewise, he seems content to be working on an overcast day, which keeps everything except the flowers in a kind of chromatic check. Monet was known to be a hard worker and remarkably productive, the result not only of his enviable dexterity but also of his heartfelt engagement with his task. That task of course, like Renoir's, was to transpose external realities into art. In Monet's case, as Renoir in particular knew, that meant wrestling discordant elements into a distinctive but orderly whole, not unlike the picket fence.

How confident Monet appears as he paints in his garden, although his easel looks relatively fragile and his canvas is of modest size. Unlike so many of Honoré Daumier's caricatured painters, Monet stands back from the easel and looks beyond his painting while his hand independently translates what he sees. The canvas itself is a willing partner in this process, as it leans back to receive the next touch of his brush. His pose underscores his determination, and his smartly cocked wrist a corresponding flexibility and sophistication.

That Renoir faithfully includes the jumble of buildings in the background, with their assorted sizes and shapes, makes it clear that Monet is not working in some remote site, as his Barbizon predecessors did. He is in the middle of town, with people walking by (note the two in the center of the scene) and houses crowding in on all sides. This was his chosen world. Like Renoir and the other impressionists, Monet had opted to immerse himself in the here and now and to extract from the contrasts between the natural and the man-made, the cultivated and the constructed, that which spoke forcefully and poetically about the times in which he lived. According to this deeply sympathetic portrait by his friend Renoir, he was quite at home among this competition of forms and amply capable of ordering them in meaningful ways, a distinction history has also awarded him.

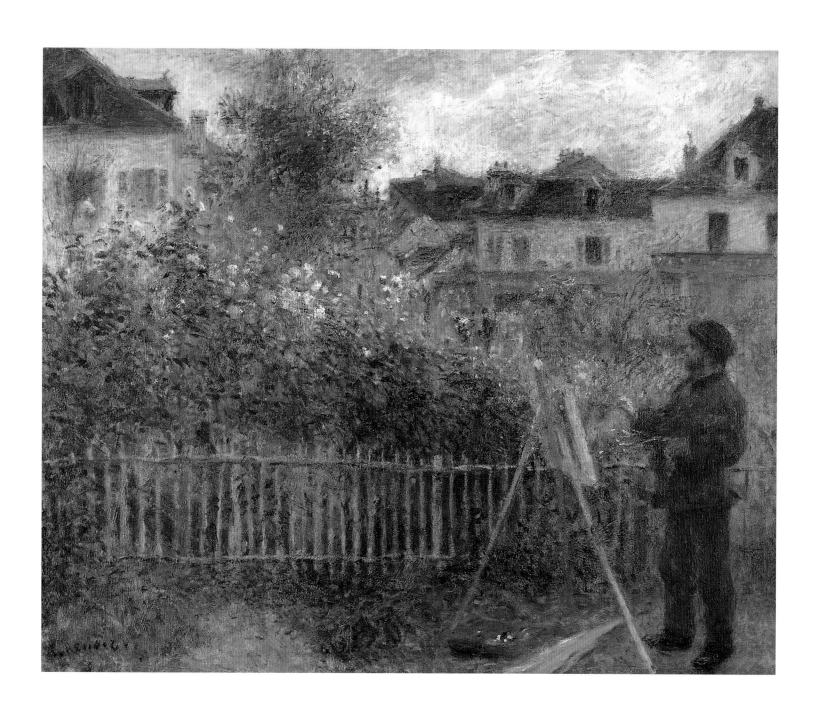

Claude Monet
A Corner of the Garden with Dahlias
1873
oil on canvas
61 × 82.5 (24 ⅛ × 32 ½)
National Gallery of Art, Washington,
Gift (Partial and Promised) of Janice H. Levin, in Honor
of the 50th Anniversary of the National Gallery of Art

Monet's first house in Argenteuil sat on a sizable piece of property just down from the railroad station on the way to the river. The garden that accompanied the house was immense, approximately 2,000 square meters. It bordered two undeveloped parcels of land, which must have made it seem even grander. The house itself was substantial and undoubtedly appealing to the newly transplanted Parisian artist, his new wife, and young child. But the grounds must have been one of its primary attractions. During his first year in Argenteuil Monet painted five pictures of the garden (see cat. 17), none of which was true to its full breadth or splendor. In the summer of 1873 he nearly doubled that number, most of which revel in the glories of this suburban setting.

Of the second group of paintings, this richly impastoed work is one of the most animated. The ground is covered with a plush quilt of fallen flower petals. A formidable array of dahlias bursts with brightly colored blossoms. The trees on either side arch toward the center of the picture, their branches seeming to bend in the wind, their leaves to tremble. Scattered clouds allow only intermittent glimpses of the blue sky.

The one thing that is solid and immutable is the three-story house that rises behind the dahlias. It does not possess the puckishness of the flowers, but it is hardly staid, thanks to its asymmetric façade, eccentric rooflines, and contrasting chimneys. Slightly off-center, it reigns over the scene, with windows like watchful eyes and its right edge defining a square with the left side of the canvas, making it appear logically located.

The same sense of order prevails throughout the picture, despite the sustained vitality of its surface and the dynamism of the illusion. Like the classical landscape artist Claude Lorrain, Monet frames the scene with tall trees, divides it into counterbalancing areas, and invites the viewer to enter the space by emptying the immediate foreground of any encumbrances. Monet quickly compromises that access, however, with the thicket of dahlias, which surges into the view, pushing more than halfway across the picture plane to occupy nearly a quarter of the scene. Despite their aggressiveness, the flowers are carefully coordinated with other elements in the painting.

Beginning at the midpoint of the left side, they follow the line of the trees behind them, cresting about midway between the leftmost tree and the house. They then descend to the right, following the arc of the right-hand tree and ending on axis with the right corner of the main portion of the house. These syncopated rhythms find echoes elsewhere, such as the three thin yellowish trees in front of the house. They too imitate the curve of the dahlias, but they also bracket the façade of the house, with the tallest one in the center rising directly between the two blue-shuttered windows.

The dahlias are both contained and countered on the right by the open space and expansive lawn that lead past the tangle of flowers to a fence, where a woman in white stands with a man dressed in black. Although discreet, especially in comparison with the dahlias, these figures are easily readable, down to their individual postures and contrasting hats. They are not out of scale, as is evident from their positions relative to the fence. Nor are they out of place. On the contrary, they lend purpose to the site. Without them, the scene would be disconcertingly empty. The flowers would seem abandoned, the house cool and distant, the bending trees and overcast sky mournful and disconnected.

In the end, this painting celebrates suburbia, not some bower beyond the reaches of civilization. Nature, in this modern version of the world, is to be nurtured and appreciated in one's own backyard, something Monet's rented property in Argenteuil allowed him to experience on an extended basis for the first time. Little wonder that the painting seethes with life, that he applied his medium in so many ways, or that he juxtaposed such bold colors in the garden while using memorable contrasts of light and dark in the sky. They reinforce the joys of living in Argenteuil and provide the rationale for his decision to move there.

But the picture poses some persistent questions. How accurate is it? What lies beyond the edges of the view? A painting by Renoir (cat. 19) provides partial answers. Presumably executed at the same time as Monet's, that iconic landscape depicts Monet working on a canvas in the same backyard. But in Renoir's image the town of Argenteuil plays

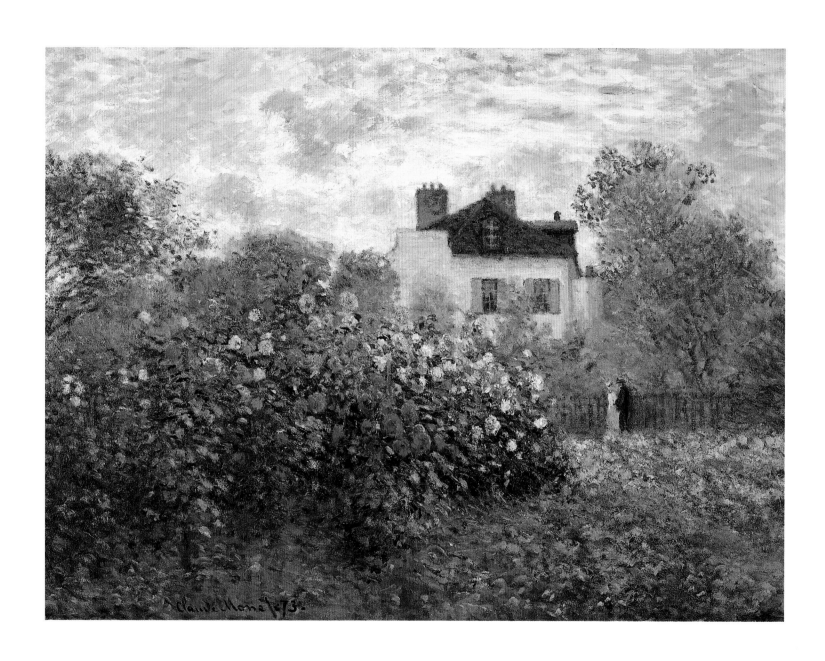

a significant role. Indeed it presses in on the space, transforming Monet's idyllic garden into an ordinary part of a real suburban neighborhood. The jostling houses Renoir depicts lie just to the right of Monet's bowed tree, as the blue-shuttered house and tree are clearly the same in both paintings.

It is by no means certain that the dahlias were Monet's own, as they do not appear in other views of his garden. He may have borrowed them from his neighbors on the other side of the fence, exercising his artistic license. Although they differ somewhat in the two paintings, the yellow blossoms tend to be on top with the red ones below, and both groups are astonishingly dense. Monet painted no other picture of the blue-shuttered house, which suggests that Renoir's homage to his friend may depict Monet in the process of painting *A Corner of the Garden with Dahlias.* Unlike Renoir, Monet was determined to discern fundamental harmonies in Argenteuil, at least during his first years in town, when he still firmly believed in the suburban ideal.

Detail, cat. 20

Auguste Renoir
Madame Monet and Her Son in Their Garden at Argenteuil
1874
oil on canvas
50.4 × 68 (19⅞ × 26¾)
National Gallery of Art, Washington,
Ailsa Mellon Bruce Collection

If the destruction of inherited hierarchies was one of the impressionists' chief accomplishments, then this portrait of Camille Monet and her son Jean ranks as one of the most poignant examples of how that end was achieved. There is little about it that members of the Paris art establishment in the 1870s would have recommended and little that other sitters would have found complimentary or worth preserving. Yet its originality and apparent lack of decorum, however disturbing at the time, now clearly distinguish the painting.

As a portrait, the work contains none of the genre's traditional trappings. Eschewing the formal or dignified pose, Camille sits nonchalantly on the grass, her chin supported on her left hand like many of Ingres' female sitters or Rodin's later *Thinker*. She recalls Monet's own image of her in his great *Luncheon on the Grass* of 1865–1866. In Renoir's startlingly fresh image, her full white dress splays out around her, falling out of the picture at the bottom. Seven-year-old Jean leans back against his mother even more casually, his legs akimbo, his right arm nestled in a fold of her dress. One eye is focused on the viewer; the other seems to drift. Camille casts her eyes aside, looking down to the left.

The rooster makes a curious companion. He stands on the same plane as Camille but is totally incompatible. His erect stance assumes an almost self-conscious air, as he is presented in sharp profile like a properly bred Renaissance patron. No less perplexing are three other birds that appear to be in the background. Renoir contradicts any logical reading of this space, tipping up the grassy area so precipitously that it fills the whole right side of the picture. Thus the smaller birds cannot be located specifically in the illusion of the scene. He positions a tree directly behind Camille so that its trunk seems to grow directly out of her back, on a scale that makes no sense. Is this the way one would want to be immortalized? The ambiguity continues with the sliver of a flowerbed at the top left that is shown at a scale too large for the fowl but not entirely inconsistent with the figures. We are therefore left in some confusion.

Renoir's brushwork does not help to clarify spatial relationships. While he separates one form from another with crisp outlines or decisive changes in color, he does little to define overlapping forms or three-dimensionality. He renders the grass with irregular brush strokes moving in so many directions that it is impossible to judge its recession. And he suppresses indications of light and shade that could suggest textures and contours in the landscape.

A companion painting by Manet done in the same garden at the same time (see illustration at left) proves that Renoir's view was remarkably accurate. Manet depicted Camille more frontally and Jean looking to the right. He included the voluminous dress, relaxed poses, stumpy tree, green grass, and geraniums (tended by Monet himself). The fowl appear in the guise of goslings. Despite his shorthand, Manet made the space more rational than Renoir did. He employed bands of light and dark to establish a measured recession that leads to a recognizable background and a glimpse of sky.

In comparison to Renoir's view, Manet's is not only more conservative, it is also larger and more worked, which may have prompted the older artist's supposed quip to Monet after inspecting Renoir's canvas: "He has no talent, that boy! Since you are his friend, tell him to give up painting!" Given the support Manet had previously demonstrated for Renoir, this often-repeated remark would surely have been made in jest. But it hints of competitive relationships among these innovative artists. That the two could devise such different scenes from the same material also attests to their insistence on invention, which is evident in myriad details, particularly in the artful use of the tree. Camille and Jean were posing, not merely lounging around. The casualness of each scene was thus carefully orchestrated, just as the apparent spontaneity was quite deliberate. It was with determination and clear-mindedness that Renoir and Monet attacked the inherited traditions of French art, altering its course in both form and content.

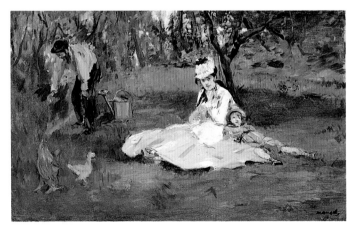

Edouard Manet, *The Monet Family in Their Garden at Argenteuil,* 1874, oil on canvas, The Metropolitan Museum of Art, New York

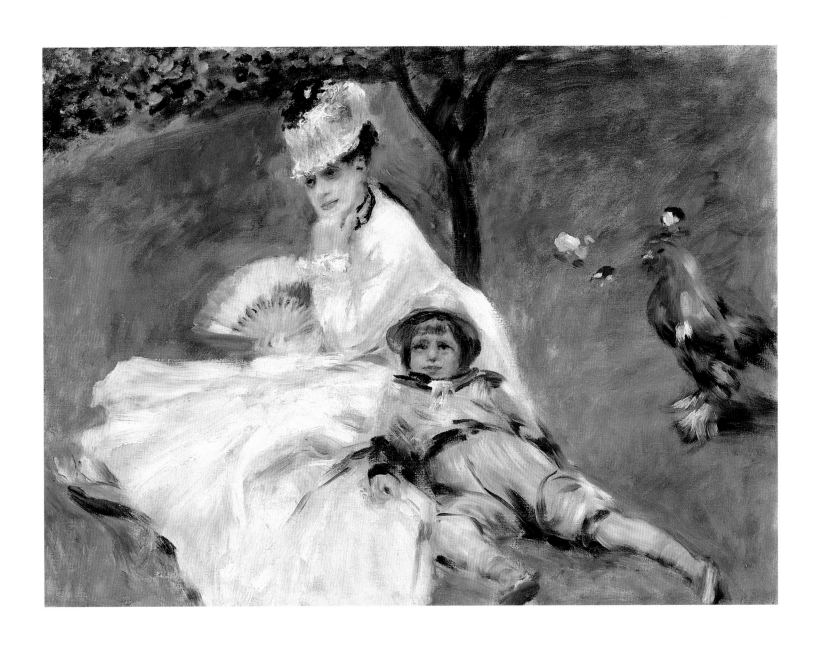

Claude Monet
Frost on the Plains of Colombes
1873
oil on canvas
52.5 × 72 (20 ¼ × 28 ⅜)
The Niigata Prefectural Museum of Modern Art, Japan

It is late autumn. The ground is covered with frost. A chill is in the air. The trees have turned. The Paris crowds have retreated to the city, allowing the fields to regain their traditional tranquility. Standing alone on this spacious site just across the river from Argenteuil, Monet paints a picture that seems especially sensitive to these conditions and the transitional qualities of the time of day he has chosen to render. It also bears witness to the emptiness of the place and the reveries it prompts, underscoring Monet's ability to find meaning in the mundane.

Soft orange-yellow light streams into the scene from the left, caressing the land and its forms while suggesting the onset of the winter sun's long rays. The earth awakens to its touch, as do the façades of the houses, which warm with each moment. The trees on the right bend like lithe dancers, their leafy tops melding into a single rounded shape that arcs upward before being cropped by the canvas' right edge. As with the orange roofs of the houses below, the foliage on the trees contrasts with the thinly painted breadth of blue sky that Monet allows to dominate the landscape, its faint cloud cover filling more than two-thirds of the picture plane.

The humble rectangle of land is more articulated than is the sky. It is divided into several parts—a small wedge below the horizon on the left, a ridge that curves toward the middle of the foreground, and a flatter section to the right. Although all three contain many of the same colors, each is painted differently, reflects a distinct quality of light, and gives varying emphasis to the hues and values. The differences are particularly noticeable in comparing the ridge and the large flat field. The former is rendered with thicker, longer, horizontal touches of paint laid down with greater bravura and more lead white; the latter is more uniformly defined, its brushwork more restrained, its colors deeper in tone and less luminous. These contrasts are heightened by the rich blue shadow that slices through the scene, separating the two areas while sculpting the contours of the landscape.

This shadow, sweeping from Monet's signature at the lower right to the solitary trees on top of the ridge, is central to the painting's dramatic perspective. It makes the land seem to rush deep into the distance, past the houses and trees on the right to end at the low horizon, which is punctuated by more houses and trees. Two factory chimneys also mark the meeting of earth and sky, spouting trails of smoke. The speed with which the land appears to recede is increased by the vacancy of the site and the other diagonals Monet employs: curved on the left, straighter and more regulated on the right, all of which add visual complexity to what otherwise could have been a rather ordinary scene.

Monet finds much else to celebrate in this unpretentious landscape: the bracing isolation of each building, the alternation of the contrasting groves of trees, the alignment of the three white houses in the distance on the left against the background screen of trees on the Île Marante, the bisection of that foliage by the clump of trees at the crest of the foreground ridge, even the vertical accents of the factory chimneys echoing the trees, their smoke paralleling the horizon. Monet insists that we recognize the individual characteristics of all of these elements, but he implies by their relative simplicity that each relies on the next for its effect and that the whole is more than the sum of its parts. Painting traditionally depended on incident, so by reducing one of the medium's primary appeals, Monet reveals his modernism. He also suggests his enthusiasm for his new life in the suburbs, where each experience was novel and noteworthy, each part of the landscape a marvel to behold.

Nowhere is this more evident than in the interaction of the light and the soil. Tangible, persistent, and clear, the sunlight burrows into the ruts and hollows in the land, attempting to melt the nearly frozen upper layers before pushing farther into its depths. The earth responds, heaving slightly or spreading apart, changing color in the process. With each shift in hue or brush stroke, Monet reminds us of nature's vitality and his own versatility in capturing its wonders. Over the years he spent in Argenteuil, Monet would experience profound change, which would ultimately compromise his innocence and his opinion of this suburb. But for the time being, the delights of early morning prevail, with all its intimations of promise and reward.

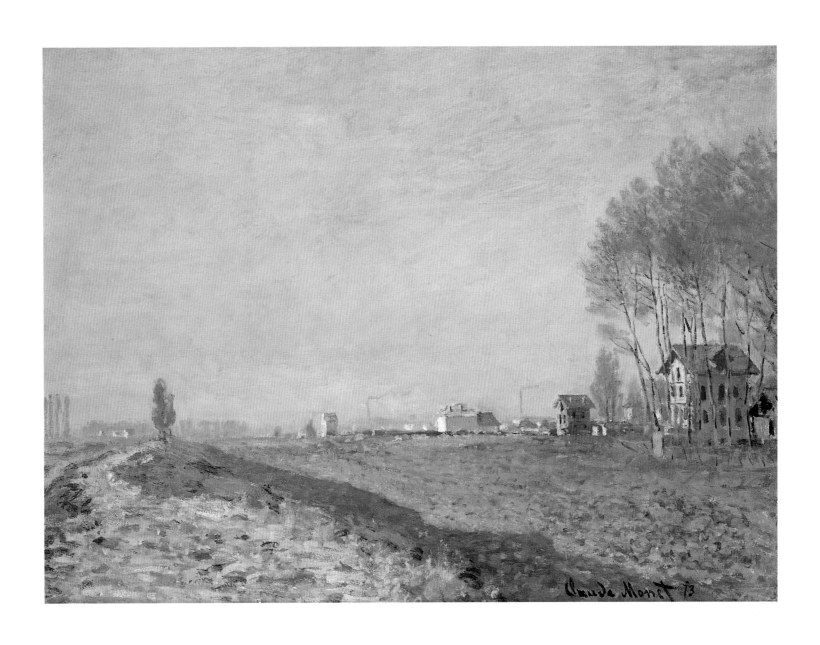

Gustave Caillebotte
The Yellow Fields at Gennevilliers
1884
oil on canvas
54 × 64.7 (21 ¼ × 25 ½)
Fondation Corboud, on permanent loan to the
Wallraf-Richartz-Museum, Cologne

Vibrant fields of yellow and orange daffodils stretch across the foreground of this dramatically composed view of the plains of Gennevilliers across the river from Argenteuil. Their proximity to one another makes their bold colors and the impasto of their petals particularly pungent. Shimmering with light, they recede sharply into the distance between fresh green fields on either side. Prefiguring abstract shapes that Kazimir Malevich would devise thirty years later, these assertive geometric forms rise high on the picture plane to end considerably above the midpoint of the scene.

At the horizon we encounter the only vertical accents in the landscape: a band of trees that proceed from the left edge of the canvas to a point above the junction of the orange and yellow fields. There the trees become more distinguishable as a series of poplars that continues out of view on the right. Above this orderly arrangement of forms hangs a sky that has been subjected to an equally rigorous geometric sensibility and made into a strict, virtually uninterrupted rectangle. No cloud disturbs its surface, extending the expansiveness that the fields suggest.

Despite the division of the land into such legible areas, it is surprisingly difficult to measure the space in this work. There are no visual signposts, no *repoussoir* elements, no figures to establish scale. Only the trees in the distance provide points of reference, but they are too far away to be very useful. The picture therefore captures the exhilarating but unnerving feeling of our being part of a place and yet estranged from it, of knowing where we are physically and metaphorically in the world and yet unable to describe that position with assurance. Other details contribute to this reading. The varied brushwork not only emphasizes the individuality of the larger parts of the painting but also implies that they are held together by some rationale that is mandated from without and different from what defines them. The absence of figures increases this tension. It is evident that the foreground fields were plowed and planted, but the presence of the person responsible is now seen only in his handiwork. Assumptions are thus both confirmed and unanswered, while knowledge is only approximately supported by perception.

These conflicting sensations are distinctly modern, a product of the ways in which the world of the later nineteenth century was increasingly ordered and understood by science and technology and yet simultaneously made more confusing by the expansion of knowledge, the dissemination of information, and the overload of experiences. No matter how well things might be described, they were not always what they appeared to be. And the closer one might think one was to truth, the more elusive it became.

These contradictions, so close in kind to those of our own moment, were largely based on the urban experience, at least in nineteenth-century France. Rural people knew their environments on a relatively intimate basis, felt comfortable with them, and took pleasure in the continuities of their time and space. In Flaubert's *Dictionary of Received Ideas* he claimed that "people in the country [were] better than those in towns" and said we should "envy their lot." For those who lived in the city, like Caillebotte, the consummate cosmopolitan, the yearning for continuities did not disappear. It was merely superseded by a fascination with the faster pace of life and the risks and disjunctures produced. While sources of excitement, the contradictions also offered more complicated ways of locating oneself.

In this painting Caillebotte may have taken us from the Paris boulevards and apartment interiors he had depicted so often in the 1860s and 1870s to the light-filled countryside. But he has not abandoned the essential urbanity of his haut-bourgeois upbringing. The dictated order of his picture is a highly personal strategy, not found with the same insistence in the work of any of the other impressionists who painted in Argenteuil and its environs. But of course none of them came from the same privileged background as Caillebotte.

To his credit, Caillebotte understood his penchant for imposed authority and ensured that it did not go uninterrogated, as is apparent here in the tensions he creates between shapes, colors, brushwork, and spaces. Most ingeniously perhaps, he suggests these fundamental philosophical inquiries—about modern life and art making, knowing and sensing, earning and wanting—in the physical character of the painting. Central to the power and significance of this carefully considered image is the strain of its vigorous forms against the shape of the canvas itself, which is just ten centimeters short of square. A square is not only an uncompromising shape but also one that is basically ill-suited to landscape painting. Landscape artists had long recognized that their genre was best served by

horizontal rectangles, just as portraitists preferred more sympathetic vertical formats. The former imitated the breadth of the land, the latter the upright pose of a sitter.

A square format is unyielding, like some accepted hierarchy or proven body of knowledge. Steeped in tradition and bound by his roots, Caillebotte had a particular affection for strict geometries, but like his impressionist colleagues, he also wanted to carve new spaces out of the old, where independent thinking and new formulas for understanding could coexist with the inherited and the established. By turning to these fields so near his newly constructed house in Petit Gennevilliers and rendering them so starkly against the forceful shape of his canvas, he found the perfect vehicle for giving form to these struggles and for envisioning the future while grappling with the present.

Detail, cat. 23

Claude Monet
Houses at the Edge of the Field
1873
oil on canvas
54 × 73 (21 ¼ × 28 ¾)
Staatliche Museen zu Berlin, Nationalgalerie

This painting is a paradigm of how a simple scene can be made sublime by Monet's keen eye and sensitivity to the effects of harmonious contrast. The view is divided into three roughly equal zones: one for the foreground flowers, one for the houses and trees, the other for the windblown sky. Despite covering a similar amount of the picture plane, each band could not be more different. The foreground field is ablaze with color, a sea of soft yellow flowers and blood red poppies, all rendered in small, variegated touches. The sky is more limited in hue and more broadly painted. It is also more dramatic, with its division between the open and airy region on the left and the overcast area on the right. Between these contrasting expanses rise the houses and trees. They are welcome vertical notes in what is otherwise a predominantly stratified scene. Two types of trees enliven this band and link the earth and sky: thin, recently planted saplings along the edge of the field, with fluttering leaves that echo the flower blossoms; and larger, more mature specimens in the background, with rounded, huskier forms that mimic the shapes of the clouds.

The two smaller houses clearly emerged from a single architect's drafting table, although closer inspection reveals slight variations. In the one on the left, the central window in the tympanum is a lighter shade of blue and is crowned with rounded, not rectangular, molding; the lower right window either does not exist or is blocked by shutters; and the front door is shorter and wider, while its cornice between the first and second story is a thicker, continuous white band, not two separate stringers. The larger house on the far right is different in color and design, but it continues the pattern of three ground-level rectangular openings and sports the same salmon-toned chimneys. The greater bulk of this house helps to close the scene with appropriate authority, while the radical cropping of the one on the left contributes a sense of immediacy.

This group of houses was located in the western part of Argenteuil, with the Seine and promenade to the right. The center of town lay straight ahead, designated by the church spire, which parallels the verticals of the house chimneys and repeats the peaked rooflines in a narrower format. This section of Argenteuil was experiencing rapid development during Monet's first years there, as were other edges of town. In fact, the two smaller houses and the cropped one on the left had just been built; their size and similarity suggest they were aimed at individuals of modest means, possibly the increasingly mobile residents of Paris who wanted a taste of the country.

The desire for a *petit pavillon* outside the city was widely shared by residents of the capital, although it was also parodied by cartoonists and by writers like Flaubert, whose *Bouvard and Pécuchet* revealed the many, often hilarious, shortcomings of country living. Monet himself was obviously not immune to the dream of peace and repose beyond the urban din, for he too left Paris for the pleasures of suburban Argenteuil. And initially, like Flaubert's city-dwellers-turned-country-gentlemen, he was delighted with his move. The town had many advantages: fresh air, beautiful views, open spaces, and easy access to the city. This canvas is therefore a testimony to Monet's enthusiasm for Argenteuil and the phenomenon in which he was a willing participant, namely the alteration of the countryside by the force of change.

That force is felt throughout the painting: in the sharp delineations between discrete areas, the dramatic light and dark, bold color contrasts, and the way the houses encroach so unrepentingly on the field that once covered their now divided lots. That Monet could have painted such a picture underscores his embrace of the new; other contemporary landscape artists would have thought the scene too insignificant. But for the modernist Monet, meaning lay in the moment, in the shifting beauties of nature, so evident here, and in the changing values and landscape of his time.

Thus *Houses at the Edge of the Field* can be seen as a modern version of great Dutch landscape paintings like Jacob van Ruisdael's *View of Haarlem with Bleaching Fields* or Jan Vermeer's *View of Delft,* both homages to the artists' respective seventeenth-century cities and icons of their kind. Monet's painting affirms his belief that Argenteuil could enter that pantheon and that he, like his heralded predecessors, could go down in the history of art as having recognized its significance and immortalized it in paint.

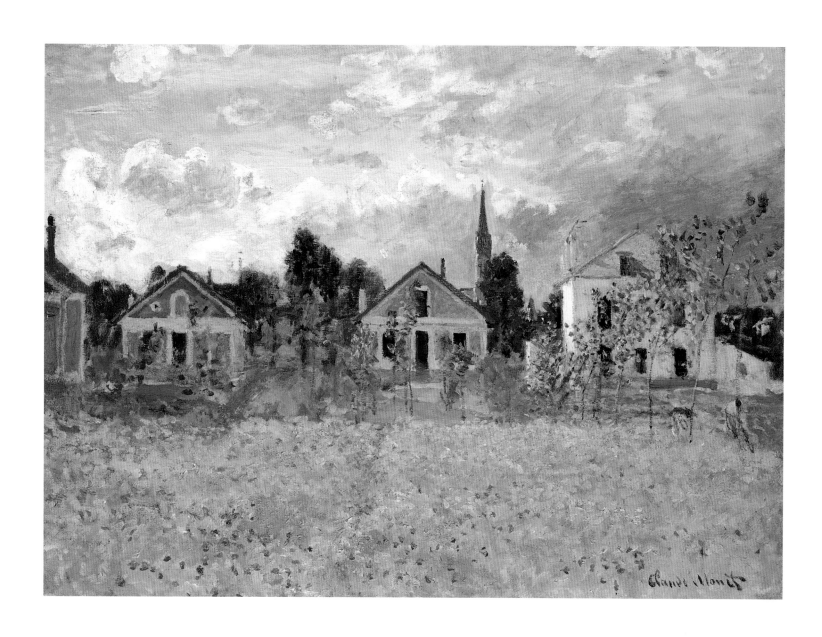

Gustave Caillebotte
Factories at Argenteuil
1888
oil on canvas
65 × 82 (25⅝ × 32¼)
Private Collection

Under a churning sky of thick gray clouds sits a huge factory complex. Its main buildings extend from the middle of the scene to the far right, paralleling the even longer blue-gray wall in front of them and the dark green and brown bank of the river. Above these abutting geometric shapes tower six tapered chimneys, which rise like rockets toward the top of the canvas, while their reflections wriggle in the opposite direction across the broad stretch of the Seine. Two large houses to the left seem diminished by their proximity to this sprawling industrial establishment, but they anchor their side of the composition and act as metaphors for the human, something otherwise absent in this unconventional picture.

Argenteuil had never been represented as stridently as Caillebotte renders it here. As the center of the development of impressionism in the 1870s and a popular site for boating and other leisure activities well beyond the end of the century, it was generally portrayed as a more attractive place: washed by sun-dappled waters, graced with flowing fields and rich blue skies, animated by happy distractions from the rigors of contemporary life. If a single view of the suburb could contradict this image, *Factories at Argenteuil* would probably be the best candidate. There are no sailboats, no Sunday strollers, no seductive light to enchant the viewer or disguise the harsher realities of the town. Instead, with unabashed candor, Caillebotte focuses on these unglamorous factory buildings.

He chooses a vantage on the Gennevilliers side of the Seine that maximizes the visual impact of the factory, moving far enough to the right to see a second, low-lying structure behind the first one inside the enclosing wall. Showing the right

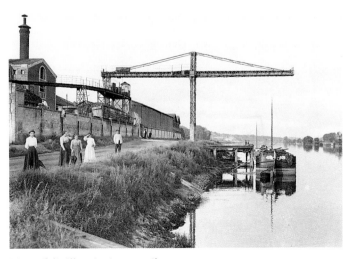

View of distillery in Argenteuil, c. 1900

sides of these two buildings as well as the façade, he enhances the plasticity of both and gives them a weightier presence in the landscape. The same is true of the taller, tawny-colored building that is perpendicular to the other two. Representing it from two sides, he draws attention to its three-dimensionality. Another similarly aligned structure behind this one would not have been visible if Caillebotte had stood directly in front of the complex. His position also emphasizes the intersection of the two buildings closest to us. If he had moved downriver to the left, they would have seemed more distinct, whereas here the lower building appears to grow out of the taller one.

This subtle point is important, because it suggests the factory's growth over time, as do the different sizes, designs, and colors of the buildings. In perhaps the strongest witness to this notion, the three tallest chimneys are spaced at almost equal intervals, which makes them initially seem as if they are all on the same axis; this in turn makes them appear to have been conceived and perhaps constructed according to a single plan. Closer study reveals that this was not so, however; nor was it true for the three smaller and more irregularly located chimneys behind them. Such evidence confirms that the plant expanded as business developed, much as did Argenteuil itself.

This was in fact the case. The establishment Caillebotte depicts is the distillery that sat near the eastern end of town, a stone's throw from the railroad bridge, which is just outside of the scene to the left. Converted from a glass-making factory in 1878, it expanded several times before Caillebotte painted it. And it continued to grow, as is clear from a photograph of the site taken around the turn of the century (see illustration at left). The first building in the photograph is the tawny one in Caillebotte's view; the low-lying ones in Caillebotte's picture are behind the elevated metal walkway in the photograph. Another building has been added to the complex; it sits parallel to the pathway under the arm of the crane in the later image. At the end of that structure are the roofs of two smaller buildings; they are the same ones that appear near the right edge of Caillebotte's work.

What this makes plain is that Caillebotte's subject, vantage point, and compositional strategies contain various meanings, some of which can be confirmed by the historical record. In this painting Caillebotte confronted the industrial presence in Argenteuil with a bluntness Monet never did, placing the smokestacks in a central, indeed a dominant position. The one in the middle falls almost exactly in the center of the view. The disposition of elements thus appears to possess an imposed rationale (something the rich surface of the painting seems

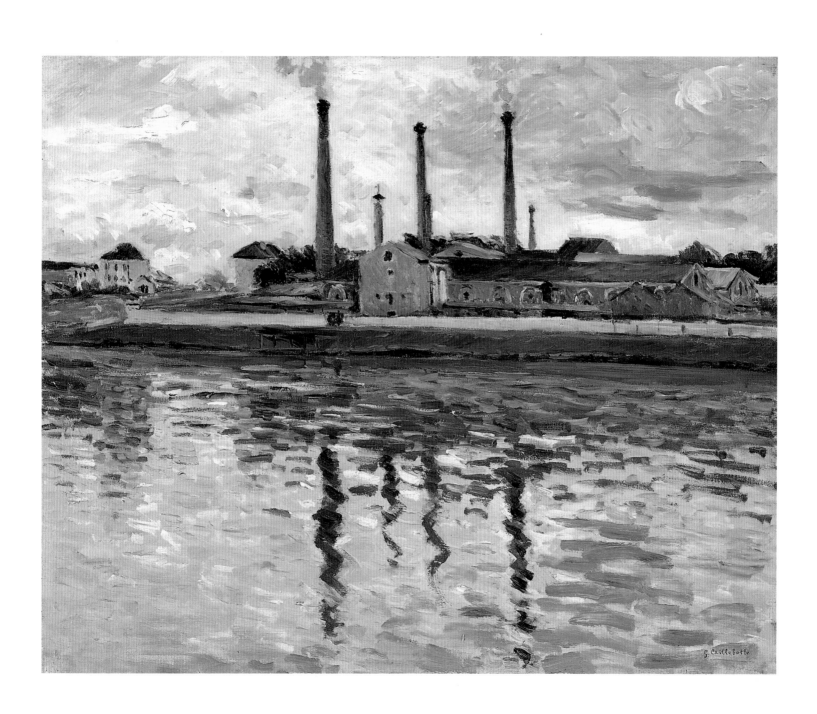

conversely to lack). Caillebotte underscores this rationale by extending the reflections of the chimneys almost to the bottom of the scene, which creates a Mondrian-like grid on his canvas. He makes the reflection of the second chimney on the left virtually as long as the taller one to its right, and he allows the one on the far right to be longer than the one on the far left even though the latter chimney is actually taller.

This grid is softened by a number of factors: the interplay of light and shadow in the water and the sky, the impasto that Caillebotte applies liberally in both regions, the indistinct reflections of the buildings on the river, and the buffer of trees on either side of the factory compound. The grid is also weakened by the asymmetries of the composition. The work is divided into three unequal horizontal rectangles of water, land, and sky; in fact the water takes up more area than the land and sky combined. In addition, the right side of the painting is more substantial than the left, owing to the location of the factory and to the longer, thicker strokes Caillebotte uses to describe its reflections as well as those of the clouds above. Finally, none of the structures is strictly parallel to the picture plane, which means none is entirely stable despite its logic or authority.

The sense of instability, movement, and change gains its greatest expression in the energized sky and agitated waters that bracket this modern motif. Although Caillebotte elevates this complex high on the picture plane, like some exalted offering to the viewer, he reminds us at the same time of the fickleness of all things, human and natural. Nothing could have been more apt for France in the 1880s, as anyone who lived in or around Argenteuil knew very well.

Detail, cat. 25

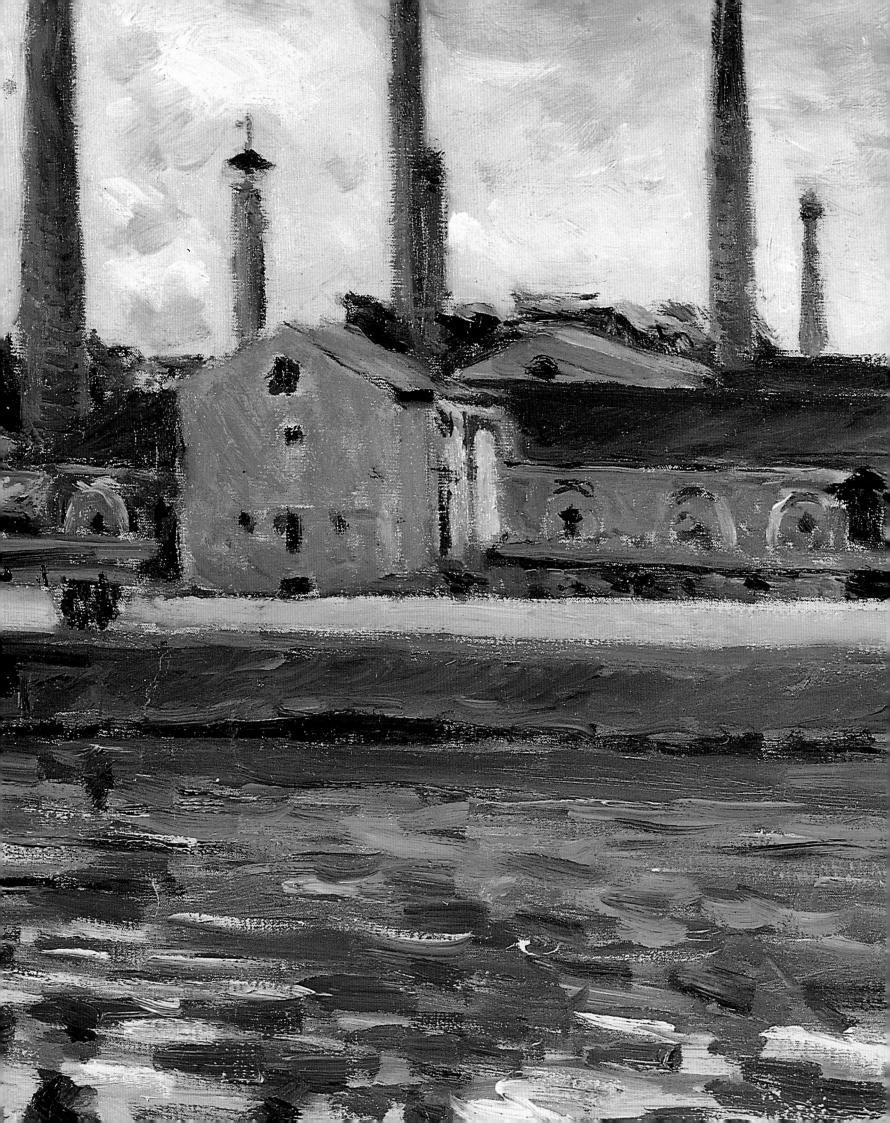

Claude Monet
The Railroad Bridge at Argenteuil
1874
oil on canvas
60 × 99 (23 ⅝ × 39)
Private Collection, Switzerland

This is one of the classic paintings of the period, filled with all the novelty and drama of Monet's undisguised embrace of modern life and art. Dominating the scene with imposing authority is the railroad bridge. Elevated above the Seine on glistening stone piles, the sleek, undecorated structure streaks across the landscape without interruption. It seems to stretch the already elongated horizontal canvas to its extreme, emphasizing the bridge's immutable presence and its ability to extend the world of the possible.

Though monumental and obviously industrial, the bridge is neither a foreign nor an unwanted element in the scene; indeed it appears fully appropriate. It has been baked by the warm afternoon sun until it has turned almost white. It is rendered humane by two men on the left who stand on the raised bank of the river seeming to admire the structure as a testimony to modern engineering. With its remarkable expanse and incontestable stability, it appears to be a technological wonder, entering the picture on the left without any support and then spanning regimented spaces large enough for the sailboats below to pass through without hindrance.

The bridge's purposefulness is suggested not only by its rigorous lines and tensile strength but also by the two trains that it carries in its trestle—one heading to the left into Argenteuil, the other to the right toward Asnières and Paris. The smokestacks of each are visible above the chute. The one on the right billows smoke as it builds up power, while the other is quiet as it approaches its destination. As with the bridge itself, Monet makes the might of the Paris-bound train seem fitting, its smoke drifting up into the cloud-studded sky to dissipate in the depths of the blue, as if it were an intimate part of nature.

The rest of the painting is crafted with equal subtlety. It is carefully divided into closely coordinated shapes: the triangle of the bank finds its echo in the more open-ended wedge of the water. The spans of the bridge frame rectangles of sky and the far bank. The merged form of the surging steam and the cloud above repeat that of the cloud formation rising from the horizon to just over the train on the left.

Most impressively, Monet has the bridge draw a new horizon line in the picture, an indication of his belief in the progressive power of the structure and all that it represented. At the same time he insists that this industrial form be not only an integral part of the landscape but also a complement to the leisure activities that Argenteuil offered. These pastimes are symbolized by the two sailboats below the bridge's iron bed. As with everything else in the painting, Monet cannot help but locate these recreational vessels in the most aesthetically pleasing positions—one directly under the middle span of the bridge, the other skimming its way into the light past the male spectators on the shore.

At the same time, Monet suggests certain tensions. He juxtaposes the modest wooden railing along the foreground bank with the immense iron bridge above it. He makes the trees in the background twist and turn like nature's equivalents to the bridge's geometric piles. The bridge pulls to the right while the clouds tug to the left. Even the moment Monet has chosen creates contrasts. The sunlight illuminates the piles closest to us but not their mates beyond, just as it appears to divide the surface of the Seine into an active foreground area and a relative staid background.

Such contrasts and stresses of course were like those of modern life, the result of the continuing pressure of industry and change on the once familiar world of nature. In this picture Monet molds these potentially disruptive relationships into a dynamic whole, creating harmony out of dissonance. It is the vision of an idealist, someone who believed in the benefits progress could bring. While noble—and widely shared—Monet's belief was in the end naive and short-lived.

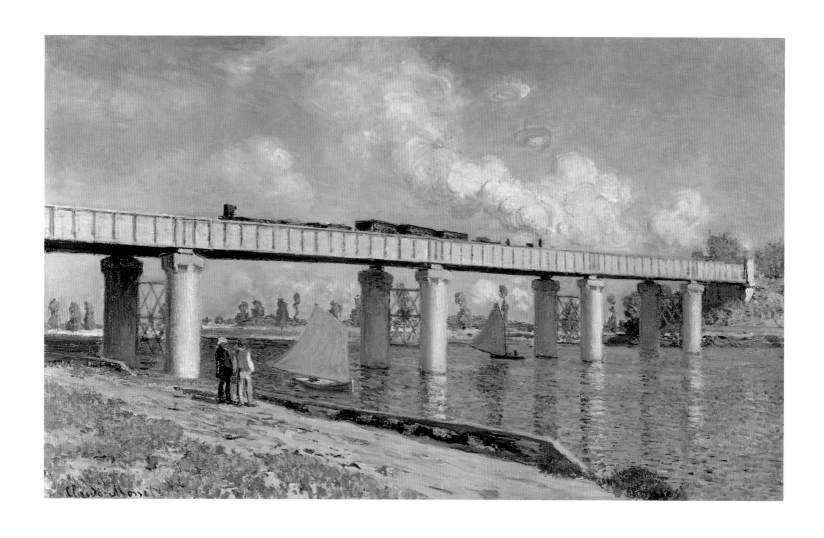

27

Claude Monet
The Railroad Bridge at Argenteuil
1874
oil on canvas
54.3 × 73.3 (21 ⅜ × 28 ⅞)
Philadelphia Museum of Art, The John G. Johnson Collection

Monet here combines neat geometries and enchanting light to create a sharply defined image of great tactility and appeal. Each part seems to have been honed with as much feeling as precision by a master craftsman who was keenly aware of the expressive possibilities of the materials at his disposal. Orderly, stately, and lyrical, the painting reveals much about Monet and his time while evoking the splendor of a summer's day.

The foreground is dominated by a bold triangular area of high grass rendered in various shades of green and blue. Beginning slightly to the left of center, just after a rickety wooden fence, it rises steeply up the picture plane to end about halfway up the right side. It is crowned by a large shrub, whose splayed foliage, described with rich impasto, is the culmination of the shorter but equally energized grass on the bank. Together they create a pliant, contrasting cushion for the railroad bridge that strikes out across the river from the upper right corner of the canvas. The bridge and its piles form another triangle, which establishes spatial recession with the authority of a Renaissance perspective system. They connect the foreground bush and bank with their counterparts on the other side of the river while keeping them irrevocably apart.

The bridge is illuminated by a warm, late afternoon sun, which causes the right side of the piles to glow like candles and cast a flickering, reflective light on the underside of the trestle, drawing attention to its striated structure. Conversely, the left side of the columns are draped in a cool, purplish blue shadow—essentially the same hue, though somewhat higher in value, as that which veils the vertical sections of the trestle. Monet extends the line of the piles to the foreground bank by stretching their reflections across the river so that they touch or disappear behind the ragged edge of the grass. This ploy adroitly unites the bridge and the bank—the most prominent elements in the painting—while underscoring their essential differences, as the thin, irregular slats of the fence rise to meet the huge, sleekly engineered columns above. The poetry of these decisions is enhanced by Monet's coy suppression of any reflections from the cross-beams between the piles so that nothing interferes with the measured rhythm of the supports.

Three rectangular cars and a steam-spouting engine roll across the bridge. Although we might initially assume that they belong to the same train, the opposite is the case: knowing that the engine would have been the same size or larger than the cars, we realize it is farther away; in fact it is on the far right track of the bridge, which explains why it is lower and less visible in the trestle. That track carried trains from the Argenteuil station (outside our view to the right) along an eleven-kilometer route into Paris. The three cars are at the end of a train coming from the capital into Argenteuil on the near track. Such a seemingly small detail proves to be surprisingly complicated and suggests Monet's close attention to the nuances of the site. It also manifests his desire to heighten the internal dynamics of his picture and to expand its illusionary space, something he implies in the cropped bank, fence, and bush, and in the way the light streams down the river from the right.

Monet is also eager to forge unity out of disparate parts. He relates the strong rectangular shapes of the train cars to the structure of the trestle in which they ride by silhouetting them against the sky and using the same orange yellow for their panels as he does for the bridge's underbelly. He has the engine spew a stream of smoke that becomes the only cloud-like form in the sky, though he alludes to its earthbound source by repeating its profile in the trees and bushes. The bridge ends on the far bank exactly where the trees begin, in line with the first slat of the wooden fence below. That line is the *rabatment,* which divides the canvas into a vertical rectangle on the left and a square on the right. Such a tactic was not new and was easily executed. The line situates forms on the canvas so that they appear harmonious or natural in the illusion of the scene. That in turn gives the painting an iconic quality.

Monet goes further. While the square section contains the largest elements, the vertical rectangle echoes the shape of the piles and helps to emphasize their strength and monumentality. Moreover, the trees along the distant shore break to expose the horizon, which, if continued to the left and right, would cut the picture perfectly in half. Extending the upper edge of the trestle to the right leads to the upper corner of the canvas; drawing it out to the left touches the top of the sailboat and ends at the water's edge. Everything is intimately connected, because Monet has distilled the jumble of the site to create a kind of ideal world, part fact and part fiction, partly seen, partly imagined. While solidly constructed in this deeply felt image, Monet's personal vision was one that he would soon find untenable.

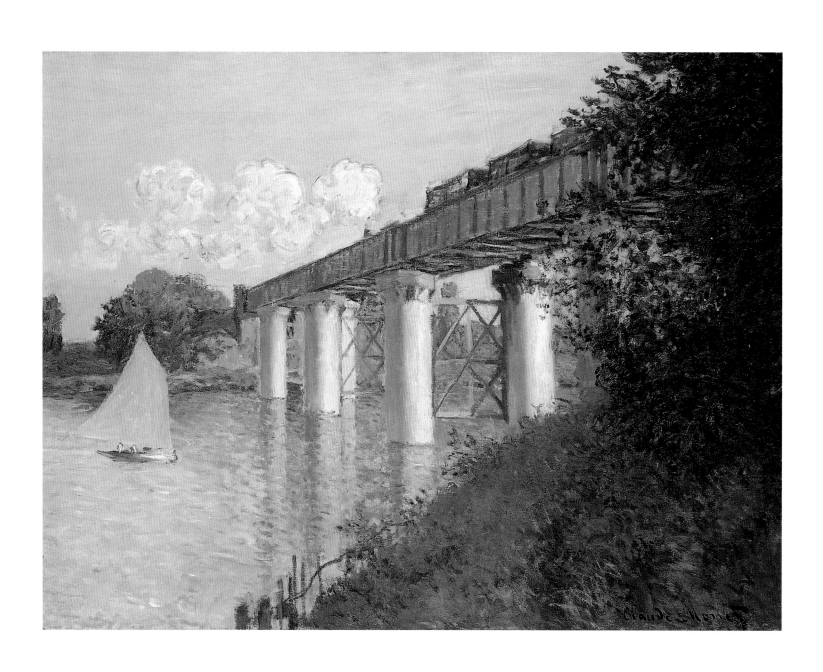

Claude Monet
The Highway Bridge and Boat Basin
1874
oil on canvas
60 × 79.7 (23 ⅝ × 31 ⅜)
National Gallery of Art, Washington,
Collection of Mr. and Mrs. Paul Mellon

Standing on the banks of the river at Petit Gennevilliers looking north toward Argenteuil's tree-lined promenade, Monet transforms the most popular site in his adopted town into an image of classical calm and modern beauty. Each element in the scene is precisely measured, meticulously disposed, and exquisitely refined.

Compositionally the painting is a model of restraint. The Seine stretches across the canvas, a broad span of water carrying a dazzling array of heightened color. It is paralleled by the thinner strip of the beige and green bank on the opposite side, as well as a lush, fairly regular stand of trees and the airy expanse of the cloud-filled sky. These successive horizontal bands—each of different color, texture, and density—provide a structure of great stability.

This balance is daringly challenged by the massive form of the highway bridge, thrust into the picture on a radical diagonal, offering a forceful contrast to the strata of water, land, and sky. The bridge ends at a multistory tollhouse whose strict but modestly scaled geometry complements the more rugged forms of the arches, roadbed, and piers. It emerges from a sharply defined shadow into the glare of direct sunlight, its triangular roof culminating where the line of foliage breaks to reveal the sky.

Such subtle conjunctures abound in the picture. The triangular patch of foliage in the immediate foreground cushions the intrusion of the bridge. An open triangle defined by the mast, bowsprit, and stay of the black-hulled sailboat at anchor is artfully aligned with the bridge so that most of that weighty structure appears poetically balanced on the craft's thin cord like some mighty arrow on an enormous bow. The mast at the left rises from no definable source, though it presumably belongs to a boat that lies out of our view at the very edge of the river. Like a conductor's raised baton or one of Malevich's suprematist elements, it hovers in space, locked into position by our assumptions and Monet's artistry. Superimposed on background objects, it seems to touch the right edge of the raised white cabin of the boat behind it and to overlap the corner of the white house on the distant shore, a device more often associated with Cézanne in the 1880s than high impressionism of the 1870s. The top of this mast changes from orange yellow to purplish blue where it meets the sky.

One startling detail begins at the top of this mast, where the stay descends to the left and crosses in front of the background trees, then touches the tip of the mast of the boat under sail. The stay does not traverse the triangular white sail to meet the boom of the boat to which it belongs; instead it ends at the sail's upper right edge. This was a conscious decision, which bears witness to the varied ways Monet stitched together disparate elements to create a place of idyllic enchantment.

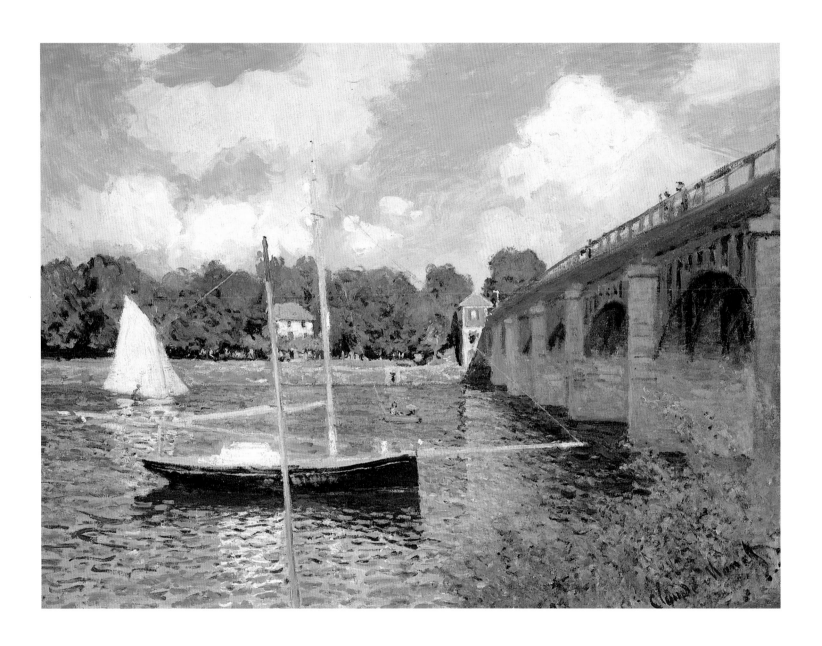

Gustave Caillebotte
The Argenteuil Bridge and the Seine
c. 1883
oil on canvas
65 × 81 (25 ⅝ × 31 ⅞)
Private Collection

Prior to the arrival of the railroad in 1861, the highway bridge was the primary link between Argenteuil and Paris, providing the only way over the Seine. First built in 1830–1831, this bridge quickly became the lifeline for the town. It was also one of the area's most noted landmarks. An elegant structure of seven arches that sprang from substantial stone foundations, it was bold and beautiful, qualities that Caillebotte aptly emphasizes in this dramatic image.

With typical imagination and a distinctly modernist flair, Caillebotte views the structure close up, not from a distance, which would have forced him to play its long, straight roadbed against its rhythmic arcade. He concentrates on a single span, pulling it so close and elevating it so high on the picture plane that we see only one of the hand-laid, stone piers on the far left. His low, angled vantage allows him to expose the underside of the five steel ribs that leap across the width of the picture and to silhouette the far rib against the cloudless blue sky. We can likewise inspect the bottom edge of the roadbed as it overhangs the nearest arch. The tensile strength of all these supporting elements is heightened through a subtle manipulation of light and dark.

As an amateur engineer and boat designer, Caillebotte was clearly interested in the mechanics of the bridge, something he reveals in his attention to its many structural details. He carefully delineates its various horizontal and vertical members; he differentiates the perforated exterior ribs from the solid, interior ones; and he shows that the feet of the arches are bolted deeply into the midsection of the pier, as is most evident in the one on the far right, which receives the strongest sun.

But what is perhaps most impressive about Caillebotte's treatment of the bridge is how he suggests its elasticity and demonstrates that each part works together to create an integrated whole. This is clear from the multiple touches of blue, beige, yellow, and white on the pier, which imply that it is not a single entity but a composite of individual blocks. From the angle of its right edge, this massive form appears to be leaning to the left, as if in response to the pressure of the arches springing out of its side. The ribs begin in unison but join together as they rise to the right, then disappear behind the rib closest to us just past the midpoint of the span.

On the right Caillebotte makes the rectangular openings in this near rib coincide with those of its mate on the far side, an optical illusion compounded by other interesting visual effects: the almost inexplicable square opening in the bridge above this alignment; or the continuity of the far rib down the

pier by virtue of its shadow, which Caillebotte ends exactly halfway across that support. This point is also where the shadow of the bridge's roadbed on the water begins.

The shadow of the roadbed, like the bridge itself, cuts across the canvas on a slight angle, but it becomes lighter and more slender as it approaches the right side. That Caillebotte does not have it meet a pier there is a mark of his ingenuity. This quality is even more apparent in the way he lets the arches appear to leap into a void. The only things that hold them up are our belief in the existence of a pier beyond the frame and our trust in Caillebotte's artfulness.

His cunning is easy to confirm, as it derives from the dynamic Caillebotte establishes between the thrust of the bridge and the rectangular shape of the canvas, the latter being reiterated throughout the scene—in the pattern of darks and lights on the water and in the distant bank and pathway. Other carefully devised moments in the picture reveal his painstaking decision making: the railroad bridge in the right background appears to intersect the end of the foreground arch; the bow of the steamboat on the river aligns with the shadow of the railroad trestle on the bank; a factory chimney rises in the middle of the background hill. This coordination is baldly repeated in the way the far rib imitates the hill as a whole. The two reach their apexes at precisely the same point, allowing Caillebotte to suggest the link—both real and aesthetic—between the human and the natural.

All of the parts seem to fit together perfectly. The steamboat and barge are almost equidistant from the highway bridge and the railroad bridge and are paired with two groups of houses in the background that themselves pleasingly frame the collection of larger houses and factory buildings in the center. In the wedge of sky above the bridge the upright posts of the railing are aligned with the weightier vertical members of the steel supports below.

The concurrence of these parts suggests Caillebotte's belief in the essential harmonies of the world, just as their dynamics underscore his embrace of the fundamentals of change that ruled his day. Nothing is entirely stable here; forms are cropped or moving through space, which itself is both open and confined, continuous and restricted. Everything in the picture is subject to the flickering light that Caillebotte so sensitively renders with his broken brushwork and lively palette, just as everything is vulnerable to the possibilities of transformation, whether through the powers of modern art or those of modern life.

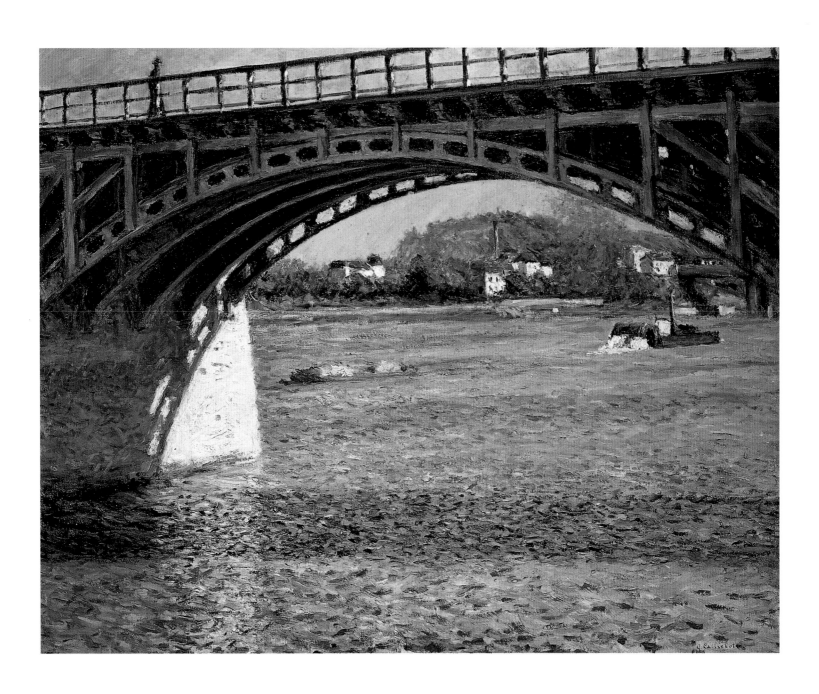

30

Claude Monet
Regatta at Argenteuil
1874
oil on canvas
59 × 99 (23 ¼ × 39)
Private Collection, Switzerland

31

Auguste Renoir
Regatta at Argenteuil
1874
oil on canvas
32.4 × 45.6 (12 ¾ × 18)
National Gallery of Art, Washington,
Ailsa Mellon Bruce Collection

Above all else, Argenteuil was known in the Paris area as a superb site for pleasure boating. The Seine here, on its second loop north out of the capital as it wound its way to the English Channel, opened to its widest reach and dropped to its greatest depth between the eastern edge of town and a few kilometers beyond the municipality's western border. This stretch of the river was also one of the straightest and least encumbered. Although bridges crossed it at various points, including two at Argenteuil, no islands blocked its passage and no projections of land along its banks forced it off its clearly defined course.

Argenteuil became a center for aquatic activities early in the development of the suburbs. Parisians, seeking solace from the city, came to enjoy themselves in the open air, savor the excitement of the river, or indulge in various forms of boating. Those who owned a boat could moor it there. From the 1850s onward Argenteuil hosted regular regattas during the summer months (see photograph on p. 120), and it was chosen as the site for international events such as the sailing competitions for the Universal Expositions of 1867 and 1878. It was also selected as the home for the most prestigious sailing club in the region—La Société des Régates Parisiennes—whose headquarters were in the capital but whose facilities were on Argenteuil's shores, where members were said to leave their hearts every summer weekend.

That so many impressionist paintings completed at Argenteuil include boats is not surprising. Recreational craft were ever-present in warm weather, especially on the weekends and on Sundays (most people worked a six-day week). That an impressionist painting depicts an actual regatta is also understandable. These events occurred quite often, were lively

Cat. 30

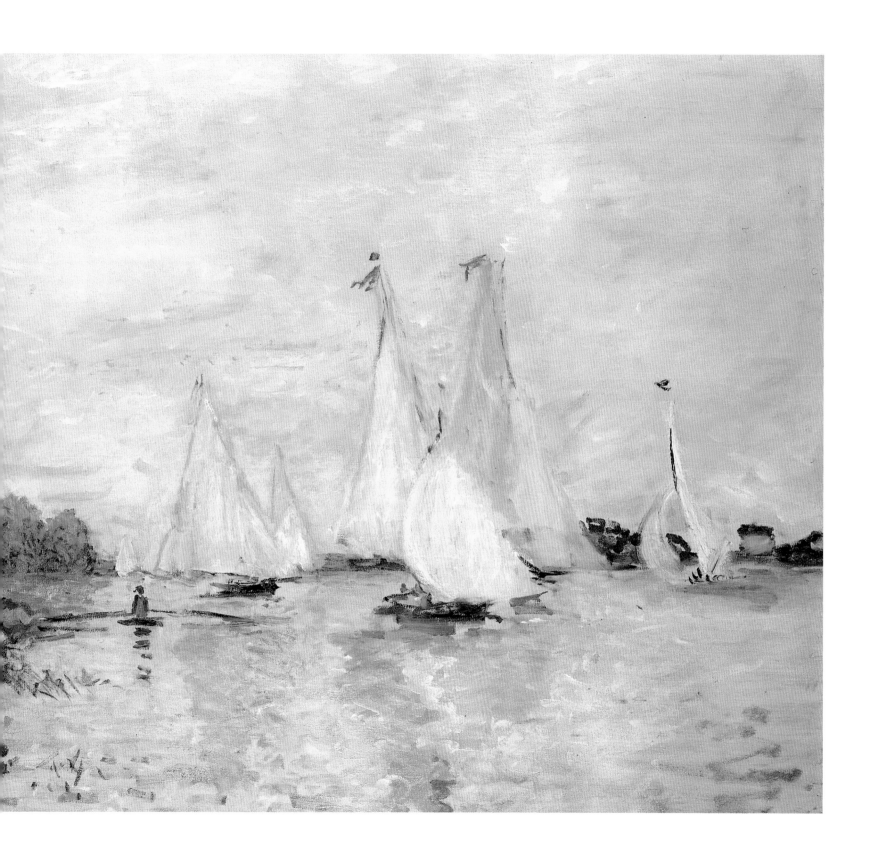

and festive, and had considerable visual and popular appeal. Yet the impressionists were not interested in documenting their world like commercial illustrators. Nor did they want to produce genre paintings for a ready market; they left that task to mainstream artists.

What then are we to make of these two canvases? Unfortunately, we know nothing about the genesis of either one. No letter survives from either artist concerning the enterprise, and no commentary from contemporaries sheds light on the subject. Both pictures represent the same site and were most likely painted on the same day during the summer of 1874 when Renoir came to stay with Monet at Argenteuil. The works share many specifics: a fleet of tall-masted sailboats that sport red streamers from their spar tops; a white tent on the shore flying a red-and-white striped flag; a crowd of onlookers; the same gauzy clouds and diffuse lighting. Each also includes an isolated boater in a different craft—a scull in Monet's view, a rowboat in Renoir's. The compositions are generally parallel—a rectangle of water and land set off against a larger expanse of sky. Both have a sketchiness that suggests a partisan style or a similarly limited time frame for their completion. Each artist seems to have been intent on conveying not only the movements of the boats and their reflections on the shifting water but also the contrasting textures of the landscape: the grassy bank, the translucent river, and the wispy clouds.

Prior to this summer Monet had completed just one other canvas of an event such as this. In 1874 he finished not only this painting but another of the same kind of gathering. These constitute the only three versions of this subject out of the nearly seventy views of the river that Monet painted during his six years at Argenteuil. Renoir's painting is unique in his oeuvre.

Whatever prompted the two friends to paint these pictures, both embraced one of the most contemporary forms of entertainment. And both created final products that are as different as they are alike. To begin with, Monet's canvas is twice as big as Renoir's. Monet also spreads his boats across the river, while Renoir allows his to form a jostling crowd in the center. The cluster of sails and hulls in Renoir's view gives the impression of greater activity, while the carefully positioned boats in Monet's painting slow the pace.

The differences are evident in style as well as composition. In Monet's picture the short, independent brush strokes that indicate the foliage on the bank lengthen and become more horizontal as Monet describes the Seine and then the sky. In Renoir's handling of paint there is very little relationship between the bank and the river, or between the water and the sky. Similarly, Monet defines the edges of most of these sails with an individual line, often of a different color, whereas Renoir gives the sails plasticity through the paint itself or through the juxtaposition of bare and painted canvas, such as that between the background trees and the second sail from the left. Renoir makes the spectators on his shore more substantial than Monet's veritable stick figures and opts for a more spontaneous effect overall. Monet insists on freedom but also on more stringent coordination of elements, a tendency in much of his work at Argenteuil, revealing his more formal sense of order.

Unlike Renoir, Monet had settled down in this suburban town to raise a family and live what amounted to a bourgeois life. He was constantly faced with the necessity to negotiate between propriety and disregard, conformity and independence. All of the impressionists were, of course; but some, like Renoir, may not have taken the challenge quite as much to heart.

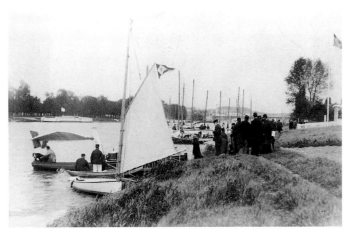

Boating activities on the Seine at Argenteuil, late nineteenth century

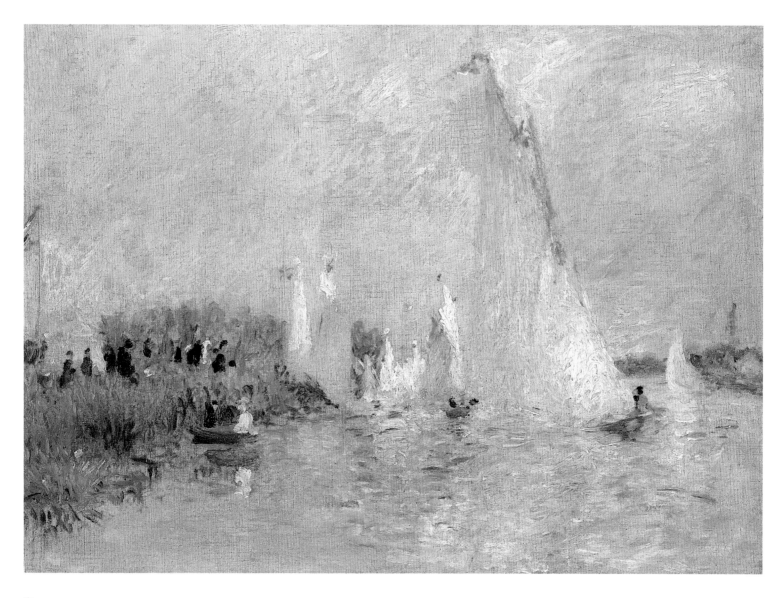

Cat. 31

32

Claude Monet
Sailboats at Argenteuil
1874
oil on canvas
60 × 81 (23 ⅝ × 31 ⅞)
Private Collection, Switzerland

33

Auguste Renoir
Sailboats at Argenteuil
1874
oil on canvas
51 × 65 (20 ⅛ × 25 ⅝)
Portland Art Museum, Oregon,
Bequest of Winslow B. Ayer

If any two paintings define the shared aims and aesthetic of the impressionists at Argenteuil in the 1870s, it is surely this pair. Done in the summer of 1874, probably on the same days, perhaps at the same time, certainly from the same spot, they have rightfully come down to us as icons of the movement. They also stand as heartfelt testimonies to the ways in which two friends could work together without jealousy or rancor to create innovative art.

There is little precedent for this kind of activity. Artists in the past copied other art, and they often worked side by side, either in the studio or on field trips, learning from each other and from mentors who accompanied them or from masters and images they carried in their heads. But it is extremely rare that two premier artists would set up their easels in front of the same motif, as Monet and Renoir did here, and produce completely finished paintings so close in kind that they intended to sell. It suggests a noble dose of humility, since neither work would be seen as unique. It also suggests profound mutual respect, since each artist knew the other's talents and could anticipate—indeed even witness—the way the other's painting would turn out. It underscores their devotion to rendering modern subjects *en plein air* and to reveling in the glories of the moment.

The moment they both capture is manifestly glorious, with warm light filling the scene. The sails of the foreground boat billow with air and anticipation, setting the tone for the craft beyond, which race up and down the river, energized by the wind. Even the ducks paddle contentedly in the immediate foreground, while the river glistens. Both artists indicate their vantage points on the bank by including tufts of grass in the lower right corner. Each allows the main components in the picture—water, land, and sky—to stretch out across the canvas. This is a day to celebrate life and to enjoy the offerings of a place like Argenteuil.

For all of their similarities of site, subject, and feeling, the two landscapes are actually marked by many differences. Renoir depicts more sailboats than does Monet, including one at anchor, while Monet opts for two sculls that Renoir omits. The white house in Renoir's background trees is not to be found in Monet's. The dock enters Renoir's view from behind a cushion of grass; in Monet's it begins higher on the picture plane and emerges without encumbrances. A man stands at

the end of the dock in Renoir's painting, silhouetted against the jib, his hands in his pockets; his counterpart in Monet's canvas is on the deck of the boat and seems about to climb into the cockpit, where a second figure sits holding the tiller. In Renoir's picture the skipper stands, allowing the jib to luff and the ropes to lie on the deck by the mast. Even the ducks are different. There are four in each. But in Monet's version they are all white and divided into pairs; whereas in Renoir's two are white and two are brown, while three are grouped together in no apparent order and the fourth swims alone toward the dock.

The differences do not end there. The reflections in Monet's view are more consistent and intact; in Renoir's they are more fractured and dissolved, as evident particularly in the reflections of the sails of the foreground boat. Monet makes the contours of the background trees more regular than does Renoir, with fewer sharp drops and rises. Renoir includes two boats at the far left that do not appear in Monet's picture and also more of the bank. In addition, he shows more of the bridge at the far right than does Monet, even providing a glimpse of what lies beyond the first span.

Comparison of the two works is therefore a lesson in artistic decision making, an opportunity to evaluate contrasting ideas about compositional tactics, editing, and surface structure, all of which reveal different ways of thinking about art and ultimately about the world. Compositionally, Renoir's version is messier, more jumbled, more active and congested. His touch is also more varied and erratic. Monet's composition is cleaner, simpler, neater, and more disciplined, just like his manipulation of the medium. The internal harmonies have been more distilled in his painting: two red sculls run parallel to the bank in the background, for example; and the more erect mast of the foreground boat makes the whole image tauter and more poised. Renoir's left-leaning mast makes the jib and mainsail less muscular.

Emblematic of this contrast is the way each artist handles the bowsprit of the foreground boat. Renoir's not only inter-sects the dock, it runs parallel to the bottom of the picture, its stay overlapping the stern of the anchored boat to the right. In Monet's view the same bowsprit angles up from the dock, allowing it to be silhouetted against the water so that it appears more forceful, active, and engaged, much like the sails

of the boat itself. The mainsail in Monet's picture tends to dominate the scene, whereas in Renoir's it has to compete with other white forms for our attention. Monet's sails become purer, more abstract, and more insistent, evident from the fact that he allows the mainsail to prick the top of the painting. Renoir's sails seem part of the general chaos of life, as they are less rigorous and cut off by the top of the canvas.

Monet coerces the larger whole into an orderly set of relationships; Renoir allows relationships to remain organic, as if they were generated from within, not imposed from without. Monet's image offers a particular kind of idealism, one that is considered and rational, balanced and reassuring. Renoir's world is closer to real life, with all of its entanglements and loose ends. Neither is better or worse. These paintings are simply different, which in the end is perhaps more significant than the initial impression of their many similarities.

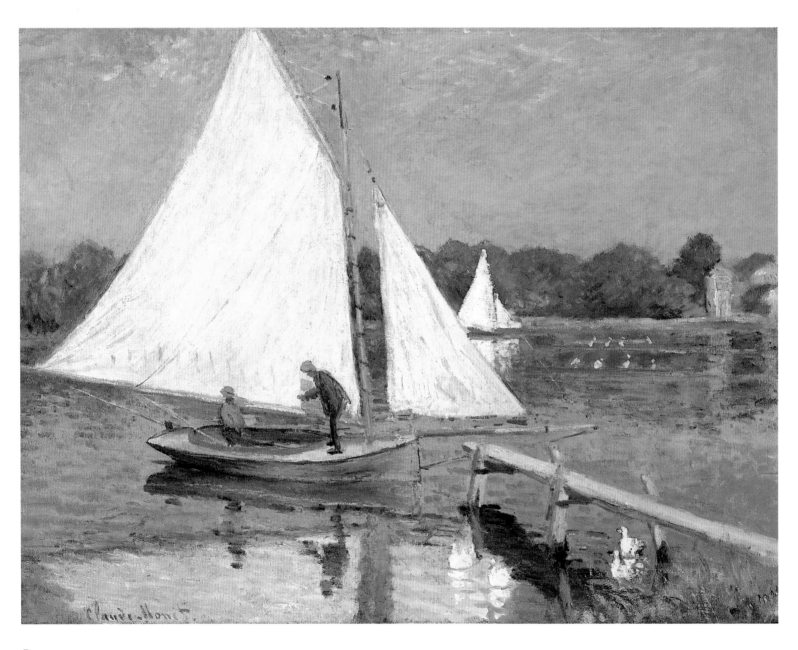

Cat. 32

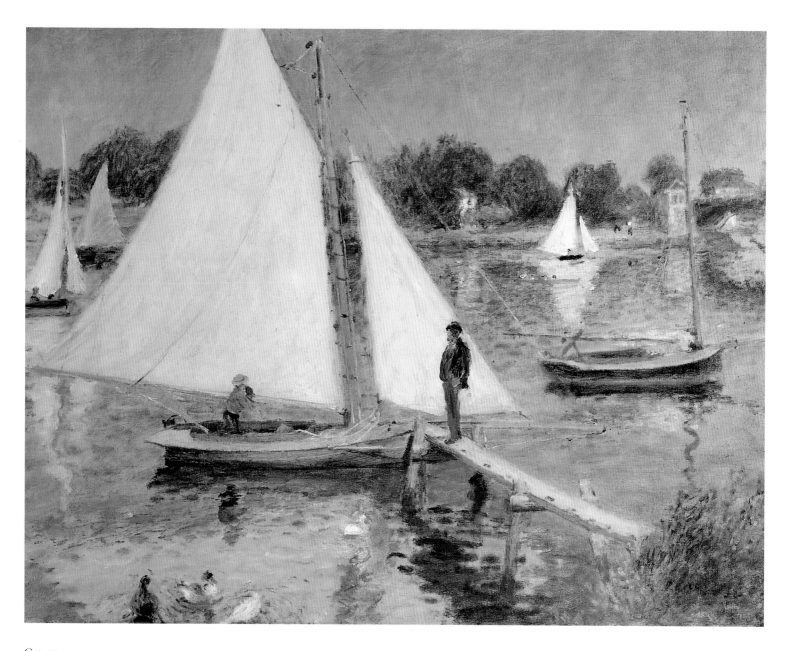

Cat. 33

34

Edouard Manet
Argenteuil
1874
oil on canvas
59.4 × 81.3 (23⅜ × 32)
National Museum and Gallery Cardiff

From the banks of the Seine at Petit Gennevilliers, Manet looks across the water to Argenteuil's laundry houses and promenade. Unlike most paintings by the impressionists, this canvas is activated more by forms and fluid paint handling than by light and weather conditions. This is due in part to the unfinished nature of the image; like his view of Claude and Camille Monet in the studio boat (cat. 39), it was the product of only a few working sessions. Thus even in the nineteenth century it would have been considered a sketch, not a completed work of art. If Manet had pursued the painting further, he would surely have developed the natural effects he hints at here.

But what is particularly compelling about the scene is its apparent spontaneity and undeniable directness. Little seems to have come between Manet's eye and hand, which translated the visual data onto the canvas with consummate freedom. The immediacy and purity of that transcription were most likely the result of his executing the picture *en plein air,* not in the studio, as had generally been his practice. Ironically, it may well have been the difficulty of carting the canvas, easel, and painting supplies to the site and enduring the fluctuations of nature and perhaps the interest of onlookers that contributed to Manet's decision to leave the work in its present state.

In any case, the impression of its plein-air execution derives from its bravura application of paint. Long strokes of golden brown and teal in the immediate foreground palpably describe the ripples of water, the reflections of the boats, and the whispering light of the mirrored sky. The boats themselves are more sculptural, particularly the hulls, where blended touches of gray suggest their plasticity. These strokes seem to have been set down with stunning swiftness, which is even more noticeable in other aspects of the craft—the deck, boom, sails, and masts—all of which have a freshness that suggests their nearly instantaneous realization.

Beyond the boats Manet changes brushes, colors, and effects, covering the area between the pleasure craft and the bank with broad, multilayered swaths of olive green and black that completely hide the canvas left visible elsewhere. Yet here too there is a straightforwardness to his handling that implies he painted the passage while standing on the bank. The laundry houses support this notion, as they consist of single brush strokes, laid down without hesitation. While expressing utmost confidence, these marks are also lightly outlined in black, as if Manet were consciously pairing line and color, edge and form, a raw juxtaposition he would have refined if he had

continued to work on the image. The trees above are dashed off with great facility, while the sky is made up of energetic strokes that head in different directions, underscoring the ease of Manet's actions and the openness of his aesthetic to novel motions of the brush.

This picture is compositionally very close to Manet's fully developed *Seine at Argenteuil* (cat. 35). Three boats sit in roughly the same position in each, their gaffs, furled sails, and reflections all but identical. So similar is the disposition of elements in the two paintings that we might presume this version served as a preliminary study for the other or as a first essay Manet decided to broaden to create the finished work. It is highly unlikely that the artist would have painted the sketch *after* the more developed image, which lends credence to the assumption that this version was at least begun on site.

The evidence is of course purely circumstantial. Given Manet's virtuosity, he could easily have painted this canvas in his studio. Certain details do suggest the kind of care that such an environment inspires. Note the way the bows of the boats nudge each other, the first rising above the gunwale of the second, the second precisely in line with the edge of the third. In the finished painting Manet pulls the first bow down slightly so that it just misses the gunwale of the second boat, as the second does the third. In the sketch the masts are almost too perfectly aligned and too judiciously spaced. In the final version Manet disrupts both solutions, tilting the masts more irregularly and making the space between them more evenly divided, which renders them less consciously artful. Furthermore, in the sketch Manet is deliberate about coordinating the masts with the laundry houses in the background. From left to right, the first one parallels the right edge of the first building, the second bisects the second structure, and the third imitates the first by falling at the right edge of the second washhouse. In the finished picture he adjusts the points of contact to accommodate the shift in spacing; in so doing, as with the angles of the masts, he makes their relationships appear less planned.

Whether the product of the site or the studio, the sketch reveals how well Manet balances the spontaneous with the considered and how much he relies on stringent formal structures, despite the apparent casualness of the surface. He divides the picture into successive bands of light and dark— the lighter foreground water and darker hulls, the lighter sails and darker reflections in the water, the lighter stretch of the bank and laundry houses and the darker band of trees,

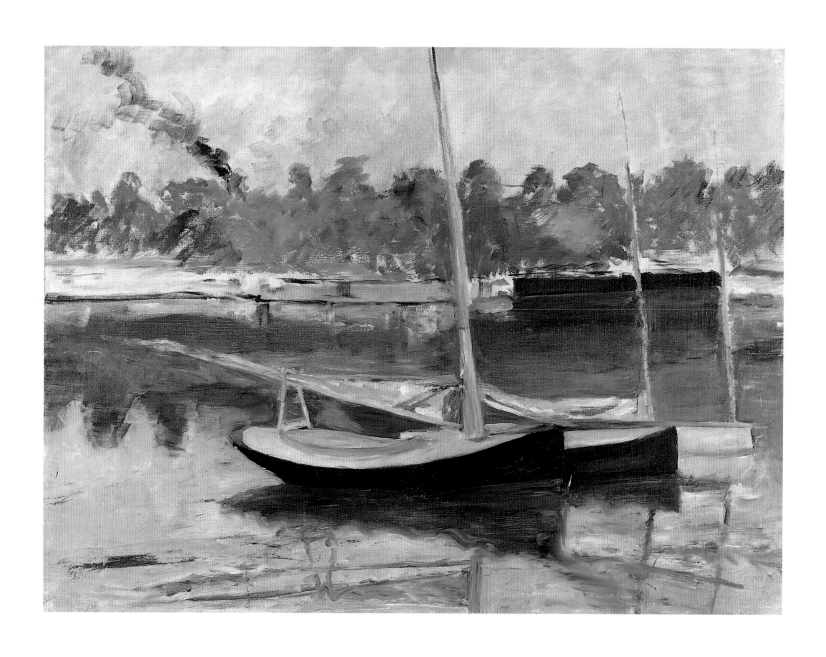

and finally the lighter sky. In an equally discriminating way, he controls the heights of the masts so that they descend on a consistent diagonal. In the final version he opted for less obvious rhythms.

Perhaps Manet employed these strategies to keep his errant brush in line or to help him order the inchoate—the unmanned boats and moving waters, the indeterminacy of modern life and the fickleness of nature. Whatever the case, the sketch holds as many surprises as it does recognizable relationships. He includes a trail of smoke, for example, that twists upward toward the left-hand corner from an unseen source. In the finished painting he depicts several factory chimneys, though all of them are silent.

The challenges of the picture and its evident working state may explain why it was never exhibited during Manet's lifetime and why it remained in his hands until his posthumous studio sale in 1884. It then passed from dealer to dealer until it entered the great Welsh collection of Margaret Davies, the only private owner of the picture, who generously donated it to the National Museum and Gallery Cardiff in 1963.

Detail, cat. 34

35

Edouard Manet
The Seine at Argenteuil
1874
oil on canvas
62.3 × 103 (24 ½ × 40 ½)
Private Collection, on extended loan to the
Courtauld Gallery, London

In Manet's hands the familiar is often layered with the mysterious or inexplicable, the comprehensible transformed into the confusing or strange. Occasionally, the reassuring can suddenly seem inauspicious.

Such elisions or crossovers occur even in paintings as radiant as this. They are more subtle here than in much of Manet's work, particularly that from the 1860s when he burst onto the Paris art scene, laying siege to long-held beliefs about French art. That may be because in this large and ambitious picture he has engaged a subject that had not been part of his repertoire during the previous decade. It was not until after the disasters of the Franco-Prussian War and Commune of 1870–1871 that he began to develop an interest in the innovations of his younger impressionist colleagues—so evident in this canvas—namely, the rendering of contemporary figures *en plein air* in recognizable settings with broad brushwork and heightened color.

During the summer of 1874 Manet spent several months at his family's property in Gennevilliers across the river from Argenteuil. He immersed himself in the study of these impressionist strategies, producing some of the finest paintings of his career, this work among them. Ostensibly, this view of the boat rental area at Argenteuil presents a motif that would have appealed to most urban dwellers in the 1870s, the primary clientele for such art. The countryside appears bright and inviting. Two well-dressed figures—an elegant woman and a spruce young child—stand on the banks of the river whose surface shimmers with light and color. Boats bob at anchor on either side of them, while a soft but insistent wind blows through the scene, causing the water to form ripples and the grass in the foreground to become activated. Manet's scandalous *Luncheon on the Grass* and *Olympia* of the Salons of 1863 and 1865, respectively, are very distant from this image. There is no apparent dependence here on studio refinements and no expressed desire to make a name for himself by appropriating past art in an overt and shocking manner.

All is not as simple as it may appear in this painting, however. While initially dazzling, the landscape suggests inherent ambiguities typical of Manet, who by 1874 was widely acknowledged as one of France's leading artists, even if he did not enjoy broad-based support. First, there is the question of the two figures. They are most easily understood as a mother and her child. But Manet provides no support for this reading. The two do not interact with each other or

with their environment. It is not even clear if they are holding hands. The most one can say is that they seem to be out for a stroll and have stopped to look at this stretch of the Seine.

Yet it is not the most picturesque site. Although the boats are attractive, the structures at the opposite bank are not. They are houses that did laundry for residents of Argenteuil. They immediately lock the scene into modern culture (formerly people washed their clothes in the river) and affirm the area's proximity to an urban community. Without these floating buildings, the view might seem more rural. Their hard, planar shapes compromise the idyllic quality of the setting, contrasting with the trees and with the graceful, sculpted hulls of the boats in the foreground whose colors they unexpectedly share. This site obviously serves labor as well as leisure and has been irrevocably altered by the presence of human beings.

The band of trees beyond the washhouses confirms this realization. In views of more remote locales by mainstream contemporary artists, trees are more randomly arranged. These were planted by municipal agreement. They are the same species, regularly spaced, and of similar shape and height. Manet underscores the suggestion of human intervention by having the masts of the boats vaguely imitate the line of trees, from which they of course derive. He also implies it with the two figures on the bank, whose closeness to each other mimics that of the trees and whose hats even echo individual tree shapes.

It would not be unreasonable to expect more activity near an urban environment, but only these two figures occupy the site, making the scene seem almost ominously empty. Why are the child and the woman there? Are they waiting for others to join them for some pleasant activity? Or are they in a reflective stasis, caught—like the other objects in the picture—between one moment and the next, between stability and change, illusion and reality? Manet allows us to contemplate these slightly troubling questions so fundamental to his time, just as he invites us to enjoy the beauties of the day and the brilliance of its translation into paint.

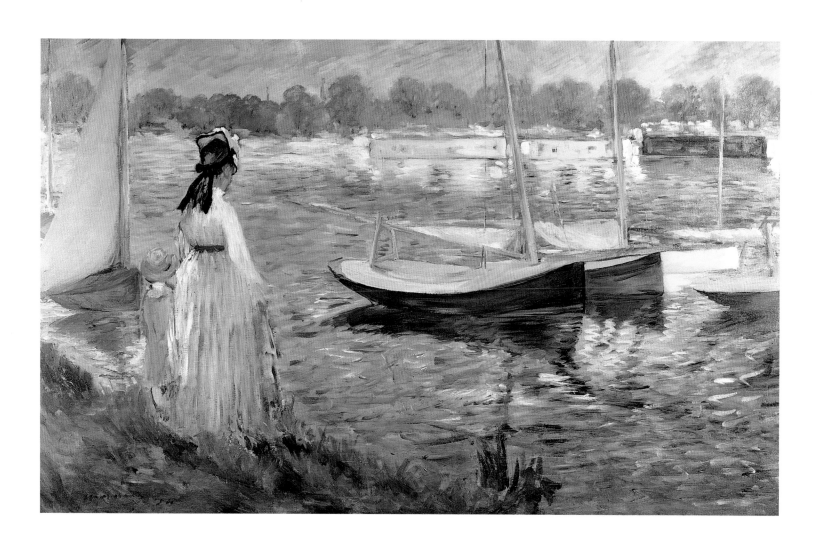

Gustave Caillebotte
Richard Gallo and His Dog Dick at Petit Gennevilliers
1884
oil on canvas
89 × 116 (35 × 45⅝)
Private Collection

Carefully considered yet strikingly fresh, alive with light but marvelously restrained, this painting is as imaginative as it is direct. It is also as much a portrait of a place and a time as it is of Caillebotte's good friend Richard Gallo. Mixing genres as well as traditions, the timeless with the transient, it attests to this artist's ingenuity and the ways that the suburban town of Argenteuil could continue to yield novel material for the advancement of modern painting.

With his typical rigor, Caillebotte divides the scene into four strata—the foreground bank, the Seine beyond, the houses and trees on the other side of the river, and the cloudless sky. Stretching the width of the canvas, these bands suggest the continuation of the space beyond the confines of the frame. Except for the sky, which is thinly painted with a relatively pale blue, each area is emboldened by rich pigment and almost tangible light. Little wonder Richard Gallo is out for a walk with his dog on this fine day.

Because Caillebotte lived on the Petit Gennevilliers side of the river, it seems appropriate that he painted this picture on his home turf. Given the strength of the late morning or early afternoon sun, it also makes sense that Gallo posed in the shade, where it would have been cooler. The shade was provided by a grove of trees that photographs and other paintings show standing on this bank of the river. While protected from the sun, which bakes the promenade across the Seine, the foreground nonetheless bears telling evidence of its powers. The untended grass on either side of the well-trod path sparkles with light. So too does the path, dotted with pom-poms of light intense enough to obliterate the forms beneath them. Even Gallo and his dog are adorned with these sun spots, although they are softer and less distinct. One wonders what Seurat would have thought of these amorphous but believable points of light.

It was from such highly intelligent impressionist paintings of course that Seurat learned his lessons. Gallo and his dog are clearly outlined and statuesque, much as Seurat's figures would be; the two also seem curiously frozen, despite their implied movement through the scene. They are not connected to one another by a leash; indeed both are in their own worlds, walking without regard for the other. At the same time, they are subtly linked. Both walk only on the grassy part of the path; each leads with the right foot, the left pushing off or raised; both hold themselves erect and assume serious, elegant airs,

the dog more so than his owner. The dog is further distinguished by his position in front of a dais-like area of the bank, which begins just below his nose and continues past his bejeweled neck to end behind him. His tail punctures the outline of the slope on the right, its fuzzy extension standing up like the tufts of grass.

Gallo's position is similarly calculated. Most of his body overlaps the river, unlike his dog's, which is largely landlocked. The water conveys a sense of being open and free, reflective and changeable. The ground, by contrast, imposes restraints and limits. Only the dog's head and tail push beyond the bank's hold, but the figure of the master rises through all three zones—the path, river, and opposite shore—appropriate for this man of the world, who was the editor of *Le Constitutionnel,* a major Paris newspaper. Note the way Caillebotte aligns Gallo's head with forms in the background. The far bank draws his gaze horizontally across the canvas and out of the scene to the left; the wall lines up with his nose in front and his hairline in back, a conjuncture that is reinforced in the melding of his bowler hat with the foliage on the trees across the river.

Richard Gallo, unlike his dog, is fundamentally related to the complex constructs of Argenteuil, a distinctly modern place. It is where trees give way to large, sun-bleached houses, and then to an array of smaller structures on the left. Initially there appears to be no rationale to this progression. But it is ruled by late nineteenth-century logic, which sees the realm of nature giving way to suburbia, and suburbia is altered by commercial pressures, which leads to the elimination of all natural elements. The human takes over the landscape, creating an all-too-familiar innocuous sprawl.

The reflections on the water reinforce this progression. First the foliage stretches across the river to enclose Gallo's figure, then it quickly diminishes to allow the two large houses to assume their place of prominence; they are followed by the more modest, blue-roofed house to the left. At this point the reflections level out and become more amorphous as the buildings diminish toward the left edge.

It was men like Richard Gallo whose intellect and power effected this transformation and created the diverse, contradictory situation laid out in this picture. There are no judgments rendered here; like a good journalist or newspaper editor, Caillebotte makes certain that the strata are level. He captures

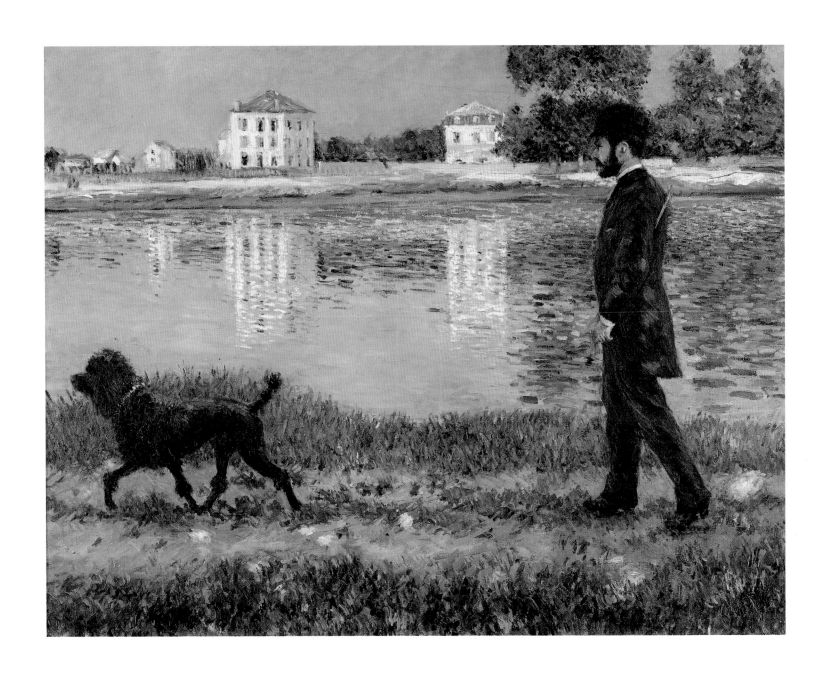

a similar balance between the painting's posture as a portrait of Gallo and its allegiance to the venerable, though modernized tradition of landscape art. Given the amount of canvas he devotes to the reflections in the river, however, not to mention the seemingly random dashes of light in the foreground, the artist communicates the lurking sense that many things are unknown and unforeseen in the world, despite his almost scientific naturalism or the brimming confidence of Gallo and his rococo pet. Gallo steps forward like a modern *kouros,* but he enters a universe dominated by shifting relationships and unpredictable realities. He is isolated and alone here, as is fitting in a painting created to honor him. But that would not have been the case in the broader arena of combative Paris and its evolving suburbs in the 1880s.

Detail, cat. 36

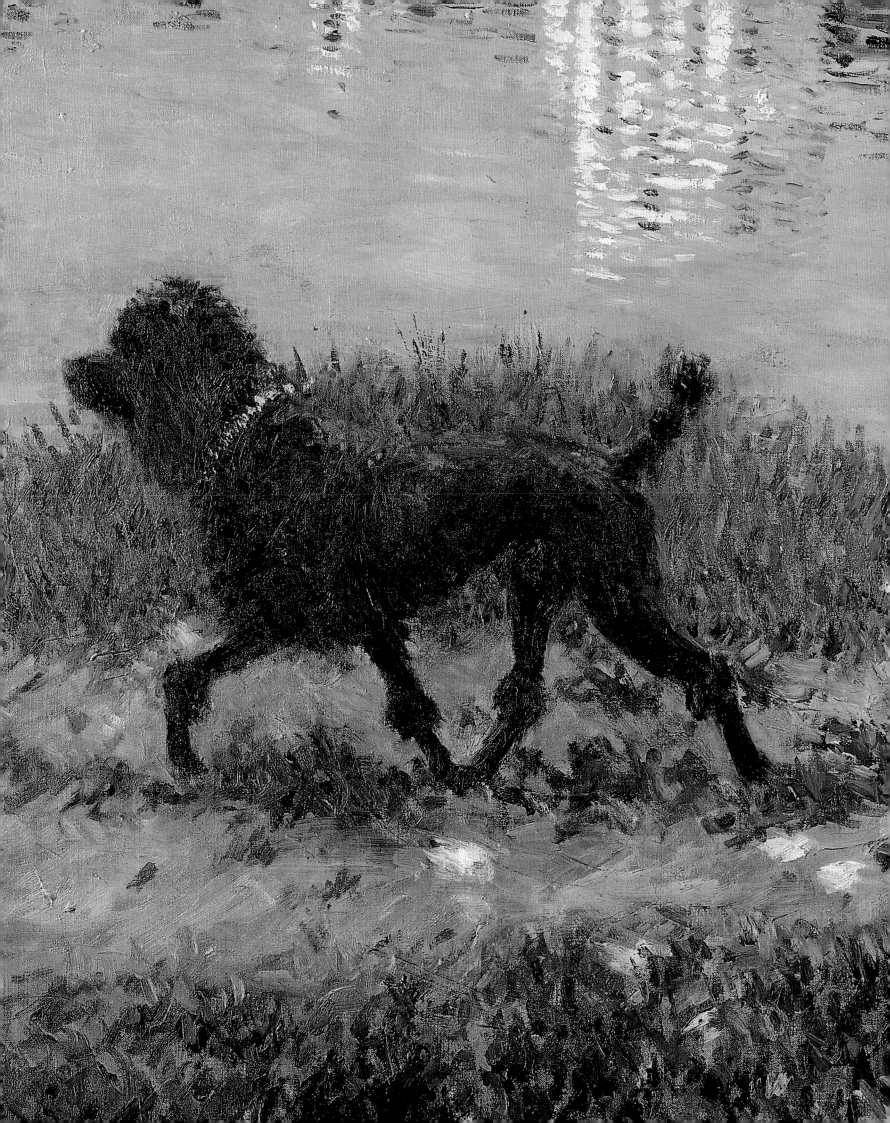

Claude Monet
The Ball-Shaped Trees, Argenteuil
1876
oil on canvas
60 × 81 (23 ⅝ × 31 ⅞)
Private Collection, Europe

Standing on the Petit Gennevilliers side of the Seine, looking northwest to the end of Argenteuil's tree-lined promenade, Monet endows this painting with a noble stillness and an emotive grandeur more reminiscent of Claude Lorrain and earlier art than the breezy spontaneity of high impressionism. To some extent, this seriousness derives from the partitioning of the composition—a grassy bank in the immediate foreground, a stretch of undisturbed water, a strip of land in the background with its assorted houses and trees, and a broad swath of sky capped by a soft gray cloud that reaches the width of the canvas. But the gravitas also springs from the intricate relationships Monet establishes among these areas. The bush on the left is echoed first in the ball-shaped trees, then in the denser arc of the chestnut grove to the right. The reflections of the central trees reach across the Seine to unite the two banks, a coupling that is encouraged by the dip in the foreground undergrowth. The reeds on the right, by overlapping the reflection of the trees along the promenade, provide another link between near and far.

The classical calm of the view is further engendered by Monet's close coordination of color and touch. The greens, purples, and browns of the foreground reappear in deeper values in the background, while the pale blues, pinks, and beiges of the sky are carried across the central section by the tranquil waters of the Seine. Similarly, Monet's staccato-like brushwork in the foliage of the near shore finds its counterpoint in the more matted application of paint in the distance. Conversely, the long, horizontal strokes in the sky are given even greater prominence in their reflections on the river. Other small alliances reveal Monet's sensitivity to the site and his desire to evoke a harmonious parity among its elements.

The scene represented is exceedingly peaceful. No boats ply the waters, no factory chimneys spew smoke, no promenaders disturb Monet's contemplative isolation. So quiet is the image that the river could easily be mistaken for a small pond or lake, while the two houses might be misinterpreted as being part of a private estate. Nothing could be further from the case, as the area was one of the most popular in Argenteuil and the subject of many paintings, including Boudin's early view of about 1866 (cat. 1) and Caillebotte's portrait of *Richard Gallo and His Dog Dick* of 1884 (cat. 36). The same houses appear in Caillebotte's stately rendering of his friend, while the tallest trees in Boudin's landscape are the same that stand in the middle of Monet's. By eliminating people and pleasurable pastimes, however, Monet transforms this public site into a place for personal reflection, which ultimately explains why the painting possesses such an aura of distilled serenity.

The impressionists had often turned the private into the public. Degas peered into backstage areas at the ballet and intimate interiors of brothels for his art, while Monet used his backyard at Argenteuil as the setting for numerous paintings. But in this gentle, evenly lit scene Monet achieves the opposite, as he does in his portrait of his studio boat from a vantage point slightly further to the right (cat. 38). He suggests the ways in which the external world can give rise to poetic reveries and the contradictions of modern Argenteuil can be suppressed for the evocation of a bygone order.

It is not that Monet renounces his period or compromises his commitment to a contemporary vocabulary. No Barbizon artist or follower of Claude Lorrain would have applied his medium with the freedom Monet demonstrates throughout this work, particularly in the bush on the left, whose branches are forcefully set down with single strokes of a loaded brush, causing each leaf to quiver with life. Nor would they have been as attuned to the specific conditions of light and atmosphere, temperature and movement, that Monet so deftly conveys here.

Yet Monet has clearly framed his view in a rigorous enough way to carve a classical idyll out of a more diverse setting. The melange of structures that stood to the left of the imposing houses, which Caillebotte included without apology, were part of the sprawling development of Argenteuil's western corridor. Monet does not avoid them entirely in this painting; they are partly visible through the branches of the bush on the left. But he has minimized them. After four years of living among Argenteuil's bold transformations of tradition, which he had propagated in dozens of iconic images, the now thirty-five-year-old artist had begun to revise his opinion of this progressive-minded suburb. There was something splendid about silence and quiet sunsets, just as there was much to be gained by retreating to one's own garden, an option Monet increasingly exercised from 1876 onward. This painting exudes Claudian qualities because they were becoming essential to Monet. It should be no surprise that the foreground foliage seems so strained; nature was at risk in Argenteuil's evolving future, which makes the subtle connections that Monet effects between foreground and background all the more elegiac.

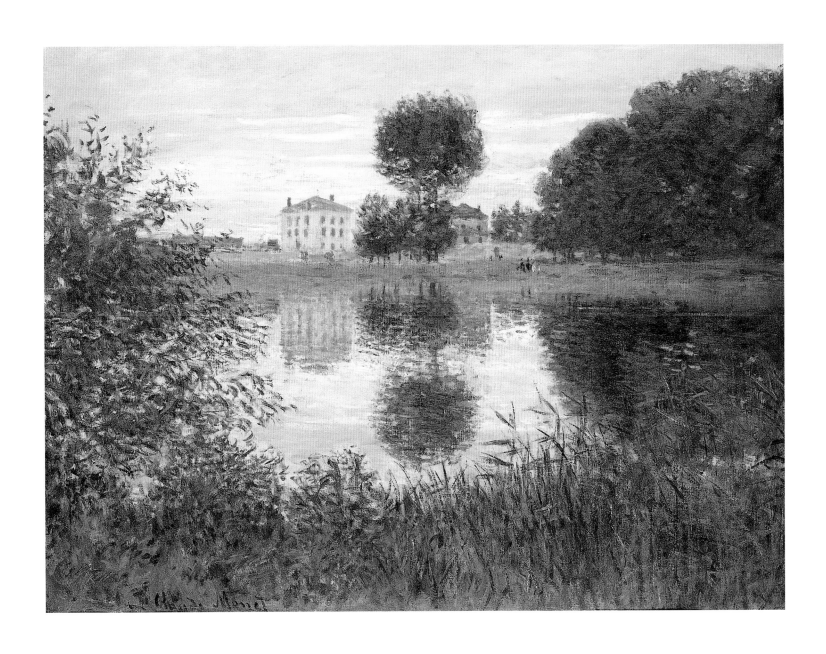

Claude Monet
The Studio Boat
1874
oil on canvas
50 × 64 (19 ⅝ × 25 ¼)
Kröller-Müller Museum, Otterlo, The Netherlands

This subdued but resonant painting of a tranquil stretch of the Seine is an imaginative though verifiable combination of elements dear to Monet. It depicts one of his favorite sites, the boat basin just downriver from the highway bridge, which is out of view to the right. And it includes the promenade at Argenteuil, which appears in the background, bordered by a line of richly foliated trees and the houses on the left. Most important perhaps, it features his studio boat.

Lying at anchor next to two tether poles presumably sunk into the river bottom by the Petit Gennevilliers bank of the Seine, the boat turns on an acute angle. Its light green wooden cabin is tucked neatly inside the gunwales of the shapely black hull, its sleek roof lifting up at the back as a broader counterpart to the elongated bow. Although the boat appears relatively substantial here, it was a modest craft that Monet had commissioned in 1874, the year he painted this picture. After living in Argenteuil for two and a half years and completing many views of the Seine from its banks, he wanted to be able to work directly on the river. This desire was natural for someone creating images of great immediacy. Painting from his boat, he could provide his viewers with the sensation of being virtually at water level, buoyant and unfettered, alone and yet at one with the world. He probably also wanted to be able to take the boat out for pleasure rides on the Seine, imitating so many of his contemporaries.

Growing up in Saint-Adresse, a bourgeois suburb of the industrial port city of Le Havre, Monet was familiar with nautical craft and had painted them in all shapes and sizes throughout his youth. One of his earliest works is a pencil drawing of frigates and dories he saw regularly along the coast of the English Channel. There is no record of Monet's having done much traveling by boat, except when fleeing to England and Holland during the Franco-Prussian War and the Commune. Nor is there evidence that he ever owned a boat before moving to Argenteuil. His father earned his living servicing larger ships as a chandler, so perhaps until this time boats were too closely associated with labor to instill notions of leisure.

That Monet at age thirty-three purchased a boat and rendered it so faithfully is significant on a personal and a practical level. It speaks of his success, as such a boat would have been expensive. Monet earned 24,800 francs the previous year, or twice what doctors and lawyers were making in Paris at the time, and he was ordering his wines from Narbonne and Bordeaux instead of drinking cheaper local vintages. At the same time, he must have believed that the boat was a reasonable investment. Although he was generally careful about money, he never skimped on professional expenses. He bought his painting supplies from one of the best houses in Paris, for instance, and maintained a studio in the capital so that he could meet dealers and collectors; he was keen to ensure that his canvases would remain in superb physical condition over time (as most of his work from the Argenteuil period has). Monet also had unwavering confidence in himself as an artist and would do what it took to advance his career.

Yet this painting does not express boldness. The boat sits alone on the river, utterly unadorned, as if abandoned or overlooked. In other views, notably by Manet (see essay fig. 20), it features a sporty striped awning above the door and a flagpole that stands erect near the bow. Here it appears somewhat forlorn, much like the scene as a whole, with its somber tones, dull gray light, and absence of human beings. The site hardly seems the same one that inspired so many vibrant paintings of modern life during the decade.

The peace in this picture is weightier and more prescient; we are being asked to enter a contemplative world, symbolized by the boat with its solemn reflections and sense of isolation. Although we are in one of the most popular areas of town, we are looking at a studio, a place where the artist ponders the nature of things and tries to give form to feeling. The invitation is complicated in Monet's case, because he always claimed that he never had a studio but painted only in the outdoors. In addition, his floating atelier was modeled on a boat that his older friend, Barbizon artist Charles Daubigny, had built in the 1850s and employed to paint in remote corners of nature that had not felt the pulse of change.

The quiet in Monet's painting seems hard-won if not slightly forced. The boat appears attached to the background by the poles and the reflections of the trees, at the same time it is pulled toward the foreground by its orientation to the right. Monet himself was likewise caught between conflicting concerns—between desires for undisturbed nature and for the exhilaration of modernity, between the romantic past and the realities of the present. As a modern landscape painter, he sought to resolve these conflicts in various ways, providing tethers and guideposts like the poles in the river. But he may have also felt obliged to expose the difficulties of the task: inside the cabin sits a vaguely defined figure, perhaps Monet himself, alone in the shadows as if contemplating the mysteries of art making and the ways in which the old and new, the imagined and visible, inform our understanding of ourselves and our time.

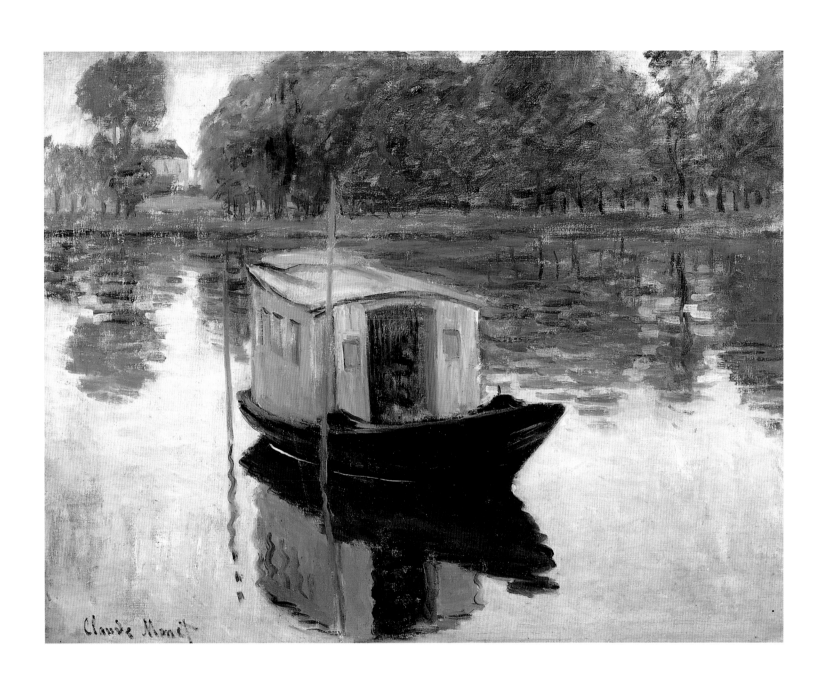

Edouard Manet
Claude and Camille Monet in His Studio Boat
1874
oil on canvas
106 × 134 (41¾ × 52¾)
Staatsgalerie Stuttgart

He sits snug and secure in his floating studio, his beautiful wife at his side, the boat's ornamental awning extended over their heads. Bedecked in his straw hat, his brush in his right hand, his palette and other instruments of his craft in his left, the quintessential impressionist is represented by his urbane friend Manet as hard at work. With his canvas angled into the picture beside his knees, his body is oriented toward his art. But he seems to have been distracted by our presence and turns his head and shoulders in our direction. Despite this slight contrapposto, his position is stabilized by the planar surfaces behind him. Those to his left and right are the exterior walls of the studio cabin; the one directly behind him is the studio's interior. The edges of these walls frame his head, keep his torso erect, and lock his arms into their actions.

His wife sits in profile, her arms by her side, her chest boldly outlined against the right panel of the cabin. From this closed, formal position, made more so by her full dress and high-collared jacket, she turns her head to face us, her eyes unblinking, her reserved expression matching her overall stance. She is held in place by the outside edge of the cabin as it descends behind her elegant, oversized bonnet to her chin and by the curve of the awning that hangs down just above her head. She is also pinned by the railing on the gunwale at the lower right, which projects from the juncture of her jacket and her bustle, and by the lax halyard that begins at her backside and rises to touch the edge of her jacket before exiting the scene at the right on the same horizontal axis as her pinched waist. Finally, her back is firmly silhouetted against the irregular but evidently open area behind her.

Claude and Camille Monet are literally and figuratively bound together in this picture, like muse and performer, or more mundanely, like some bourgeois couple whose privacy has been invaded by an outsider. Manet emphasizes their connectedness, not only through their proximity—their legs overlap, and Monet's left elbow touches Camille's right hand—but also through the radical limitations he has imposed on the composition. There is nowhere else to go here, so constrained is the space and so limited are the number of elements.

Of course the latter is due in part to the painting's incomplete state. In the nineteenth century as well the work would have been seen as merely a sketch and would have required considerable refinement to qualify as a finished work of art. It would have held little value and less meaning for the contemporary French audience, a well-heeled and narrow-minded group. Even those who thought highly of pure bravura would have expected more definition. Monet's face, for example, is blurred, and the rest of the canvas very thinly painted.

It was the pervasive prejudice against the spontaneous and the unfinished that Manet and his impressionist colleagues challenged, especially during the 1870s. They believed that the direct expression of sensations that were derived from personal contact with carefully chosen subjects could provide their audience with a more vital and honest art. By clinging to the present and to that which was verifiable, the impressionists could affirm the heroism of their own period (which Charles Baudelaire had declared to be imperative for artists as early as the 1840s). They could assert the value of the artist as a living and sensitive individual responding to the things of this world. They could also elevate the fundamentals of their craft, drawing attention to their expressive characteristics, not suppressing them through the ploys of illusionism to some ideal realm drawn from the mind of the artist and his awareness of art history.

Their efforts were not greeted with immediate success; traditions were deeply ingrained. But they were not universally derided, as is often made out. The first impressionist exhibition, held in 1874, the same year Manet painted this work, attracted as many positive reviews as stinging criticisms. Even writers who did not like the show applauded the artists' initiative and daring.

Manet did not participate in this inaugural exhibition, preferring to test his mettle against the mainstream competition in the annual state-sponsored Salon. While he too bore the brunt of strong remarks, he was widely recognized as a talent of enormous promise. He would never have submitted this painting to public review, however; in his eyes too it would have been only an initial essay. It is not known why he abandoned the sketch. But it is certain that he was committed to modern subjects—in this case, a friend and his wife—and to what even in its infancy was a forceful image, given its cropping, immediacy, and forthrightness. This was an orientation that Monet greatly appreciated. The painting was also one that he greatly admired, which is perhaps why Manet gave it to him and why Monet kept it until his death in 1926.

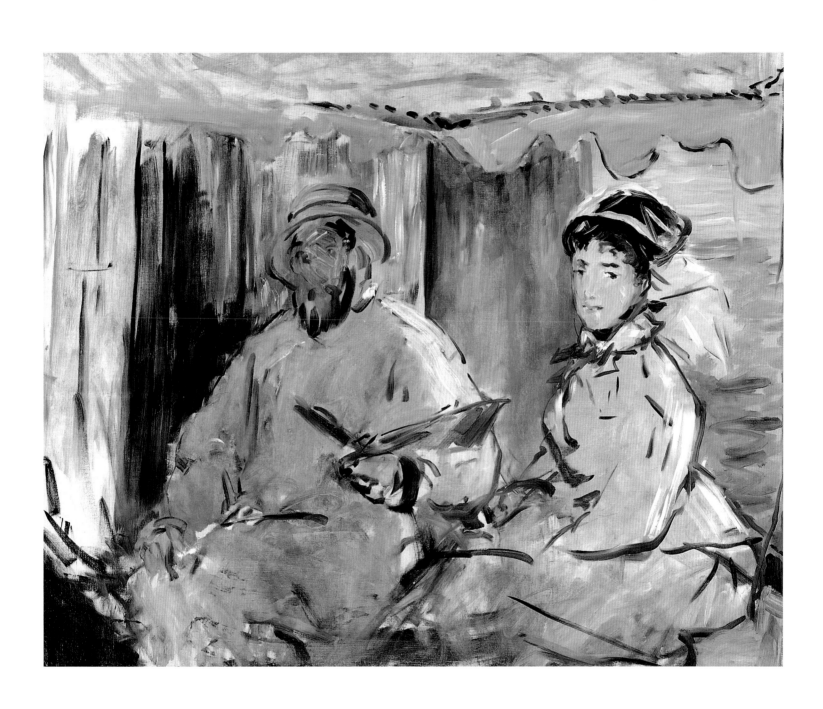

Edouard Manet
Boating
1874
oil on canvas
97.2 × 130.2 (38 ¼ × 51 ¼)
The Metropolitan Museum of Art, H. O. Havemeyer
Collection, Bequest of Mrs. H. O. Havemeyer, 1929

There is something strange and disconcerting about this remarkably simplified painting, a feeling that undercuts its leisure subject, fresh light, and appealing color. The unease derives in part from the couple that dominates the scene as well as from their cryptic attitudes, but it also stems from the bluntness of the composition and from Manet's aggressive handling of his medium.

Initially it is the man in the center who attracts our notice. Seeming at once disinterested and disdainful, he trains his eyes on us as if we were the object of contemplation, not the other way around. His stare is intensified by his bushy eyebrows, one of which arches higher than the other, contributing to his perplexing expression. His power is also increased by the heed Manet gives to his facial features, with strong refracted light sculpting his nose and emphasizing the prominent ridge above his eye sockets.

Seated at the helm of the radically cropped boat, this man appears completely in charge. Although no longer young and not particularly athletic, he seems fit, with the Belvedere bend of his upper body, a taut neck, and sizable arms all adding to the impression of strength. In contrast to his face, his arms are crudely rendered. His right arm emerges force-fully from the tight, crisply defined sleeve of his white cotton shirt, extending the length of his left thigh and closing in a fist just above his knee. His left arm rests firmly on the tiller, his hand cupping its end.

His arms create a U-shaped form that is echoed in the stern of the boat and made sharper in the angle of his legs, the truncated sail, and the section of water defined by the halyard. The diagonal of the halyard parallels the man's back and is vaguely repeated in the black ribbon of the woman's bonnet—small harmonies that reinforce those of the larger whole. The parasol on the right lies parallel to the gunwale and the man's left leg; the oarlock at the lower left is the reverse of the looped end of the material hanging from the woman's hat directly above it.

In many ways the woman is the opposite of her companion. He confronts our gaze; she looks in another direction. He bends forward, twisting to his left; she leans back in a more rigid pose. He is engaged in maneuvering the craft but is not paying attention to his task; she is simply relaxing but focuses on something outside the scene, an intentness that is emphasized by her clear profile, the distinct vertical line of her neck, and the juxtaposition of her nose and the stern. Her dress is colorful, striped, and carefully painted; his sporty sailor's outfit is more broadly rendered in shades of white and gray. Her hat is a floppy, bell-like shape; his is a crisp, straw boater with neat geometries.

At the same time, the two figures are subtly linked. Her hat appropriates the colors of his clothing, just as his assumes those of the stripes and belt of her dress. In addition, the shape of her hat is retraced in the outline of his right shoulder as it continues in the fold at the back of his shirt and the edge of his sleeve. His legs set up the most obvious connections: while his left leg stretches out and disappears under the flutter of the woman's dress, the right one bends up sharply from behind her upper body, almost appearing to grow out of her chest and abdomen, which are accentuated by her high-riding gold belt.

There is something vaguely sexual about these conjunc-tures and contrasts, a suggestion Manet heightens by posing the woman in such a vulnerable, "unladylike" position. The tight cropping of the composition, moreover, concentrates attention on the few elements in the scene and makes us feel as if we have intruded on this couple, prompting the man's visual interrogation. Other details further these notions: such as dark lines inside the man's left pant leg, which appear to imitate the stripes on her dress; the rise of the boom, which is restrained by the tightly tied halyard; and the highly sugges-tive way this halyard is knotted around a peg protruding from the wooden seat.

In a distinctly modernist sense, less is more here. Manet is silent about the ambiguous relationship between these figures or our relationship to them. Wrapped in anonymity yet extraordinarily immediate, the couple and the moment in which they are framed are loaded with meanings. These implications cannot be fully set out, a conclusion the artist underscores with his broad application of paint in so many areas, especially the background waters of the Seine. The painting is therefore both frustrating and fascinating, tangible and elusive, much like modern life in the later nineteenth century.

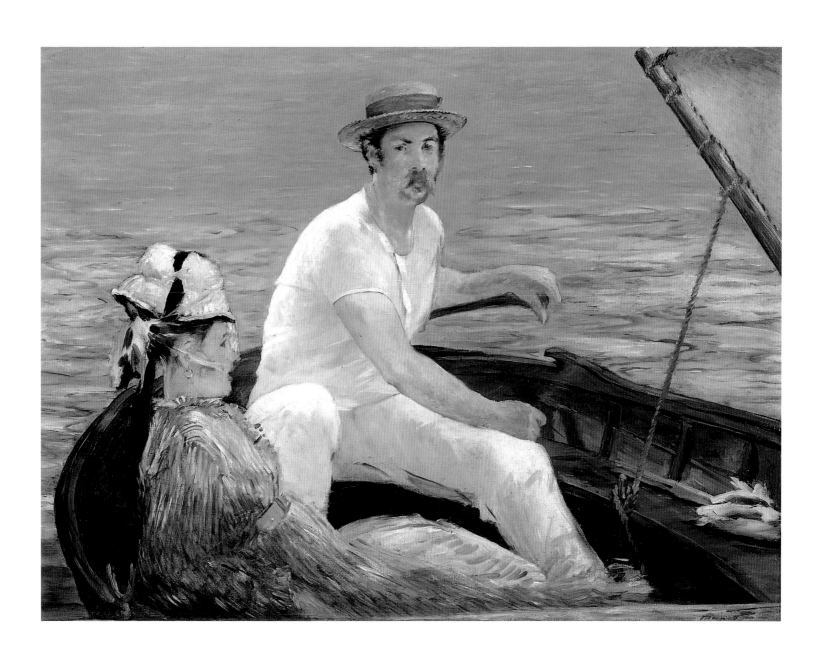

Claude Monet
The Seine at Argenteuil
1874
oil on canvas
55 × 65.2 (21 ⅝ × 25 ¾)
Kunstmuseum Bern, Legat Robert Vatter

Almost evenly divided between earth and sky, this painting is one of the simplest yet most spacious and evanescent that Monet completed at Argenteuil. It is filled with quiet contrasts, beginning with the blind of unruly reeds in the immediate foreground set against the still waters of the Seine.

Supple, gracious, but highly independent, the reeds rise from unseen sources, their lithe stems bunched together at the bottom in a cacophonous group, their upper reaches breaking free into elegant silhouettes. Each reed seems to emerge from the river in an individualized way and turn in a different direction, ensuring the appearance of orchestrated disarray. Several on the right stand apart from the pack, while the tallest stretches high enough on the canvas to touch the sliver of land in the background.

These artful overlaps of near and far and the occasional penetration of the distant shore by the sharp points of the parrying plants create essential alliances in the picture while suggesting unresolved tensions. Monet juxtaposes the intimate, personalized space of his vantage by the water's edge with the breathtaking expanse of the river and sky. He pairs humble, untended nature, as represented by the reeds, with the supposedly rational presence of the human on the opposite bank. Underscoring these contrasts with great subtlety, he allows some of the leaves on the foreground reeds to be suspended in midair, as if floating between two worlds.

Similarly, the land in the background seems poised between river and sky. It splits the scene into two distinct parts, not on a strict horizontal but on a barely perceptible diagonal, adding yet another nuance to a view that initially might seem straightforward. Houses and factories stand solemnly on its shore, their geometric shapes and insistent verticals the antithesis of the flickering foliage in the foreground. There is no trace of nature in this part of the view—no rushes play along its banks, no trees soften the horizon—just as there is no evidence of the human in the foreground. Instead, factory chimneys spout streams of smoke that move resolutely across the sky, blown parallel to the Seine by what appears to be a brisk, late afternoon wind.

Ironically, the sky attains its greatest illumination just above these blue-gray emissions, beginning with gentle pinks that are then energized by stronger, more generously applied yellow beiges and whites. This splay of color is created by the setting sun, which also defines the cloud formation at the left that pulls the eye up the canvas away from the smoke and land.

The right side of the sky could not be more different. Rendered with long, soft strokes that stretch horizontally across the picture before dissipating at the edge, this region is thinly painted with reduced shades of the same few colors that appear on the left; so sparingly is the paint applied that the canvas is visible throughout the area, giving the atmosphere and light Monet has represented here an ethereal quality.

The contrasts in the sky are echoed in the reeds. The ones to the left are dense, restless, richly impastoed. They have been painted wet on wet with a wide range of color—deep purple, olive green, turquoise, yellow green, sea green, light blue. Those to the right are set down with single strokes of a less loaded brush. The colors of these reeds, like those in the sky, are reduced, making their pliant forms appear to vacillate between physicality and illusion, reality and reflection. As simplified versions of the reeds on the left, these plants are more distinctive as calligraphic marks and as signs of Monet's ability to evoke nature's poetry with the most meager of means.

These unaltered touches recall Japanese and Chinese prototypes, an association Monet would have appreciated, given his admiration for the art of the East and his belief in its ability to capture the essence of things with a few quick but practiced gestures. Monet had begun to collect Japanese *ukiyoe* prints during his years at Argenteuil, and a number of his paintings from the period contain specific references to their influence on his aesthetic—*Japonnerie* of 1875 being the most obvious. Renoir hinted at his friend's passion for Japanese art and culture in his portrait of Camille Monet (cat. 16), including a flurry of *uchiwa* fans in the upper left corner.

Like a non-Western artist seeking to reveal distilled truths about his world, Monet ignores the multiple activities of Argenteuil's boat basin, which lay just to his right, and radically reduces the number of pictorial incidents in his painting. He employs few lighting effects and little atmosphere, concerns that were important to impressionism. He shows no pleasure seekers, regattas, or modern bridges arcing through the landscape. In fact, without the turreted house in the background, the site would be difficult to identify. This house appears in many images of Argenteuil (see cats. 8 and 52); it stood at the end of the town's famed promenade.

With the smoking factories and buildings on either side, the house affirms Monet's roots in the present and his embrace of a progressive future. At the same time, the distance that the artist places between himself and those structures, combined

with the relative emptiness of the rest of the scene, suggests the opposite could be the case. Instead of celebrating modern life, Monet may be meditating on the ways in which continuities coexist with change, the natural with the man-made. He may also be reflecting on the ways in which the art of the East was altering the perceptions of the West.

These were weighty concerns for Monet and his contemporaries, and they were not easily resolved. That Monet would express them with such an unusual combination of clarity and restraint in this painting is only further testimony to his perspicuity and willingness to make fundamental contradictions of his life central to his art.

Detail, cat. 41

Auguste Renoir
The Seine at Argenteuil
1888
oil on canvas
51.4 × 64.8 (20 ¼ × 25 ½)
Private Collection

An orange-yellow, Turneresque light pervades this riverscape, enlivening its jumble of competing forms and penetrating its depths, making everything appear tantalizingly sculptural and familiar. At the same time, the view is charged by invisible forces that reveal the world's inherent incomprehensibility. The foliage on the trees is energized by the same powers that activate the cloud-veiled sky. The river is equally vital, its surface heightened by bold strokes of blues and whites that leap left and right like schools of darting fish. These marks contrast in color, shape, and movement with the vertically disposed, squiggling reflections of the mustard yellow masts to the right. Suggesting the motion of the river and the rocking of the sailboats, these reflections pull the background forward, where several ducks swim near a female figure who is crouching in the stern of a rowboat to reach the water.

Initially, this woman seems to be the only person in the picture, but two smaller figures stand on the shore under a large tree on the left, with a fourth on a dock in the distance. Although marginal, these figures help dispel the faint aura of alienation that hangs over the inlet, a feeling engendered primarily by the sailboats. Although the boats appear weighty and calculated, solemn and substantial, they lie at anchor, inactive and unmanned. Oriented on diagonals that exit the scene without impediment, they act like anonymous members of an urban crowd passing us by. Some almost bump each other, but they declare their individuality by their different-colored hulls and singular masts, which rise to staggered heights. The two rowboats in the foreground contribute to this impression, as their dark, ill-defined shapes jut aggressively into the space, partly barring our entry by their blunt alignment with the bottom of the canvas.

Renoir notes further anomalies in this otherwise alluring view. The large red-and-black hulled boat on the far right, for example, is radically cropped, but it towers over the white craft in the foreground. Two masts and a sizable white smokestack rise behind this larger boat, but from vessels we do not see. Just as inventive is Renoir's decision to make the closest rowboat smaller than the one behind it, reversing the norm of perspectival recession. The second boat also appears larger than the white craft to the right, an unlikely relationship that is forced by the confrontation between the horizontal extension of the rowboat and the sharp foreshortening of the sailboat.

These jumps in scale and spacing are evident elsewhere: in the three trees on the left, or the large tree on the right set against the smaller grove behind it. The right bank is more consistent, but the taut, narrow forms of the syncopated masts

provide a counterpoint to the amorphous mass of foliage in the background. Similarly, the clouds expand and contract, thin out and change color, without any apparent logic, manifesting Renoir's sensitivity to the meteorological conditions of the day and his intention to keep his brushwork as varied as possible. This variety creates considerable visual interest while attesting to Renoir's versatility. He also establishes broad connections between the sky and the forms below, with the clouds swelling to their highest point directly above the apex of the river before dipping and rising on the right like the masts below.

These alliances are rare, however, as Renoir prefers the irregular and the unexpected: the patch of light blue sky between the trees on the left, the brilliant white at the center of the composition where the water meets the distant bank, the flecks of emerald green along the shore on the left. He likes the enigma of the woman in the foreground. Why is she alone and what is she doing?

These unresolved, seemingly undisciplined moments in the painting are symptomatic of Renoir's vision of the world as being controlled more by the unanticipated than by the predetermined. He believed in the eccentricity of nature and the value of working without rigid rules and methods. In his youth as a porcelain painter, he wanted every mark on the objects he decorated to be independent and free, every design unique. Human beings, he felt, should not be bound by machines, with their emphasis on repetition; they should revel in the handcrafted and instinctive. These notions became central to the development of his version of impressionism.

The tension Renoir recognized between tradition and progress, the individually fashioned and the mass-produced, was of course that of modern life. And Argenteuil in the late 1880s was more torn than ever between its roots in the rural past and its embrace of the industrial present. Growing rapidly as an ambitious Paris suburb, Argenteuil still wanted to be a site of solace and pleasure, but it could not maintain a viable equilibrium in this struggle. The appeal of change and its attendant rewards was simply too great.

Perhaps in keeping with his distaste for the increased role of machines in his day, Renoir includes no evidence of the industries that had established themselves along the Argenteuil side of the river on the right, where the turreted house that appeared in so many previous paintings of the area still stands. Caillebotte, whom Renoir was visiting when he completed this picture, was likewise judicious in many canvases of the period, suggesting their mutual desire to find the idyllic in the ordinary, even if it had to be carefully extracted or constructed from other realities.

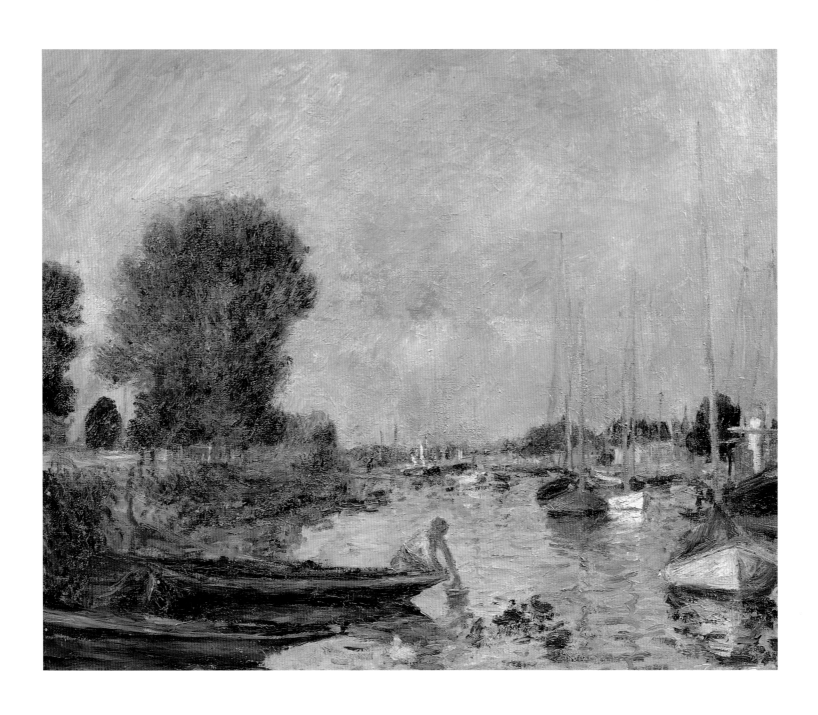

Claude Monet
The Towpath at Argenteuil, Winter
c. 1875
oil on canvas
60 × 100 (23⅝ × 39⅜)
Albright-Knox Art Gallery, Buffalo,
Gift of Charles Clifton, 1919

We are standing just off a path that runs along the bank of the Seine. It is a cold, dank day. Snow has fallen, covering the landscape with a dusting of white. A lone man in the middle of the scene walks toward us, while two others huddle some paces behind him, perhaps in conversation; a fourth stands alone in the background. These figures are a welcome human presence in a less-than-hospitable setting, but they are too far away to offer much of a feeling of connection.

The sense of isolation is increased by the empty foreground and the unadorned vista. There is no drama here, no engaging activity to attract our attention, no break in the meandering line of the river's edge or the more insistent curve of the path as they disappear into the distance. The only thing that interrupts the muffled silence is a boat in the background that spews a stream of smoke. Even the steely gray waters of the river are absolutely still, as are the heavy blanket of purple blue clouds above. Occupying nearly a third of the picture, these clouds add substantially to its unassuming character. They also emphasize the somberness of the moment Monet has chosen to portray.

So unpretentious is the site on this particular winter's day that one almost wonders why Monet decided to plant his easel there and paint the view on such an impressive scale. A closer inspection of the canvas suggests some explanations. First is the appeal of the patchy white snow in its lively contrast with the greens and browns of the earth beneath it. With its tonal purity, the snow gives a freshness to the scene that it might otherwise lack. Then there is the challenge of depicting the various textures of the land. To render the ruts and ridges,

mounds and hollows, Monet had to manipulate his brush like a virtuoso. The area to the left of the path is especially rugged. Monet's many impasto touches, set down so differently one from the other, create compelling effects, confirming yet again his freedom and inventiveness.

This orchestrated cacophony culminates in a huge bush that crowns the slope on the left and rises high above the path. Its branches are silhouetted against the sky, stretching in myriad directions, their fine tracery providing a counterpart to the thicker marks that describe the ground below. Like the solitary figure in the foreground who finds an echo in the two people behind him, this energized bush is balanced by a tree farther back along the path and by the spare trees across the river on the right.

Monet deftly plays the many parts of the painting against each other, balancing their varied surfaces with aplomb. He also places them in high relief—both literally and figuratively—by contrasting the land forms with the placid waters of the river. Nothing disrupts the Seine's silent passage into the distance. No ripples disturb the reflections of the columnar trees on the opposite shore. The river is so calm that it almost appears frozen, a suggestion contradicted only by the movement of the boat.

The boat is a small but telling addition. A craft of industry and commerce, it automatically subverts the rural charm of the scene. Without it, Monet's painting would remain modern by virtue of its style; but its subject, composition, and conceits would recall generic precedents: Barbizon landscapes by Charles Daubigny or Camille Corot, for example, or seventeenth-century river views by Jan van Goyen or Meindert Hobbema. The appearance of the boat at the apex of the river proclaims Monet's allegiance to contemporaneity while underscoring his desire to create new art from the contrasts and contradictions of his own time and place.

That desire must have been what led him to paint this location on the eastern edge of Argenteuil. Only a short walk upriver from the railroad bridge and the heart of town, which lay just behind him, the area was distinguished by its simple but unglamorous parts and its ability to evoke the past while being rooted in the present. The path itself had actually been the only way to get to Paris prior to the construction of the highway and railroad bridges. It had also been the route for horses that towed barges up and down the river before the invention of the steam engine. As a period photograph suggests (see illustration at left) one could easily

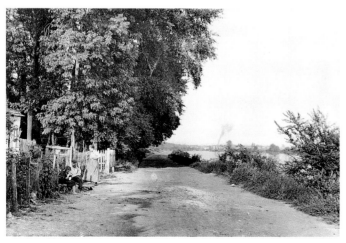

View of the Seine at Argenteuil, late nineteenth century

be lulled into believing that time was standing still. There are no buildings in the view, no factories, houses, or other evidence of the modern world.

Monet contributes to this effect himself. Nothing in his picture is endowed with special gravity; nothing seems to aspire to be anything other than itself; nothing, except for the boat, holds any particular significance—and the boat is relatively discreet. Monet clearly wanted to press each component into an integrated whole. His low vantage enhances this impression, as do the rigorously maintained tonal values and the open access he provides to the scene. Filling more than half the width of the foreground, the path invites us into the picture with unfettered ease.

Yet there is something distinctly unpastoral about the landscape, something that keeps us from believing we are being led into the past. The boat of course is a product of modern engineering. But the path too, unlike those in Sisley's views of the Seine (see cats. 9 and 13), rushes into the depths of the space with the speed and deliberation of a roadway, not a country lane. Even more insistent is the way that Monet renders the features of the land. His aggressive handling of the paint in these areas suggests the rough and tumble of life. It is not a scene for peaceful reverie or dreams of days gone by. There is simply too much tension in the paint, too much movement, contrast, and nonconformity.

Monet also physically differentiates the road from the land and water, the bush on the left from the hills beyond, which themselves differ from the sky. This allows him to affirm the integrity of each element and to justify its presence and visual interest. His intention is to take these common, ungainly forms, even those that might traditionally seem unattractive, and stake a claim for their place in the lexicon of landscape. Initially they may not all appear to be worthy of inclusion, but by selecting a humble site and casting it in an unprovocative light, he invites us to inspect it more closely and in the process perhaps discover—as he did—the mysteries and poetry that lie all around us.

Detail, cat. 43

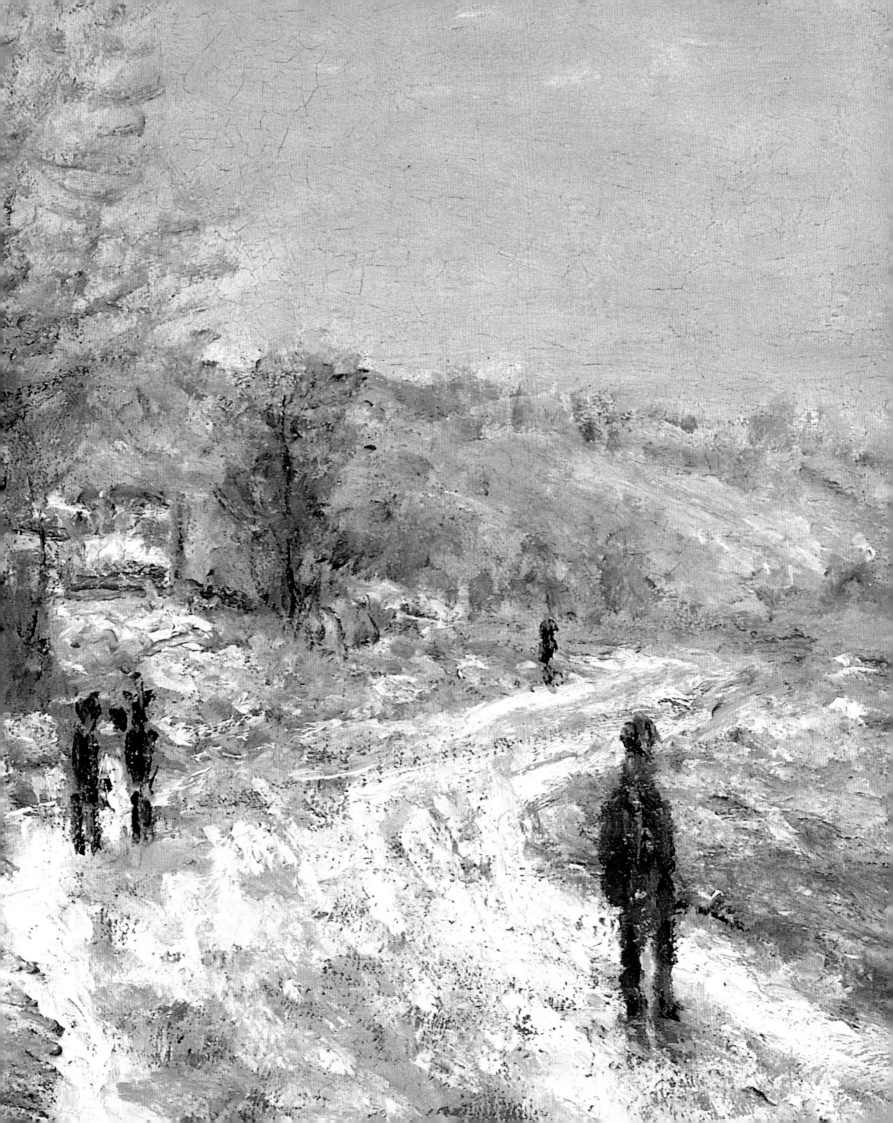

44

Claude Monet
The Boulevard Saint-Denis, Argenteuil
1875
oil on canvas
60.9 × 81.5 (24 × 32)
Museum of Fine Arts, Boston, Gift of Richard Saltonstall

Snow flurries and sunshine—an odd combination of natural effects to experience in reality much less in an impressionist picture. But this solemn and at the same time bracing painting, dating from the fourth winter Monet spent in Argenteuil, reveals the artist's allegiance to the diverse aspects of his sub-urban home and to the range of nature's wonders he relished and ennobled.

It is a blustery, overcast day. Half a dozen figures walk up the snow-covered path or along the street in the middle distance, bent against the wind, trying to shield themselves from the elements with strained umbrellas, no matter how unsuccessfully. Snowflakes swirl throughout the lower half of the scene, while the trees and bushes, especially on the right, shudder under the weight of the barometric pressure. The snow has been falling for some time. It has blanketed the street, covered parts of the roofs of the houses, and collected on the ledges of the pink and green walls. It has also settled on the horizontal members of the fence on either side of the foreground path.

The snow provided Monet with ample opportunity to enliven his scene, not only through its texture, density, and temperature but also through its varied responses to light. Some areas of the path and street appear to glow, while others have absorbed the blue-gray tonalities of the sky and appear deeper and more somber. Such subtle effects, especially in a landscape that is for the most part evenly illuminated, attest to Monet's sensitivity to the ways that snow reveals itself under these unusual conditions.

More obviously, the snow establishes a compelling contrast with the larger constituents of the site—the fences, houses, walls, and trees—all of which appear darker in comparison. The snow is far from pure, however, at least that which has already fallen. The middle of the path has been packed down by pedestrians, while the edges are a bit scruffy. The hill at the left, marked by many blotches of brown, blue, and gray, was either never completely covered because of its uneven surface or it was disturbed by some previous activity. The top of the tree on the right is bare, whereas the branches on the bottom are laden with snow.

This general lack of consistency may reflect what Monet confronted when he was painting, but he used the variations to enrich his picture visually and to suggest certain meanings. The snow helps to delineate areas that are highly geometric: the semicircular hill, a triangular area of foliage on the right,

the hourglass of the path and street, the rectangular walls and the irregular rooflines of the houses. The disorder of nature is constrained by human-imposed order. Monet marshals these forms to create further tensions, especially where the rounded hill and the triangle of foliage impinge on the path while out-lining its boundaries. The two shapes push and pull against each other while stretching to fill the illusionary space. The houses and trees continue the contrasts, as they are distinguished by type, size, and location.

Such differences undoubtedly existed more or less as Monet portrayed them, but he chose a vantage point to reveal and emphasize them, then gave them their dynamic by employing a highly intelligent compositional strategy. They remind us that nature may be varied and difficult to define but that human actions pose similar problems, particularly at that stage in the later nineteenth century when the only certainty was change itself.

Nowhere was change more apparent than in Argenteuil, which had grown rapidly during Monet's time there. The site seen in this painting is emblematic of these shifting realities. The path in the foreground led to the railroad station, directly behind us. The houses along the street were new; when Monet arrived four years earlier, they did not exist. The property had been open land owned by a single individual, the same Emilie-Jeanne Aubry who rented Monet his first house, which is the large home in the center of the picture. Monet therefore heard and saw these houses rise. Even more to the point, in 1874 he moved into the one on the far right, with its sharply angled roof and smart green shutters. He did not have to travel far to paint this picture. That he would create an image of such contrast and resolve makes sense. This was his neigh-borhood, his world, one that was in the process of being transformed, putting particular pressure on the place as well as on anyone who lived there.

To Monet it was clearly a worthy subject to commit to canvas. Like the pedestrians struggling against the elements with a destination in mind, he was facing the challenges of being a landscape painter at a time of radical change. Not sur-prisingly, the view is thoroughly modern and yet as rigorous as one by Nicolas Poussin or Claude Lorrain. It proves Monet's continued ability to balance the new and the old, the human and the natural, assuring us that they could indeed be harmo-nious, despite—or perhaps because of—the transformations of contemporary life.

Gustave Caillebotte
Landscape at Argenteuil
1889
oil on canvas
60 × 73 (23 ⅝ × 28 ¾)
Private Collection

This view of Argenteuil is unique in Caillebotte's oeuvre; it also has no parallel in the work of any other artist who painted in the suburb in the last three decades of the nineteenth century. Its rarity derives mainly from the vantage Caillebotte has selected. He is standing on the opposite side of the Seine, at a considerable distance from the town. The spire of the Eglise de Notre-Dame, Argenteuil's newly constructed church, rises just under the lower boughs of the tall trees in the center. The rolling hills in the background, which run from Sannois to Orgemont, confirm the location. Caillebotte depicted one of these hills in his rendering of the highway bridge at Argenteuil (see cat. 29). For this painting he is looking northeast; the Seine, though blocked by trees, runs horizontally through the scene just beyond the patchwork of fields.

To reach this spot, Caillebotte turned left after leaving his house, which lay directly across the Seine from the Argenteuil church. He then walked around the Île Marante, suggested by the dense grove of trees in the middle ground to the right of the steeple, and climbed a hill that appears in the foreground. This hill was the highest point in what was otherwise a relatively flat area. The rise afforded a stunning view, but Caillebotte does not maximize this advantage. Instead he fills nearly half of the canvas with the plateau itself, its midsection pushing into the center of the scene like the bow of an immense boat, its tip defined by nearly identical trees whose foliage begins at the horizon, thus linking the foreground with the background. The outline of the plateau echoes that of the distant hills, though rising and falling more radically.

Caillebotte, like so many precursors from the seventeenth century onward, wants to create an ideal landscape, where humanity is accorded a sympathetic and appropriate place. He nestles the region of greatest human activity between the plateau and the background hills. Although this is only a narrow strip between undeveloped expanses, it is in harmony with the rest of the picture. Well-tended fields at the foot of the plateau, with sharp geometries and contrasting colors, give evidence of the hand of local farmers. The verdant, fertile land appears to have been cultivated for centuries, a witness to the long, productive relationship between the site and its occupants. A large house to the right of the two central trees reinforces this, as it sits grandly but fittingly in its tree-buffered space below the church, its face warmed by the same sun that rewards the landscape as a whole. Behind the house, curtains of green stretch to either side, occasionally parting to reveal more modest structures in Argenteuil across the river.

There is nothing disruptive here, no smokestacks or dominating buildings, no crowds, tourists, or leisure pastimes—just bountiful nature. The elements of the site are so wedded to one another that they compensate for the limits Caillebotte has imposed on the panorama. The two trees in the center, which are veritable duplicates, attract particular attention. Standing starkly alone, they are merged at the top by means of their foliage and supported at the base by similarly disposed, conical bushes. They break the sweep of the view and act both as spatial demarcators and as surrogates for Caillebotte and us, energized by the light that also bathes the plains and observing the pervasive unity of the setting.

Like Constable in the Stour Valley and Dedham Vale or Claude Lorrain in the Italian *campagna,* Caillebotte fashions this unity in a highly conscious way, coercing each part of the landscape into a dialogue with the rest. At the same time he allows room for nature's vagaries: the rustling grass in the foreground, the play of darting light and shade throughout the scene, the various tones of blue in the sky that suggest its vastness. Caillebotte distinguishes each component by texture. The foreground is a medley of staccato-like brush strokes, the fields are defined by flatter, more elongated touches, the sky realized by diagonal sweeps of aggressively applied diluted pigment.

Monet left Argenteuil more than ten years before Caillebotte painted this view, apparently disenchanted by its transformation from a picturesque suburb to an increasingly industrialized, working-class town. Caillebotte stayed in the area, largely because he was an avid sailor and could indulge his passion for the sport at his very doorstep. In a painting such as this, however, he also suggests that the region could still engender the kind of reverie Monet seems to have found only in more rural locations—first in Vétheuil, then in Giverny.

This was the only time Caillebotte created an idyll of these proportions in which Argenteuil itself appears. Perhaps he knew that it was myth-making. That may also explain why this picture is so reminiscent of past art. It would be natural for Caillebotte to want the place he called home to nourish his work as much as possible, even if he had to invoke the preindustrial vision of his predecessors to accomplish that end, thus contradicting the evidence that surrounded him.

Claude Monet
Woman with a Parasol—Madame Monet and Her Son
1875
oil on canvas
100 × 81 (39⅜ × 31⅞)
National Gallery of Art, Washington,
Collection of Mr. and Mrs. Paul Mellon

Silhouetted against a dazzling, azure blue sky, Monet's wife, Camille, and their eight-year-old son, Jean, stand high above us atop a hill whose dramatic presence is enhanced by the rich color and forceful brushwork that Monet employs to suggest its dense, unkempt character. We are clearly *en plein air* on a late spring or early summer day, when the air is crisp and clean and the earth joins with the sky to celebrate nature's consummate splendor.

The tousled ground cover in the foreground begins the revelry as it climbs a third of the way up the picture, culminating in the rhythmic energy of the flowers along the horizon. The upper two-thirds of the painting are filled with intense light and an almost palpable atmosphere, making everything except for the figures appear to be in motion. The clouds in the background stream across the sky, so charged that they cannot maintain their shapes or integrity. Camille's veil is lifted by the caressing zephyrs and flung out behind her, while her dress is pulled around her in the opposite direction, enlivened by the sunlight that cascades down her back and dances along the edges of her jacket and skirt. Although it is supposedly white, her fashionable gown is transformed by Monet's artistry and the colors of the landscape, which prompt it to glow with reflected tones of buttercup yellow, soft violet, and deep blue.

Elegant and imposing, Camille dominates the scene, her body in profile, her head turned to meet the eyes of all who look at her. Her arms are pressed tightly against her sides, both hands clasping the handle of a parasol that she directs to the left to shield herself from the sun, which we do not see but which appears to be almost directly overhead.

Occupying a subordinate position to her left, Jean also stares out at the viewer, although he does not have to turn his head to do so. Unlike his mother, he stands more or less parallel to the picture plane, his almond-shaped face protected from the sun by his wide-brimmed straw hat, its edge turned down. This casualness is echoed in the loose collar of his sporty boater shirt, his skewed tie, and his relaxed pose, complete with hands in pockets.

The greatest informality, however, is found in the extraordinary way Monet describes the vast, boundless space of the sky. No two areas are alike, as Monet's brush dips, turns, rises, falls, scuds, flips, rushes left, right, diagonally, each time with varying amounts of paint. It is as if he were trying to suggest the infinite manifestations of light and air, those invisible, intangible forces that activate the site and define the moment.

Most surprising perhaps are the large parts of the sky that have not been covered, notably the section below Camille's parasol and the vertical rectangle along the right edge of the picture beginning at her waist and continuing down to the top of the hill. How daring these voids are—and how modern! They look ahead to what Clyfford Still would do on a much larger scale in the 1950s. And like the abstract expressionists' strategies, they make the painting appear to be unfinished. Monet was entirely capable of rendering clouds, but he evidently wanted to use the canvas itself as an expressive element in the image. Harnessing its rawness to heighten the impact of his seemingly spontaneous paint application, he provides yet another reminder of the illusionary basis of his craft. He insists with a kind of startling forthrightness that the only things that are real about the scene he is depicting are the paint and the support; everything else is merely a fabrication.

The empty areas also allude to the impossibility—despite the artist's virtuosity—of actually capturing light, air, and a particular instant in time, as had been Monet's lifelong goal. These aspects of nature are too elusive to be locked into the physical medium of paint. They can only be suggested, as Monet asserts over and over again in his deeply felt images of the visible world. His honesty is as refreshing as it is modern. It is akin to the way his family stares at him—as well as at the viewer—posing blunt questions about the meaning of our relationship to the construct Monet has created and the relevance of our actions in a realm of our own making.

47

Claude Monet
The Gladioli
c. 1876
oil on canvas
55.9 × 82.6 (22 × 32 ½)
The Detroit Institute of Arts, City of Detroit Purchase

Glorious in its light and color, almost fragrant from its wealth of flowers, this scintillating painting is at once rational and impossible, recognizable as an avant-garde genre scene and yet resistant to easy classification. Tantalizing and sensuous, contradictory and confusing, it vacillates between extremes, defining a distinctly new, modern space for Monet to describe the dialectics of his art and life.

The site depicted is the backyard of his second house in Argenteuil, a grand garden that Monet tended lovingly after signing a lease on the property in October 1874. He painted it only about six times prior to this canvas, always with the sumptuousness evident here. Yet few of the earlier pictures are as seductive and jarring.

The composition is divided into four discrete areas: the cropped circular flowerbed in the foreground, the complementary arc of the beige path on the left, the rectangular trellis and bed of red roses in the background, and the corresponding, though slightly smaller, rectangular section of darker foliage to the right. The parts are carefully balanced to create a sense of absolute harmony. Each is also artfully subdivided to increase the visual appeal of the whole.

Monet marshals the light to equal effect. It flickers throughout the scene, touching every element. Each responds accordingly, from the millefiori tapestry of grass and carnations at the lower left to the gladioli that twist and turn in the center, their stems taut and erect. The roses in the background are pulled from their dark green bed toward the light-filled foreground, their reds continuing in the flowers across the path. Light warms the path and outlines the form of the well-dressed woman—presumably Monet's wife, Camille—while edging her parasol in a brilliant white that sets off the cool green of its silk interior. That highlighting repeats the shapes of the fluttering wings of the butterflies. Like several of these buoyant creatures, Camille hovers at the intersection of the curving flowerbeds and the path and suggests many of the contradictions in the picture: she is both female and flowerlike, alive and statuesque, just as the rest of the image weds aspects of the artificial and the organic.

The painting contains other curiosities as well. Camille was taller than the gladioli but appears miniaturized by them here. She stares straight out at the viewer yet remains reserved and contained, especially compared to everything else in the garden. While she is presumably proceeding to the left, she can be perceived as being pinned like a captive butterfly against the crisscrossed pattern of the trellis behind her. Is she a vision, or is she real? Is she breathing, or merely a fabrication of the artist? Is she a personification of nature, or a projection of some deep, cryptic desire?

These questions are not unlike those that Antoine Watteau and his followers posed in the eighteenth century in their views of elegantly dressed figures cavorting in landscape settings. Monet greatly admired Watteau, whose *Embarkation for Cythera* was one of his favorite paintings. It is therefore not unreasonable to suspect that Monet wanted to modernize such *fêtes galantes* and to imbue them with the mysteries of his own contradictory world.

This connection goes a long way toward explaining the tensions that Monet establishes between the foreground and background, the physical surface of the painting and the illusory space it describes. The foreground bed of flowers, for example, for all of its veracity, is almost impossible to accept as real. It tips up so radically that it could take over the whole scene or, conversely, slip out of the picture and tumble into our realm. The path too rises precipitously, contributing to Camille's weightless, lightly poised appearance.

What are we to make of the division in the background between the trellis and the undefined foliage? There is no logical explanation for the break and no sense of how the two areas relate spatially. And what about the triangular shadow in the left foreground? Deriving from an unseen source, it cuts the gentle arc of the path into two opposing segments, then creeps up the outside ring of grass. And what about our own relationship to the landscape? We are both a part of it and removed from it, much as is Camille. Invited and rejected, seduced and surprised, we are not given clear guidelines as to how to respond or read the work. Is the painting ultimately about the beauties we can find in our own backyards, or the fantasies that modern life can inspire? Is it a celebration or a questioning? Departing from his earlier views of his garden (see cat. 17), Monet, mimicking life itself, provides no sure answers.

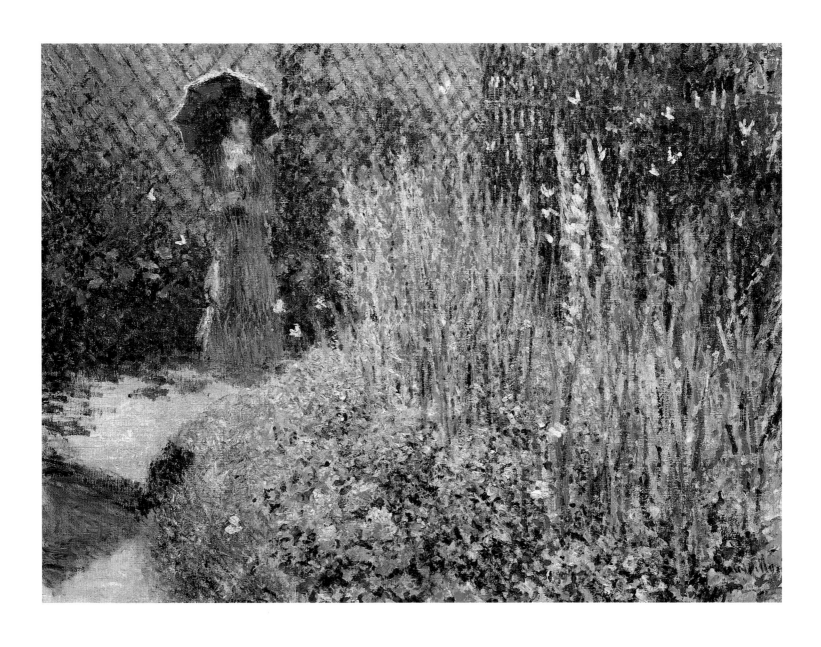

Gustave Caillebotte
Dahlias: The Garden at Petit Gennevilliers
1893
oil on canvas
157 × 114 (61¾ × 44⅞)
Anonymous lender

One of the delights of living in the suburbs of Paris in the nineteenth century was being close enough to visit the city whenever one desired and yet having a house and garden that were the antithesis of urban strain and squalor. Cartoonists poked fun at new residents of the ever-expanding towns around the capital, finding particular pleasure in mocking those who had produced some horticultural wonder that begged to be admired. Honoré Daumier was especially sage at this game, as were satirists like Gustave Doré.

When the various impressionists settled in the environs of the city and painted their new homes or those of friends, they took their task seriously, producing pictures that championed the attractions of suburban living. Among the most committed were Caillebotte and Monet, the latter having settled in Argenteuil more than a decade before his friend moved to the area. Caillebotte made up the difference, however, when he purchased property in Petit Gennevilliers in 1882 just across the Seine from Argenteuil. He focused much time and energy on his house and garden, as both a homeowner

and an artist, until his death in 1894. Far wealthier than Monet, who had left Argenteuil in the late 1870s for the more rural Vétheuil and subsequently Giverny, Caillebotte pursued his passions with resources that could satisfy his every whim.

This meticulously rendered painting bears ample witness to the results. We are in Caillebotte's backyard looking north toward his house, beyond which lie the Seine and Argenteuil. The setting is radiant with light and filled with elements of great visual interest. A place for consumption and contentment, this garden is also a laboratory for growth and experimentation— in art as well as horticulture. It would have made even the most cynical Parisian of the 1880s consider a move to the country.

The appeal begins in the immediate foreground, where a huge stand of dahlias surges up from the bottom of the canvas to occupy almost a quarter of the view. The sentrylike flowers block access to the space but at the same time invite detailed inspection, which provides many rewards. The flowers and foliage offer an engaging combination of darks and lights, soft textures and hard, edges and planes, solids and voids. They set the tone for the work as a whole, where there is much to relish and more to ponder.

Caillebotte plays the tangle of the foreground flowers against the clarity of the path on the left, its sharply defined edge leaving no doubt about the care that has gone into the landscaping. Like orthogonals in a Renaissance perspective system (which Caillebotte loved to manipulate), this line draws us into the garden proper, as do the striking patches of light along the path. We are then confronted by a small, testy black dog and a simply dressed woman, who, unlike her canine companion, takes no notice of our presence. She seems to focus on something in her hands, but because she clasps them to her breast she appears to be praying, as if she were an angel or the Virgin Mary. Caillebotte enhances this suggestion by the woman's clear outline, bent head, and halolike hat, as well as by the beauty of her surroundings. This is a kind of *hortus conclusus* that he is depicting after all, which makes it the ultimate transposition of the sacred to the secular.

Behind this modern votive figure a boldly lit four-story house reigns over the scene by its size, location, and color. The brightness of the early afternoon sun that illuminates its roof and façade adds even greater clarity to the strong geometries of its design. Together with the flanking trees, the house closes off the recession, with branches of a large dark tree near the garden path seeming to graze its left side. Caillebotte pulls the house toward the foreground by means of the path and an imposing greenhouse on the right. The monolithic form of the

Gustave Caillebotte, drawing for *Dahlias: The Garden at Petit Gennevilliers,* 1893, graphite on laid paper, Private Collection

greenhouse rises nearly two stories from a base that is hidden by a bank of flowers to its left, while its barrel-vaulted roof leads out of the space on a diagonal to the right.

That the greenhouse joins the background and foreground seems fitting. It is where infant plants are nurtured to become prize specimens like the dahlias. The link between the house, the greenhouse, and the flowers is implied by neat alignments that Caillebotte constructs. He makes the left edge of the green-house roof slice across a window on the right side of the main house, then meet the edge of the façade precisely where he places a single red dahlia blossom. He has two other red flowers touch a line on the greenhouse wall facing us just before it exits the scene on the right. That line marks a horizontal axis that bisects the painting as a whole, passing through the very point where the greenhouse roof meets the shutter of the house. Finally, if a vertical line is dropped through the middle of the house, it ends at the bottom of the picture just where the mound of the foreground dahlias begins.

Caillebotte disguises these subtle connections behind his lavishly applied impasto and the dramatic interaction of light and shade. But his compositional ploys are essential to recognize, because, like all decision making in these images, they arise from deep feeling and are the bearers of meaning. That Caillebotte devoted considerable effort to devising the alliances in this painting is evident from a drawing he made to serve as a guide (see illustration on p. 162). Almost certainly derived from previous sketches, and perhaps from photographs that he often took of his motifs, this drawing is squared for transfer, enabling the artist to plan how the forms in the scene would relate in the final composition. He also painted a smaller ver-sion of the picture that may have served as a model for the finished canvas.

Caillebotte's fellow impressionists would not have relied on such traditional aids to develop their paintings, preferring to work *alla prima,* at least in the 1870s. (Renoir adopted some of these methods in the 1880s, albeit briefly.) But all were highly conscious of the ways in which their pictures communicated information via the internal relationships that they established. This Eden that Caillebotte has created is not without its strains—of foreground against background, the human against the natural—and it is not completely isolated. Over the greenhouse on the right appears the roof of a neighboring house, making the garden seem narrower and more cramped than it would otherwise. The dahlias too take on the character of an anonymous crowd, pressed closely together and yet turning away from one another at the same time. As did other impressionists, Caillebotte experienced the country through the eyes of a former city dweller, sensitive to its glories but also to its proximity to the capital of modern culture.

Detail, cat. 48

Auguste Renoir
The Seine at Argenteuil
c. 1875
oil on canvas
54 × 65 (21 ¼ × 25 ⅝)
Private Collection, Switzerland

This imaginative, almost exotic painting is singular among those Renoir executed at Argenteuil. Colorful, light dappled, and airy, it gains its stature not for what it represents but for the daring of its facture and the novelty of its composition. It depicts the Petit Bras of the Seine, a site that attracted every artist who worked at Argenteuil, except for Manet. Renoir painted it at least three times during his periodic stays in the town from the 1870s to the 1890s; while each version is engaging in its own way, this is the most delicate and varied of the group.

The small arm of the Seine arcs into the picture in the lower left corner and bends around the Île Marante at the left. It becomes markedly foreshortened as it continues on to meet the main body of the river in the distance. The waterway helps us identify the spot, as do the stately poplars on the Île Marante. But it is the houses peeking through the foreground screen of foliage that confirm the location. They are the same ones that appear in earlier views of the Petit Bras by Renoir's fellow impressionists (see cat. 3).

In almost every other rendering of the site, we are invited to look without impediment down the Petit Bras to the skyline of Argenteuil on the opposite side of the Seine. In this painting, however, Renoir complicates that offering, filling most of the immediate foreground with the waving branches and fluttering foliage of small trees and bushes. He is interested in something other than just describing the landscape as it existed in the 1870s. And his conceits make this image more than simply an evocation of the particular effects of light and atmosphere he may have observed when he began to paint. Like a hunter behind a blind, Renoir looks out on his motif with focused intensity, but he insists that the view is not his primary concern as an artist. If it were, he would not have obscured it with the foreground folly.

The undergrowth in the foreground is of course not a folly, for it is rendered with the perspicuity of a seasoned naturalist. Branches arch and turn, seemingly of their own accord, leaves appear to flip back and forth as if blown by a brisk wind, and light flickers across the deftly carved out, semiprivate space. Everything appears to be in flux, even as this nook seems both secure and reassuring. The foreground screen, for example, is virtually impossible to fathom, so energized are its many components. Note how many kinds of strokes Renoir employs to describe the myriad diversions in this vegetation. His brush pushes, stabs, and caresses the canvas, adding layer upon layer of impasto while allowing each touch to remain distinct. Expressing nature's defiance of human rationale, the leaves on

the bushes perform an almost ecstatic dance, standing out as golden yellow flecks against the blue water of the Petit Bras where it enters the scene at the left. This detail is particularly poetic, for the leaves seem to float in the air following the fluid movements of the river; they will soon alight on its surface, to be carried away by the gentle current. The stiffer forms of the reeds below are also silhouetted against the water, but they are more rooted to the bank.

Renoir's painterly bravura continues on the right in the denser underbrush, where he makes sure we can read the recession of the waterway but encourages us to revel in the diversity he has discovered in this humble place, so unexpectedly rich in incident. No two square centimeters of the picture are the same, yet every nuance seems verifiable and just. The land drops off where the darker blues and greens appear at the lower right, then rises sharply to meet the right edge of the canvas just below an impenetrable thicket that is almost evenly divided, like the rest of the foreground, between cool blue greens and warm, light-filled yellows. These bushes are the most thickly painted of the plant life along the bank. With the equally compacted foliage on the Île Marante, they frame the view, lending it a note of understated authority.

The ethereal branches in the middle shimmer with light, as if to celebrate life and the beauty of the day. Every stroke Renoir sets down to describe them contributes to this effect, from the nearly transparent ones that he poses against the sky to the looping forms of lower branches just to the right of center. The latter seem to disregard the rhythms of the site and the orientation of the elements around them. Asserting their independence as calligraphic entities, they affirm Renoir's inventiveness and his desire to extend the language of landscape, something he clearly accomplishes in this painterly phantasmagoria by the banks of the Seine.

While the painting offers us the opportunity to appreciate nature's tremendous variety, which is the primary purpose of the genre, it also challenges traditional notions of decorum and declares visual stimulation to be a goal worth pursuing on its own terms. Only Renoir and his impressionist colleagues, who were open to change and sensitive to the contradictory conditions of modern life, could have devised such a strategy. It is not surprising that they had such difficulties convincing conservative critics of its merits. It seemed like reckless and self-indulgent behavior, but manifestly it was not.

Claude Monet
The Petit Bras of the Seine
1876
oil on canvas
55 × 75.5 (21 ⅝ × 29 ¾)
Private Collection, Germany

As Monet's years at Argenteuil waned, he became increasingly introspective. He turned more and more frequently to his garden, as if to wall himself off from the outside world. He also retraced his steps to the nearby Petit Bras of the Seine, a site that is depicted with marvelous subtlety in this little-known painting. It was the same vista that had often been the focus of his attention during his first two years in the town.

Monet's initial infatuation with the place must have owed something to its pastoral charm. Removed from the activity of the main body of the Seine and thus from the evidence of commerce and leisure that the river attracted, the Petit Bras was a picturesque retreat that evoked a sense of bygone days. Although its mouth was used as a docking area for pleasure craft, its shores were refreshingly free of development, and the trees and bushes along its banks could mask whatever encroachments might lurk offstage. It was, in short, somewhere one could be in communion with nature, despite whatever blinders one had to wear to get there.

Barbizon artists in the generation before Monet would have particularly appreciated this setting, even though bustling Argenteuil was a mere fifteen-minute walk away and the rumble of trains to and from Paris every half hour would inevitably—indeed predictably—disturb whatever state of reverie the landscape might inspire. No one who visited the Petit Bras seemed to care about this intrusion, however. Caillebotte rendered the locale nearly twenty times; one of Renoir's last views of the town is from this idyllic inlet. Monet painted it sixteen times during his six years in Argenteuil: more than half of these canvases were done in 1872; the next largest number—five—were done in 1876, the date of this picture. The two groups could not be more different in style, effect, and meaning.

The first group is actually divided into paintings done in the late winter or early spring of 1872 and others done that summer. A sense of innocence pervades the earlier works (cat. 3). Each element in the countryside seems to have held Monet's interest, whether it was the lichen along the banks, the stand of trees on the Île Marante, or the subtle contours of the earth. Everything was orderly and inviting. Monet's color scheme and brushwork supported these effects. His palette was subdued, surfaces were held in check with disciplined

brush strokes and a minimum of impasto; even the light was tempered, as were the waters of the inlet. There was no sign of Argenteuil's recreational activities. Rather, the Barbizon aura of the landscape had the upper hand. In contrast, the images from the summer of 1872 depicted a transformed site. Pleasure boats filled the neck of the waterway, color was heightened, brushwork vigorous; everything seemed vibrant and dazzling. Barbizon was a distant memory; the modern held sway.

In 1876 Monet reverted to the strategies of his first paintings of 1872. Every view focuses either across the water or away from Argenteuil and the Seine. None includes houses, recreational boats, or modern landmarks. It is as if Monet had stepped out of the contradictions of his contemporary present into some bucolic remnant of another era.

In this quiet tableau reeds occupy the immediate foreground, providing a sense of place but no actual footing. Monet articulates the individual stalks with the clear and deliberate strokes of a moderately loaded brush. Their proximity and position in the composition imply a viewpoint close to the ground, which is sympathetic to the unpretentiousness of the scene. Nothing is lively or dramatic, except for the engaging pattern of the reeds. Their sprightly forms give way to a slice of water that leads rapidly toward the horizon. Its strong recession contrasts with the vertical accents in the foreground, as does its tranquil surface, which Monet keeps well below the midpoint of the canvas.

On the right rise the trees of the Île Marante, their foliage lush and full, although their autumnal glow is being softly wrapped in the shadows of approaching twilight. Unlike Monet's first representation of the area in 1872 from virtually the same vantage (cat. 3), this painting shows the trees pulled into the upper right-hand corner, which increases the angle of their descent across the picture plane and our perception of their speedy disappearance into the distance. Comparison with the earlier rendering reveals how faithful to the site Monet remained. The same single tree stands at the end of the line on the right; to the left is the same row of more separated trees.

There is something at once more forceful and more elegiac here than in the earlier view. It involves the denser foliage and undergrowth that Monet includes and their dominating role

in the picture. It also relates to the more energized sky, with its blanket of more heavily worked clouds. Finally, it derives from the absence of humans in the scene or any suggestion of their presence. Closed off by the trees and foliage, the space appears more contained and introspective. At the same time it seems more strained.

By 1876 Monet had seen enormous changes in Argenteuil that caused its initial appeal to wither and his own urge for fulfillment to increase in inverse proportion. Turning more frequently to his garden, he found a haven of peace and repose that he could control. Similar rewards awaited him along the Petit Bras. Despite the developments across the Seine and the continued invasion of pleasure seekers, its grace was still resonant. Nearly two decades later it remained a source of solace for Caillebotte, who painted it shortly before his death in the 1890s. By then Monet had left its shores behind, opting for inspiration much farther from Paris, where the beauties of nature were more plentiful than just a single sweet holdover from the past.

Detail, cat. 50

Gustave Caillebotte
The Petit Bras of the Seine
1888
oil on canvas
75 × 100 (29 ½ × 39 ⅜)
Mr. and Mrs. Trammell Crow

Only an artist completely devoted to nature, with an aesthetic informed equally by the powers of past art and the marvels of contemporaneity, could have painted this picture, so deeply lyrical but verifiable is it. If a nineteenth-century poet wanted to sing the praises of summer or a lexicographer wanted to define particular qualities of the season, this image could have been their guide. It is a heartfelt distillation of an ideal summer's day.

Delicate, precise, and subtly charged, it also depicts what the suburbs of Paris offered the harried urban dweller, even in the late 1880s when Caillebotte signed and dated this canvas. That was long after the first wave of development had washed across this once-rural land and more than a decade after Monet had left Argenteuil. Caillebotte's painting is proof that the town—more specifically, the nearby Petit Bras of the Seine—had not lost its allure or its sense of being far from the city. Only a short walk from Caillebotte's property in Petit Gennevilliers, the inlet was a pristine vestige of times past and was highly popular among painters. Caillebotte painted it more often than any avant-garde artist working in the region.

This is certainly one of his most exquisite views of the site. Every detail seems called into being by a touch that is both calculated and gentle. Sure and deliberate, Caillebotte was also immensely sensitive to the nuances of the landscape. The bank on the left, for example, is rendered with countless marks that vary in size, orientation, and consistency. Each is just as convincing in its description of the texture, contour, and flow of the land, while each seems to carry in its physical presence a sense of Caillebotte's enchantment.

Caillebotte's attention is particularly evident in the way he has aligned the parts of the composition. The bank at the left, which fills the immediate foreground, rises on a graceful curve from the artist's vantage on the left to the midpoint of the picture's height. There it is crowned by a row of poplars, whose slender forms are echoed by less regimented trees in the distance. Caillebotte individualizes the trees, just as he demarcates the sections of the bank by physical breaks or changes in grade or direction. The poplars serve almost as sentinels, adding drama and definition to the scene while confirming the unstated influence of the human beings who planted them.

Caillebotte positions the towering tops of these trees so that they seem to touch the bottom of a long, horizontally disposed cloud. This unlikely cylindrical form is one of a series of clouds suspended in the rich blue sky. A dense row of trees on the right closes off the view with muffled authority, rising from a line of rounded bushes that runs along the edge of the river. These trees form a large triangle that fills the upper right half of the canvas and leads definitively to the deepest point in the space, just to the left of center, which is precisely where the placid waters of the inlet disappear.

This arrangement of parts is very satisfying and is enhanced by the light that fills the scene. Coming from directly overhead through air that is crystal clear, the light seems palpable, even life-giving. It touches virtually every element in the landscape, making each glisten or glow. The trees and bushes on the right appear particularly receptive, their branches reaching up toward the sun and sky.

Confronted with such a seductive, carefully considered picture, it is difficult to understand how impressionism could have sparked the controversy it did. By 1888, however, it was entangled in its own challenges. More than twenty years old by then, it had lost members such as Camille Pissarro to the ranks of the neo-impressionists led by the younger Georges Seurat. It had also felt the rebuke of protégés such as Paul Gauguin who were painting in a more abstract style and staking strident claims to the leadership of French art. Caillebotte understood those pressures. A work such as this is his candid response, an uncompromising affirmation of impressionism's principles set down with undaunted faith and boundless beauty.

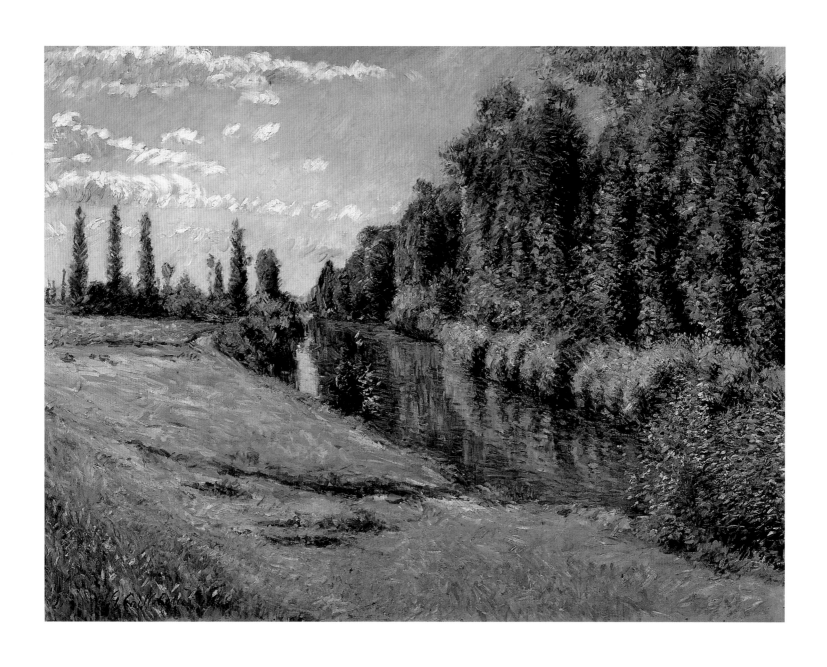

Claude Monet
Argenteuil, the Bank in Flower
1877
oil on canvas
54 × 65 (21 ¼ × 25 ⅝)
Private Collection, Japan

Monet was continually drawn to paint the promenade along the Seine during his years at Argenteuil, which suggests that it held special meaning for him. This attraction began his first summer in the town, when it seems to have held all of the promise he expected from his new suburban home (cat. 8). In each of those early pictures crisp, clear shapes were locked into relationships of great resolve. They were warmed by caressing light and liberally applied pigments of distinct, unmingled color. Everything appeared to have its place; everything was inviting and reassuring.

It is perhaps fitting that during his last summer in Argenteuil Monet returned to the promenade and took up a position along the bank that afforded him the opportunity to paint the scene again. He included the same features that had made the site so appealing in the beginning: the tall, thickly foliated trees, the turreted house, the stretch of the Seine, and the Île Marante in the distance. People still walk along the path, and two boaters take to the river.

But Monet's view in 1877 differs dramatically from his earlier depictions. Instead of the path that once welcomed us into the landscape, the foreground is now clogged with a tangle of flowers and undergrowth. Across the entire canvas, red and white roses bob on a sea of darkened stems that themselves rise out of an indeterminate foliage. So dense is this area that light has trouble entering it. The thicket blocks our access too. At the same time a small wooden fence cuts across the lower right corner on an angle, its thin pickets like stems plucked from the neighboring vegetation or like miniature versions of the smokestacks in the background. What is this fence or the garden doing in a public arena?

The mass of flowers and foliage divides the composition in half and allows no smooth transition between the two parts. The Seine flows out from behind the twisting stems, while the bank climbs up abruptly on the right. What we appear to be seeing is the junction of two separate worlds—one in which we stand, in front of the screen of flowers, the other containing the town beyond, with its many offerings and continued mystique. In the latter realm Monet links the top of the bank with the bottom edge of the houses and factories in the background, aligning them as well with the woods on the Île Marante. The water glows with the reflection of the golden, Turneresque light of the setting sun, while the land is cast in shadow, its more distant forms shrouded in a purple gray mist that blurs all particulars, making them seem eerie and intriguing.

The logical delineation of shapes and spaces that had distinguished Monet's earlier paintings of this site is here seriously compromised. Although the picture is held together with equal intelligence, it is not as easily read. A number of telling details help unravel the enigma. First, the presence of people on the promenade suggests that Argenteuil continues to attract those looking for diversions. Second, the looming house in the background remains an object of importance, its tower framed by factory chimneys on either side and echoed by the steamboat that puffs out a trail of smoke. This is still a community where industry and nature coexist and maintain a measure of appeal.

The light in the background, however, is utterly sublime, offering an almost impossible contrast to the darkness below. Is it real, or is it an illusion? This question may be asked of the whole scene. What is fact and what is fiction? The foreground thicket asserts itself as the boldest reality. In addition to its scale and immediacy, it is the most powerfully painted element in the view. Constructed from innumerable brush strokes, its impassioned marks seem to bear witness to Monet's emotional state as well as to his painterly bravura. The brush blots, swirls, skips, and curls across the surface with no apparent order or forethought. This freedom, which contrasts with the evenly rendered background, is precisely what one would expect from a contemporary artist bent on renovating tradition.

Freedom was also assumed to be central to a town like Argenteuil, which was an escape for the urban pleasure seeker. On a higher level the experience of freedom—from routines, hierarchies, or social restraints—was supposed to inspire discovery and renewal, perhaps a keener awareness of oneself and the world. That was certainly an aspect of being an impressionist in the 1870s. Monet understood this. He had consistently dealt with these dimensions of his art and life in his work at Argenteuil, although never like this. Moody and introspective, this painting seems to pit one kind of liberty against another: the unfettered foreground flowers against the vast domain beyond, hedonism versus reverie, personal indulgence against shared experience. There is another side to these contrasts, however. The flowers in the foreground are hardly alluring; the tallest arch up as if trying to escape the darkness that binds them. But they are spent, their petals fallen. And the light they seek is fading. The work is steeped in nostalgia and longing, just as it trumpets independence and expansiveness. These contradictory readings become most

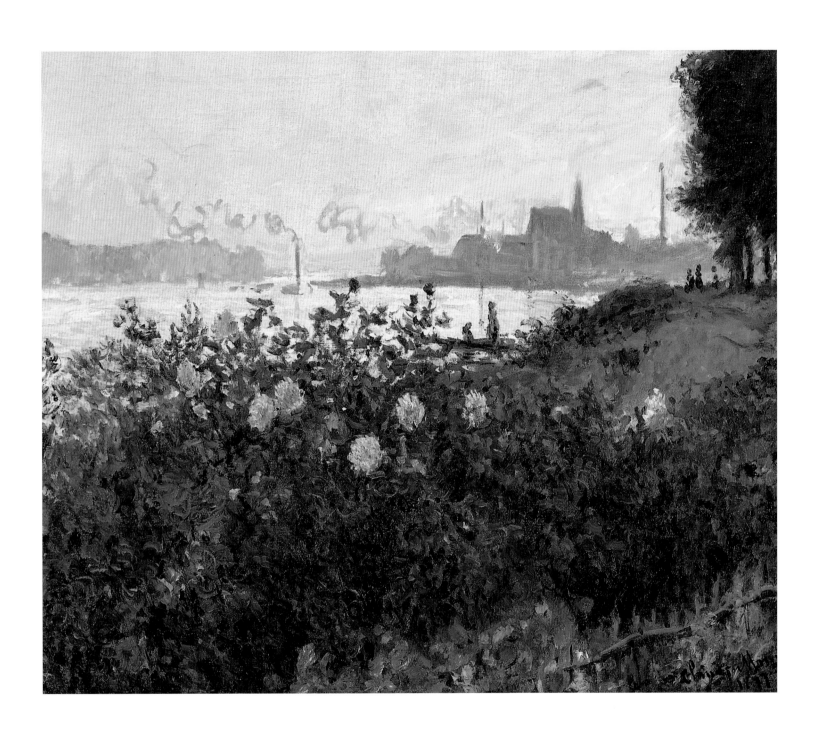

poignant when we realize that the flowers are actually part of the luminous world in the distance. The fence separates them from us and ensures their partnership with a place that may still give rise to golden illusions. But Monet knew after his years in Argenteuil that the suburb was hopelessly torn between the dichotomies of modern life—being both city and country, workaday and vacation spot, agrarian and industrial. The town had been divided since the coming of the railroad in the 1850s. Some twenty years later the split was even more pronounced, which is undoubtedly one reason for the radical partitioning of Monet's canvas. Progress, which the artist had celebrated in his early years at Argenteuil, especially in the mate to this work (cat. 8), was no longer a reliable ally. It had drastically altered the landscape, and with it, Monet's relationship to this ruptured but bountiful municipality.

Soon after completing this foreboding painting, Monet left Argenteuil for good. After stints in other Paris suburbs, he finally settled in Giverny, a refuge that was everything Argenteuil was not.

Detail, cat. 52

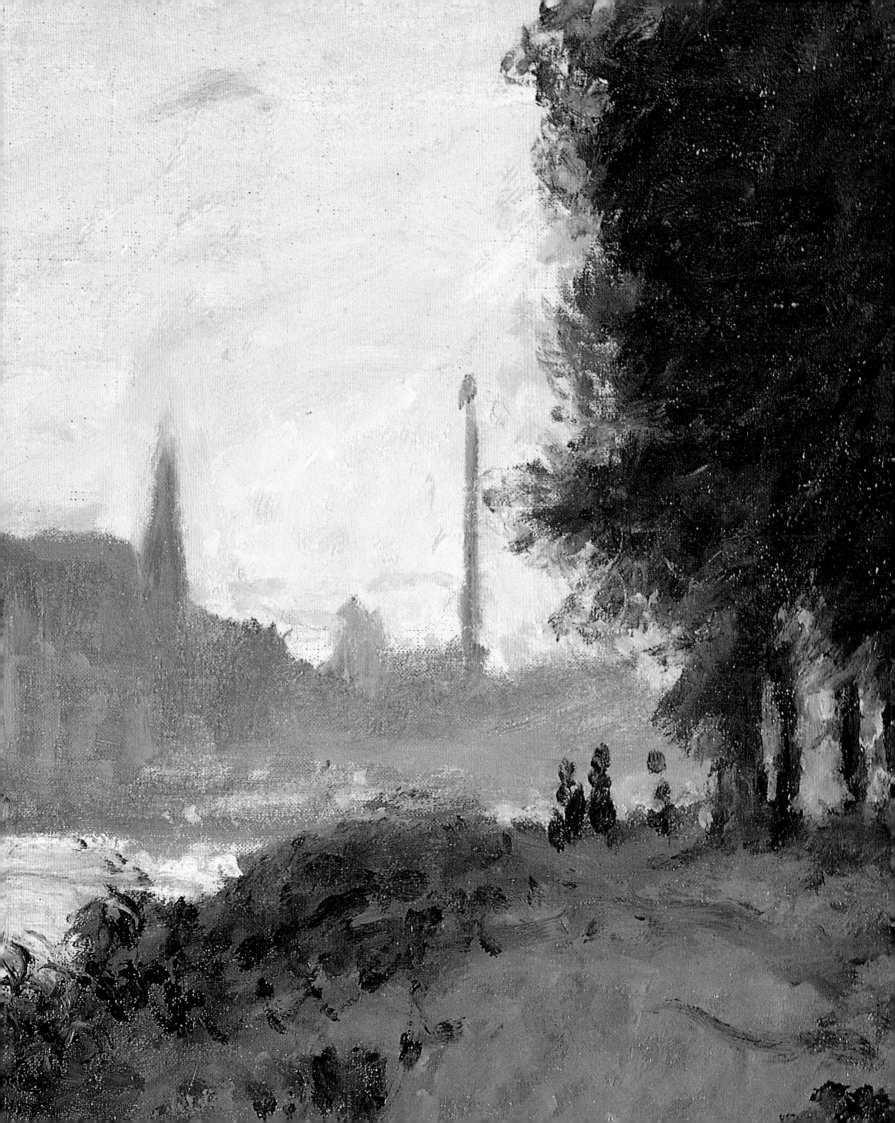

Index of Paintings in the Exhibition

Photographic credits

Argenteuil Archives, fig. 2
© 1999 Art Institute of Chicago, cat. 18
Bibliothèque Nationale, Paris, fig. 8
Joachim Blauel, photographer, fig. 20
Philip A. Charles, photographer, cat. 52
© 1999 Christie's Images, Ltd., figs. 26, 30, 34, cat. 30
© Clark Art Institute, cat. 16
© Detroit Institute of Arts (Dirk Bakker, chief photographer),
 cat. 47
Durand-Rhei, photographer, cat. 13
© Fine Arts Museums of San Francisco (McDonald,
 photographer), fig. 21
© The Fitzwilliam Museum, University of Cambridge, cat. 2
Courtesy Thomas Gibson Fine Art, Ltd., fig. 11
© Indiana University Art Museum (Michael Cavanagh and
 Kevin Montague, photographers), fig. 24
© Indien van Toepassing, Amsterdam, cat. 38
Peter Lauri, Bern, photographer, cat. 41
© The Metropolitan Museum of Art, cat. 40, and comparative
 figure for cat. 21
Courtesy The Metropolitan Museum of Art, cat. 17
Musée du Vieil Argenteuil, figs. 3 (Muriel Penpeny,
 photographer), 10, 28, and comparative figure for cat. 7
© Museum of Fine Arts, Boston, cat. 44
© National Gallery of Art, Washington, figs. 14, 16, 18, 23,
 cats. 1, 4, 8, 15, 20, 21, 28, 31, 46
Norfolk Museums Service, cats. 6, 23
Pinakothek München, fig. 22
© Portland Art Museum, cat. 33
Pro Lab, Photo Media, cat. 22
Rheinisches Bildarchiv, cat. 10
© Photo RMN, fig. 19; cat. 7 (Arnaudet, photographer); fig. 15,
 cats. 11, 25 (Hervé Lewandowski, photographer)
Staatliche Museen zu Berlin (Jörg P. Anders, photographer),
 cat. 24
© Collection Viollet, Paris, figs. 5, 27, 31, and comparative
 figures for cats. 4, 25, 30/31, 43
Graydon Wood, photographer, fig. 17

Every effort has been made to contact the copyright holders
for the photographs in this book. Any omissions will be
corrected in subsequent editions.